Shooting & Sharing Photos For Dummies

FOR DUMMIES™
BESTSELLING BOOK SERIES

Digital Photography Secret Decoder Ring

Keep this table handy to translate digital photography lingo.

Term	What It Means
CompactFlash, Memory Stick, Secure Digital, SmartMedia, xD-Picture Card	Types of memory cards used to store image files in a digital camera; sometimes referred to as digital film, although no film is involved.
Compression	A process that reduces the size of digital photo files by eliminating some picture data.
DPI	Dots per inch; a measure of how many dots of color a printer outputs per inch.
Gamut	("gamm-utt") The spectrum of colors that a printer, camera, or other device can reproduce.
JPEG	("jay-pegg") The primary type of picture file created by digital cameras; also the format used for online picture sharing.
Megapixel	One million pixels.
Pixels	The tiny colored squares used to create a digital photo.
PPI	Pixels per inch; the number of pixels in each linear inch of a printed photograph.
Resolution	A value that describes the capabilities of a digital camera, printer, or monitor. Means different things depending on the device.
Slow-sync flash	A special flash mode for nighttime photography; produces brighter backgrounds than normal flash mode.
White balancing	A digital camera feature that compensates for the color cast produced by a light source.

For Dummies: Bestselling Book Series for Beginners

Shooting & Sharing Digital Photos For Dummies®

Cheat Sheet

BESTSELLING BOOK SERIES

Exposure Glossary

These terms refer to exposure features found on many digital cameras.

Feature	What It Does
Aperture	An adjustable iris behind the lens; determines how much light enters the camera.
Aperture-priority autoexposure	Semiautomatic exposure mode; you set the aperture, and the camera sets the shutter speed.
Autoexposure	Fully automatic exposure mode; the camera selects both shutter speed and aperture size.
Center-weighted metering mode	Sets exposure based on the entire frame, but with preference to the center of the frame.
EV (exposure value) compensation	Forces a brighter or darker exposure than the autoexposure mechanism selects.
F-stop	The aperture setting; the smaller the f-stop number, the larger the aperture size.
Manual exposure	No exposure input from the camera; you select both shutter speed and aperture size.
Pattern-metering mode	Also called matrix metering, zone metering, and multimetering; sets exposure based on the entire frame.
Shutter	A barrier behind the camera lens that opens to allow light into the camera when you press the shutter button.
Shutter speed	The length of time the shutter remains open.
Shutter-priority autoexposure	Semiautomatic exposure mode; you set the shutter speed, and the camera sets the aperture size.
Spot-metering mode	Sets exposure based only on the area at the center of the frame.

Copyright © 2003 Wiley Publishing, Inc. All rights reserved.

Item 4359-8.

For more information about Wiley Publishing, call 1-800-762-2974.

For Dummies: Bestselling Book Series for Beginners

Shooting & Sharing Digital Photos

FOR

DUMMIES®

Shooting & Sharing Digital Photos FOR DUMMIES®

by Julie Adair King

WILEY

Wiley Publishing, Inc.

Shooting & Sharing Digital Photos For Dummies®

Published by
Wiley Publishing, Inc.
111 River Street
Hoboken, NJ 07030
www.wiley.com

Copyright © 2003 by Wiley Publishing, Inc., Indianapolis, Indiana

Published by Wiley Publishing, Inc., Indianapolis, Indiana

Published simultaneously in Canada

For general information on our other products and services or to obtain technical support, please contact our Customer Care Department within the U.S. at 800-762-2974, outside the U.S. at 317-572-3993, or fax 317-572-4002.

Wiley also publishes its books in a variety of electronic formats. Some content that appears in print may not be available in electronic books.

Library of Congress Control Number: 2003112653

ISBN: 0-7645-4359-8

Manufactured in the United States of America

10 9 8 7 6 5 4 3

1B/TQ/QZ/QT/IN

WILEY is a trademark of Wiley Publishing, Inc.

About the Author

Photographer and digital-imaging expert **Julie Adair King** is the author of the best-selling book *Digital Photography For Dummies* as well as *Photo Retouching and Restoration For Dummies, Adobe PhotoDeluxe For Dummies, Easy Web Graphics,* and *Shoot Like a Pro! Digital Photography Techniques*. She is a graduate of Purdue University and resides in Indianapolis, Indiana.

Author's Acknowledgments

My sincere appreciation goes to all the hard-working, talented people at Wiley Publishing, Inc., who helped make this book possible, including Linda Morris, Kim Darosett, Shelley Lea, Steve Hayes, and Kristie Rees.

I am also grateful to the always-astute Alfred DeBat, for his technical review, and to my agent, Danielle Jatlow, for her continued support and savvy professional advice.

Finally, thanks to all the family members and friends who so graciously say "cheese" when I ask and, more importantly, lend their ears and shoulders when I need them most.

Publisher's Acknowledgments

We're proud of this book; please send us your comments through our online registration form located at www.dummies.com/register/.

Some of the people who helped bring this book to market include the following:

Acquisitions, Editorial, and Media Development

Project Editor:
Linda Morris

Senior Acquisitions Editor:
Steven Hayes

Senior Copy Editor: Kim Darosett

Technical Editor: Alfred DeBat

Editorial Manager: Leah Cameron

Permissions Editor: Laura Moss

Media Development Supervisor:
Richard Graves

Editorial Assistant: Amanda Foxworth

Cartoons: Rich Tennant
(www.the5thwave.com)

Production

Project Coordinator: Kristie Rees

Layout and Graphics: Amanda Carter, Carrie Foster, Joyce Haughey, LeAndra Hosier, Jacque Schneider, Julie Trippetti, Shae Lynn Wilson

Proofreaders: David Faust, Arielle Carole Mennelle, Dwight Ramsey

Indexer: Richard T. Evans

Publishing and Editorial for Technology Dummies

> **Richard Swadley,** Vice President and Executive Group Publisher

> **Andy Cummings,** Vice President and Publisher

> **Mary C. Corder,** Editorial Director

Publishing for Consumer Dummies

> **Diane Graves Steele,** Vice President and Publisher

> **Joyce Pepple,** Acquisitions Director

Composition Services

> **Gerry Fahey,** Vice President of Production Services

> **Debbie Stailey,** Director of Composition Services

Contents at a Glance

Table of Contents

Introduction

● ●

Digital cameras are incredible tools. You can review your pictures instantly on your digital camera's monitor — no more dropping off a roll of film at the lab and then waiting with crossed fingers to see whether your pictures are any good. In addition to offering instant feedback, digital cameras enable you to share pictures via the Internet literally minutes after you press the shutter button. No wonder digital camera sales now surpass traditional film-camera sales!

If you've joined the ranks of digital photographers or are considering doing so, I can promise you that you are going to love this new way of taking pictures. I can also assure you that if you're a little confused about some aspects of digital photography, you're not alone. *All* of us who made the switch to digital had the same questions as you when we first started using our new cameras.

Whether you're interested in capturing family memories, taking pictures for your company's Web site — or both — *Shooting & Sharing Digital Photos For Dummies* answers all your digital photography questions. Among other things, this book shows you how to

- ✔ Choose the right camera settings for different types of pictures.
- ✔ Make sense of technical terms such as resolution, file compression, and white balancing.
- ✔ Transfer photos from the camera to your computer.
- ✔ Send pictures with an e-mail message.
- ✔ Prepare your pictures for a Web page.
- ✔ View your photos on a TV or record them on videotape.
- ✔ Print your favorite pictures using your own photo printer or a photo lab.

Although *Shooting & Sharing Digital Photos For Dummies* covers all these topics and more, you don't need to slog through long-winded background explanations to get the information you need. I've focused just on the essential facts so that you can zip through the learning stage and start enjoying all the benefits that your digital camera offers.

Does This Book Cover My Camera?

As you flip through the pages of this book, you can see several cameras featured in various photographs. Although I use these cameras to illustrate certain topics, the information that I provide applies to any digital camera, not just these specific models. However, the names of some features vary from camera to camera, which is why I recommend that you read this book with your camera manual close at hand.

In the margins next to some paragraphs, you see tiny graphics — *icons,* in computer-book lingo — that look similar to the icons you find on your camera. For example, most cameras use a picture of a flower to label the control that shifts the camera's lens into close-up focusing mode. And the playback mode that you use to review pictures on your camera's monitor is typically indicated by a green triangle.

I've included these icons in the book to help you locate the related buttons or controls on your camera. But every manufacturer's art department has its own take on these icons, and your camera may not even use icons for some features. So consider the icons as general guideposts; again, consult your camera's manual to see the icons used on your model. You may want to draw the icons in this book when they're significantly different from what you see here.

Do I Need Special Software?

Most digital cameras come with a CD-ROM disc that contains software that you can use to transfer pictures to your computer. Many manufacturers also provide a photo-editing program or, at the very least, a basic utility for making simple changes to photographs, such as removing red-eye.

Because this software varies significantly from camera to camera, giving specific how-to's for using each program is impossible. Instead, I've provided basic guidelines that you can apply to almost any program.

In a few cases, I do provide step-by-step instructions for accomplishing some tasks (including fixing the aforementioned red-eye). For these examples, I feature a popular photo-editing program, Adobe Photoshop Elements Version 2.0. I selected this program not only because I think that it's a great product for both novices and intermediate users, but also because it sells for less than $100

and is available for both Windows-based PCs and Macintosh computers. Again, you can easily translate the instructions to whatever software you prefer. (If you want to work along with the book, you can download a free trial copy of Photoshop Elements at the Adobe Web site, www.adobe.com.)

A Quick Peek Ahead

This book is organized into six parts, with each part covering a different aspect of using your digital camera. Here's a quick preview of what you can find in each part.

Part 1: Taking Your First Pictures

Part I shows you how to set up your digital camera and then walks you through the process of shooting your first pictures.

- ✔ Chapters 1 and 2 acquaint you with standard digital camera features, from the monitor to the memory cards.

- ✔ Chapter 3 explains the two most critical camera controls: the settings that determine resolution and picture quality.

- ✔ Chapter 4 shows you how to get the best performance from your camera's autofocus and autoexposure mechanisms. You also find out how to tweak white balance for better color accuracy.

Part II: Exploring Exposure and Focusing Options

Visit this part of the book for tips related to exposure and focus — common trouble spots for all photographers, digital or film.

- ✔ Chapter 5 provides information about using your camera's built-in flash, including how to reduce the chances of red-eye. For times when you don't completely eliminate red-eye, this chapter also shows you how to fix the problem in a photo editor.

- ✔ Chapter 6 explores ways to tweak exposure by using features such as EV (exposure value) compensation and autoexposure metering modes. This chapter also offers techniques for manipulating focus to achieve various photographic effects.

Part III: Viewing and Saving Photos

After you press the shutter button, explore this part of the book to find out how to view your digital photos, transfer them to your computer, and protect your picture files.

- ✔ Chapter 7 shows you how to play back pictures on your camera, delete the images you don't like, and "lock" the keepers so that you can't accidentally erase them. If you want a larger view of your images, this chapter also explains how to display them on a television.

- ✔ Chapter 8 discusses methods for getting pictures from your camera to your computer. In addition, this chapter explains how to safeguard important pictures and introduces you to software that makes managing your picture files easier.

Part IV: Sharing and Printing Photos

As its name implies, this part of the book tells you what you need to know to share your digital photos via the Internet and to make great, long-lasting prints of your favorite images.

- ✔ Chapter 9 guides you through the process of getting your pictures ready for the Internet, explaining how to set the picture-display size and save the images in the JPEG file format.

- ✔ Chapter 10 provides step-by-step instructions for attaching a picture to an e-mail message. This chapter also discusses photo-sharing Web sites, which offer another great way to show off your pictures online.

- ✔ Chapter 11 offers advice about various printing options, from using a personal photo printer to working with a retail photo lab. You also find out how to prepare your pictures for printing and protect your prints from fading and other damage.

Part V: The Part of Tens

Like all *For Dummies* books, this one contains a series of top-ten lists that provide you with quick, easy-to-digest bits of information — appetizers for the mind, if you will.

✔ Chapter 12 answers the ten most frequently asked questions about digital photography.

✔ Chapter 13 provides solutions to ten common printing problems.

✔ Chapter 14 offers ten tips for getting a good buy when you shop for digital photography equipment.

✔ Chapter 15 features ten accessories that make digital photography easier and more enjoyable.

✔ I explain important terms in detail throughout the book, but for quick definitions, look in the appendix, which contains a glossary. The glossary translates not only terms that are introduced in the book, but also some others that you're likely to encounter when you explore digital photography magazines and other resources.

Conventions Used in This Book

In case this is your first _For Dummies_ book, I need to explain how to interpret a few stylistic elements found on some pages.

First, instructions for using certain software tools may include a statement that reads something like this:

Choose Image⇨Resize⇨Image Size.

The arrows indicate that you're looking at a series of menu names and commands that you need to click with your mouse. For example, in this series, you click Image on the program's menu bar to display a menu. You then click Resize to display a submenu and click Image Size on that submenu.

For some tasks, you need to press a key on your computer's keyboard as you click. If the key you use is different on a Windows-based PC than on a Macintosh computer, I give the PC information first, followed by the Macinstoch information in parentheses.

Finally, some pages contain large margin icons in addition to the camera-related icons that I mentioned earlier in this introduction. These icons highlight five categories of information, as follows:

Tip icons flag suggestions that make a digital photography task easier, save you money or time, or all three.

Warning icons alert you to potential trouble spots and offer possible solutions if you already wandered into the danger zone.

Remember icons mark information that's important enough to give a prominent location in your mental memory closet.

Technical Stuff icons adorn explanations of digital-photography terminology.

Cross-Reference icons point you to other places in the book where you can find more information about a particular topic.

Where Should I Start?

This book is designed to work as a reference guide — meaning that you don't have to read it in any particular order. You can just dip in and dip out of any chapter, stopping to read whatever topic is puzzling you at the moment.

However, if you're brand new to digital cameras, I suggest that you read Chapters 1 through 4 first so that you have a good foundation on which to build your digital photography skills. To paraphrase that famous song from *The Sound of Music,* the beginning is a very good place to start. From there, where you go is up to you.

However you approach the book, remember that being a little intimidated or even completely baffled by this new technology is normal! Trust me, we've all been there — even the condescending geek down the street who pretends otherwise.

Be patient with yourself, keep this book close by, and soon your digital camera will feel like an old friend. So pick a page, grab your camera, and get ready to shoot, share, and enjoy!

Part I
Taking Your First Pictures

The 5th Wave By Rich Tennant

NATIONAL ENQUIRER PHOTO IMAGING WORKSHOP

"Remember, your Elvis should appear bald and slightly hunched. Nice Big Foot, Brad. Keep your two-headed animals in the shadows and your alien spacecrafts crisp and defined."

In this part . . .

Many digital cameras look very much like the point-and-shoot film models we've all been using for years. And in fact, some features work just as they do on those traditional models — a shutter button is a shutter button, for example, and a built-in flash on a digital camera operates the same as it does on a film camera.

Some photographic controls, however, work a little differently on a digital camera than on a film camera. Other options are digital-only and so may be entirely new to you.

Chapters in this part of the book explain all the controls on your camera and help you sort out what settings to use for different types of pictures. In addition, you can get advice about camera care, discover techniques that maximize battery life, and find out more about working with digital camera memory cards.

Chapter 1

Exploring Your Camera's Bells and Whistles

*1*f you're like most people, your first reaction when you took your digital camera out of the box was panicked confusion. Scattered across the camera body are little dials and buttons that you never encountered before. Often, camera manufacturers don't label many of those controls, and the labels that *are* provided aren't very helpful unless you're an experienced photographer. What the heck does *EV +/-* do, for example? Are you supposed to push that little button marked with a flower when you want to take nature shots? The ads that convinced you that the time was right to go digital sure made everything seem a lot easier than it looks now.

Don't panic. This chapter explains all the features on the outside of your camera and also tells you what to do with the various cables and other bits and pieces that came with your camera. As is the case when you venture into any foreign territory, you'll find that your camera isn't nearly so intimidating with a guide to help you find your way around.

Sorting Through the Box

Most digital cameras ship with a few standard items. In addition to your camera, you should find the following in the camera box:

✔ An instruction manual.

✔ A CD-ROM that contains camera *driver* software. A driver is a piece of software that enables your computer and camera to communicate.

Depending on your camera, the CD may also contain the following:

• A program for viewing your digital photos.

• A tool for transferring picture files to the computer.

• Basic photo-editing, printing, or photo-sharing software.

• An electronic version of the camera manual, usually in the PDF file format. In some cases, the electronic manual contains details not included in the printed manual. You can view and print the electronic manual by using a free program called Adobe Acrobat Reader. Check your camera CD to see whether it contains a copy of Acrobat Reader; if not, download the program from www.adobe.com.

✔ A USB cable for connecting the camera to your computer. USB stands for *Universal Serial Bus,* which is a type of connection found on all new computers. Figure 1-1 shows this type of cable.

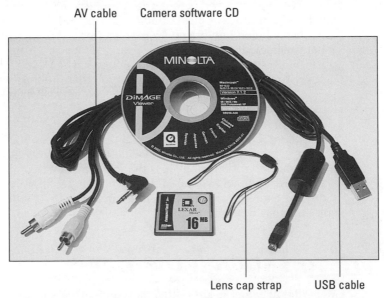

AV cable Camera software CD

Lens cap strap USB cable

Figure 1-1: Most cameras come with a USB cable and other accessories.

✔ An AV (audio/video) cable, which enables you to connect your camera to a TV, DVD player, or VCR so that you can view your pictures on a television screen. Only cameras that can output a video signal provide this cable, however. Cameras that offer this feature have an *AV-out port* (socket) for connecting the cable. If your camera also can record audio clips, one end of the AV cable has two plugs, as shown in Figure 1-1. One plug carries the audio signal, and the other carries the video signal. If your camera doesn't have audio recording capabilities, your AV cable has only the video plug.

Transferring pictures from your camera to the computer via the USB cable is not your only option; see Chapter 8 for information about other transfer methods. For help with hooking up your camera to a TV, DVD, or VCR, see Chapter 7.

Many cameras also come with a few additional accessories, such as the following:

✔ A memory card, which most cameras use to store the pictures you take. Figure 1-1 shows one type of memory card, a CompactFlash card.

✔ A battery charger, either for standard AA-size rechargeables or for a specialty battery designed just for your camera.

Chapter 2 talks more about memory cards and camera batteries.

✔ A camera wrist strap, neck strap, or both.

✔ A small lens-cap strap, like the one shown in Figure 1-1, which keeps the cap tethered to the camera body while you're taking pictures. You hook one end of the strap through a slot in the lens cap and slide the other end through a ring or slot on the camera body. Lens caps are easy to lose, so if your camera offers this accessory, use it!

Getting Acquainted with Your Camera

From the front, most digital cameras look similar to point-and-shoot film cameras. But turn your camera around, and you'll discover a few digital-only features, as shown in Figure 1-2. The camera shown in the figure is a Canon model, but most cameras

offer the same basic controls (although they may have different designs and labels).

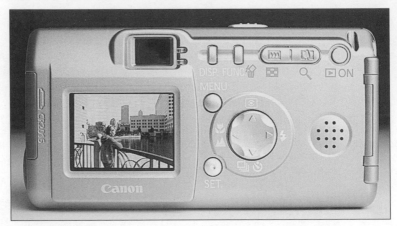

Figure 1-2: Use buttons on the camera back to access picture options.

Upcoming chapters discuss these features in more detail, but the next few sections give you a quick introduction. Your camera may not offer all these features or may implement them in a different way, so as you work through this information, you may want to refer to your own camera manual for specifics.

The monitor

Perhaps the most valuable tool on a digital camera, the monitor enables you to instantly review your pictures. You can also use the monitor to frame your shots (and you must do so if your camera doesn't offer a viewfinder). In addition, the monitor displays the menus that you use to select certain camera options, as illustrated in Figure 1-3.

Most camera monitors are *LCD monitors.* LCD stands for *liquid crystal display.* A few recent models use a new type of display, called *OLED,* which is short for *organic light-emitting diode.* This new technology produces a display that's easier to see in bright light and looks sharp from all viewing angles. (Pictures on LCD monitors wash out in direct light and can be difficult to see unless you're viewing them straight on.)

Regardless of what monitor technology your camera uses, you should find a button that enables you to turn the monitor on and

off. The button may be labeled *DISP,* as on the camera shown in Figure 1-3, or it may be labeled with a simple rectangle placed between two vertical lines. Flip ahead to Table 1-1 to see this icon label; the camera in Figure 1-7 uses this design as well.

Monitor

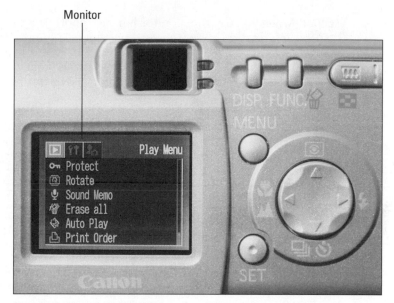

Figure 1-3: Press the Menu button to access additional options.

Monitors suck up lots of battery power, so keep yours turned off when you're not using it.

The viewfinder

The best digital cameras (in my opinion) include a viewfinder. I don't like having to use the monitor to frame shots, for two reasons. As mentioned in the preceding section, the image displayed by most monitors is difficult to see in bright light or when viewed from an angle. In addition, you have to hold the camera away from your body to take the shot, a posture that increases the likelihood of camera shake. Even the slightest camera movement can cause a blurry image, so I suggest that you use the viewfinder to frame your pictures whenever possible.

Framing with the viewfinder does have two drawbacks, however. First, on many cameras, what you see through the viewfinder isn't exactly the same area that the camera lens records. For tips on

dealing with this issue, known as *parallax error,* see Chapter 4. If your camera offers a *through-the-lens* (TTL) viewfinder, however, the viewfinder and lens should be in sync. (If you can see an image through the viewfinder when the camera's lens is covered, you *don't* have a TTL viewfinder.)

Second, when you use the monitor to frame shots, the camera displays information about the current camera settings along with the image, as shown in Figure 1-4. On some cameras, a separate status-display panel on top of the camera reveals some of this information; Figure 1-6, later in the chapter, shows this panel.

As an alternative, some new, higher-priced cameras have electronic viewfinders, which give you the best of both worlds. This type of viewfinder shows you all the camera information that normally appears in the monitor when you frame a shot. On the downside, you can't see anything through the viewfinder while the camera is turned off.

Some cameras offer a *diopter control* that enables you to adjust the viewfinder to your eyesight, just as you can with binoculars. Look for a tiny thumbwheel near the viewfinder. Peer through the viewfinder as you nudge the wheel to make this adjustment.

Viewfinder

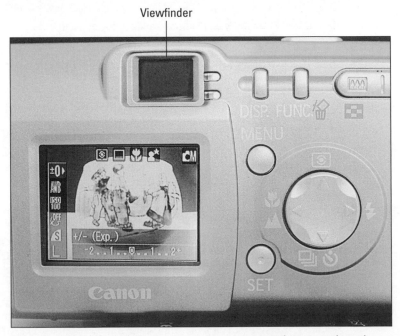

Figure 1-4: Monitor symbols show you what camera settings are selected.

Indicator lights

Cameras that have a traditional viewfinder usually have a pair of tiny — and I mean *tiny* — indicator lights positioned next to the viewfinder, as shown in Figure 1-5. These lights are primarily used to indicate correct focus and exposure. After you take a shot, one light will blink or turn red until the camera records the image.

Indicator lights

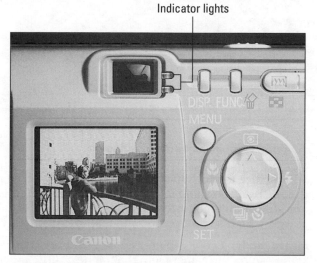

Figure 1-5: The indicator lights provide focus and exposure feedback.

If your camera doesn't offer a viewfinder, these signals usually appear on the monitor itself, but some models still use separate indicator lights. What each signal means varies from camera to camera, so check your manual to get the full story.

Camera mode control

This control shifts your camera between the various recording, setup, and playback modes available on your model. On most cameras, the mode control looks something like the one shown in Figure 1-6, which features a Minolta camera. This camera also offers the status display panel that shows you the current camera settings, as discussed in "The viewfinder," earlier in this chapter.

Status display panel Camera mode dial

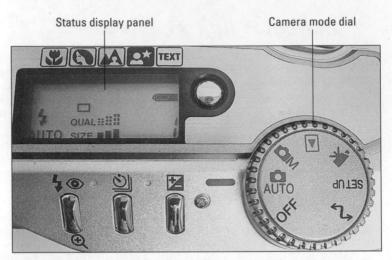

Figure 1-6: Many cameras provide a dial for changing the camera mode.

Typical mode settings include the following:

✔ **Still-picture mode:** Usually indicated by a little camera icon, this is the single-shot mode. Your camera may offer more than one still-picture mode; for example, the Minolta model shown in Figure 1-6 offers automatic and manual still-picture modes.

✔ **Movie mode:** If your camera can record short video clips, this setting shifts the camera into that mode. A little movie camera is the universal symbol for this setting.

✔ **Playback mode:** To review your pictures, switch to this mode, which is usually indicated by a green triangle.

Many cameras offer an instant review feature, which automatically displays a picture for a few seconds immediately after you take it. This feature is a great convenience because you don't have to switch to playback mode to see whether you got the shot. Check your manual to find out how to activate this feature.

✔ **Exposure modes:** Your digital camera may offer up to four exposure modes: fully automatic (known as *programmed auto-exposure*), aperture-priority exposure, shutter-priority exposure, and manual exposure. These modes are represented by a P (or Auto), A (or Av), S or (Sv), and M, respectively. Check out Chapter 4 for help with using programmed autoexposure mode; See Chapter 6 for details about the other modes.

✔ **PC mode:** On some cameras, you choose this mode when you connect the camera to the computer for picture transfer, as

discussed in Chapter 8. A double-headed arrow or the letters PC are the standard symbols for this mode.

✔ **Setup mode:** This mode allows you to access options that control the camera's basic operation. For example, you can sometimes adjust the volume of any audio signals the camera produces and select a format for naming image files. See Chapter 2 for help with setup options.

Table 1-1, at the end of this chapter, shows the standard icons used to represent these camera modes and other camera options.

Menu controls

The Menu button gives you access to all the options that are controlled via internal menus. When you press this button, the monitor turns on automatically to display the menus. (If you're using a camera with an electronic viewfinder, you can set the camera to display the menus in the viewfinder instead.)

You use other camera buttons, which vary from camera to camera, to navigate your way through the internal menus. Most cameras use the four-way rocker switch design shown in the close-up shot in Figure 1-7. After selecting a menu option, you usually have to press an OK or Set button to confirm your decision. In some cases, you instead press the center of the rocker switch.

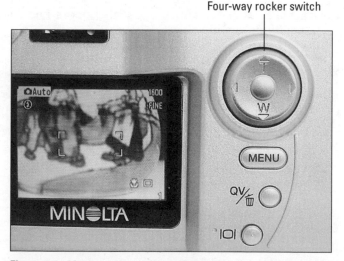

Four-way rocker switch

Figure 1-7: Most cameras use a rocker switch for navigating menus.

Zoom control

If your camera offers a zoom lens, you'll find a zoom rocker switch. On some models, the zoom control is incorporated into the four-way switch used to navigate menus, as shown in Figure 1-7. On other cameras, the zoom control is a separate affair, usually placed near the shutter button. (I'm assuming that you're not using an advanced, SLR-style digital model that offers a traditional lens design, where you twist the lens barrel itself to zoom in and out.)

Regardless of where the switch is located, you just press one side of the switch to zoom in and another to zoom out.

✔ The zoom-in side of the switch is marked with a T (for tele-photo) on some cameras; other cameras use a picture of a single large tree. (See Table 1-1 later in this chapter.)

✔ On the zoom-out side of the switch, you'll see a W (for wide-angle) or three tiny trees.

Most digital cameras offer a digital zoom, which has a different effect on your pictures than a regular zoom lens. Chapter 4 talks more about digital zoom — and why you should avoid using it.

Looking Behind Closed Doors

As you peer over your camera body, you'll spot a door covering the camera's battery chamber. Open other doors, and you may find these additional features:

✔ A slot for inserting a camera memory card. See Chapter 2 for help with memory cards (and also with battery issues).

✔ A USB port for attaching one end of the camera's USB cable. The other cable end goes into your computer's USB port, as discussed in Chapter 8.

Port is geek-speak for "a socket into which you plug a cable."

✔ A DC-in port, used for connecting an AC power adapter, if available for your camera.

✔ An AV-out port, which enables you to connect your camera to a TV, DVD player, or VCR by using the AV (audio/video) cable that came with your camera. (On cameras that do not offer an audio-recording function, this port sometimes goes by the name video-out.)

Figure 1-8 offers a look at these components. The size of the AV-out and DC-in ports vary from camera to camera, but the USB port size is pretty standard. The memory-card slot also varies; the one shown in Figure 1-8 is for a CompactFlash card.

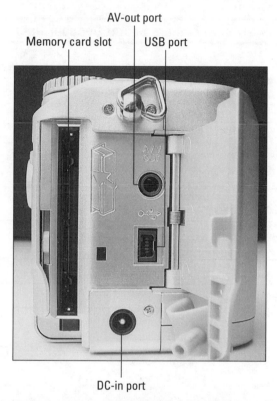

AV-out port

Memory card slot USB port

DC-in port

Figure 1-8: Here's a look at some common connection ports.

On some cameras, the lens may be covered by a sliding door as well. The door sometimes serves not just as a lens protector but also as the camera's on/off switch.

Deciphering Camera Shorthand

To wrap up this chapter, I want to introduce you to some of the symbols and abbreviations that camera manufacturers use to label various camera features. Table 1-1 offers a basic translation guide; the chapter referenced in the third column tells you where to find more details about a particular feature.

Keep in mind, however, that each manufacturer has its own take on these symbols, so the icons in Table 1-1 may look slightly different than what you see on your camera. Consult your manual for details about the specific labels on your model.

Table 1-1	Digital Camera Secret Decoder Ring	
Symbol/Label	*What It Means*	*Chapter with More Details*
Camera Modes		
	Still-picture mode	4
	Movie mode	6
	Playback mode	7
PC or	PC mode	8
Setup	Camera-setup mode	2
Exposure and Focus Controls		
P or	Programmed (full) autoexposure	4, 6
A or Av	Aperture-priority autoexposure	6
S or Sv	Shutter-priority autoexposure	6
M or	Manual exposure	6
ISO	Light sensitivity adjustment	6
EV or	EV (exposure value) adjustment	6
	Pattern metering	6
	Spot metering	6

Symbol/Label	What It Means	Chapter with More Details
Exposure and Focus Controls		
⊙	Center-weighted metering	6
🌷	Macro (close-up) focus mode	4
∞	Infinity focus mode	4
⛰	Landscape scene mode	4, 6
👤	Portrait scene mode	4, 6
🚶	Action scene mode	4, 6
🌙★	Nighttime scene or flash mode	4, 5
Flash Modes		
⚡ AUTO	Auto flash	5
⚡	Fill (forced) flash	5
👁	Red-eye reduction mode	5
⚡̸	No flash	5
White-Balance Modes		
WB	White-balance control	4
AWB	Auto white-balance mode	4

(continued)

Table 1-1 *(continued)*

Symbol/Label	What It Means	Chapter with More Details
White-Balance Modes		
	Cloudy white-balance mode	4
	Sunny white-balance mode	4
	Tungsten/incandescent white-balance mode	4
	Fluorescent white-balance mode	4
Miscellaneous Controls		
	Self-timer mode	4
	Monitor on/off button	1
	Delete picture button	7
W or	Zoom out	6
T or	Zoom in	6
	USB port	8
	On/off	2

Chapter 2

Prepping Your Camera

· ·

· ·

*O*f all the information in this book, the stuff in this chapter wins the prize for being the least exciting. It covers issues including camera batteries, memory cards, and camera maintenance. I can hear you now: "BO-ring!"

I urge you, though, not to skip over the details discussed in this chapter. They may not be the most heart-pounding topics covered in this book, and they may even seem like trivial matters. But I guarantee you, the information here is critical to long-term enjoyment of your digital camera.

Getting Smart About Batteries

Like any camera, a digital camera runs on battery power. The type of batteries you need depends on your camera. Some models use a custom battery supplied only by the camera manufacturer, and others use standard, AA-size batteries.

I'm not going to insult your intelligence by giving you step-by-step instructions for installing batteries — really, I know you can do it all on your own. (Do make sure that you orient the battery or batteries as shown in the little diagram printed near or on the battery chamber.) However, digital cameras eat up battery juice at a rapid pace, so the next two sections share a few tips that will help you extend battery life and keep your battery budget in check.

Saving money with rechargeables

Most cameras that accept AA batteries can use the rechargeable type. Rechargeable batteries cost more at the checkout counter than regular batteries, but save you tons of money over the long haul. You can easily go through a megapack of nonrechargeables a month, more if you're a prolific photographer.

You should know a few factoids about rechargeable batteries:

- ✔ Two types of rechargeables exist: NiCad (nickel cadmium) and NiMH (nickel-metal hydride). For best performance, choose NiMH. But if you already invested in NiCad batteries for other household appliances, you can use that type of battery in most cameras as well.

- ✔ If you take your digital camera on the road for vacation or business, a small-format battery charger such as the Energizer model shown in Figure 2-1 makes sense. This charger sells for about $30 and includes a starter pack of four batteries.

- ✔ Some battery chargers work more quickly than others. Check the charger package to see how fast it can restore the juice to a set of batteries. Typically, the faster the charging power, the more expensive the unit.

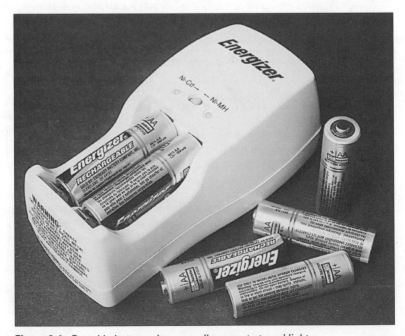

Figure 2-1: Portable battery chargers allow you to travel light.

- ✔ Whatever type of rechargeables you use, invest in an extra set. That way, you can have one set in the charger while you're working with the other.

- ✔ Rechargeable batteries can't hold a charge indefinitely. If you try to use the batteries a few weeks after you charged them, they won't be at full strength and may even be completely depleted.

- ✔ Despite your best planning, you no doubt will find yourself short of battery power every now and then. See the next section for tips on squeezing as many pictures as possible out of a weak battery.

Note that most custom, manufacturer-only batteries are rechargeable as well. However, not all manufacturers include the battery charger with the camera. For long-term savings, invest in the charger. All the tips in the preceding list related to battery use apply to custom rechargeables as well as to standard AA rechargeables.

Preserving battery power

Today's digital cameras aren't nearly the battery hogs they were when the technology was first introduced. But even the latest and greatest models gulp battery juice faster than film cameras because digital cameras have more features that require battery power.

Most cameras display a battery icon to let you know how much energy is left in the battery. When the battery icon appears solid, as in the left image in Figure 2-2, you're good to go. If the icon appears half-full, as in the right image, you're running out of power.

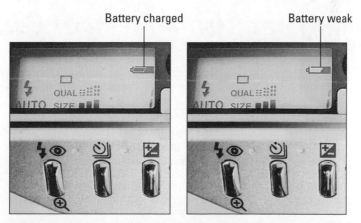

Battery charged Battery weak

Figure 2-2: When the battery icon is half-empty, you're about to run out of power.

To get more pictures out of a set of batteries, follow these energy-saving tips:

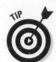

✔ Turn off the camera monitor when you're not using it. Instead of framing shots with the monitor, use the viewfinder, if your camera offers one.

✔ Don't use the camera's flash if you can get by without it. Each time you fire the flash, you consume battery power.

✔ Sometimes you can get a few more pictures out of weak batteries by shutting the camera off, waiting a few seconds, and then turning the camera back on.

✔ Batteries don't like cold temperatures. If you're working outside in the winter or shooting in some other cold environment — hey, you never know when you may want to take pictures inside a walk-in freezer — keep a spare set of batteries in a pocket so your body heat will keep them warm. (NiMH rechargeable batteries respond better to cold than NiCad rechargeables, by the way.)

✔ If your camera came with an AC power adapter or you purchased one as an accessory, use the adapter to power the camera when you transfer pictures to the computer via your USB cable (or other connection).

As an alternative to transferring pictures directly from the camera, you can use a memory card reader, assuming that your camera stores pictures on removable memory cards. With a card reader, you simply take the card out of the camera and pop it into the reader to transfer pictures — the camera itself isn't involved. Chapter 8 talks more about card readers.

Buying and Using Memory Cards

When you take a photo with a digital camera, the camera creates a picture file, which is just a data file that holds all the information needed to reproduce your picture. You can think of the picture file as the digital equivalent of a film negative.

A handful of cameras have an internal storage tank, known as *built-in memory,* to hold the picture files. But most cameras record your picture files on removable *camera memory cards,* sometimes

referred to as *digital film.* (Cameras that have built-in memory often enable you to expand your storage capacity by using removable memory as well.)

Unlike a roll of film, which can be used only once, memory cards have an unlimited life span. After you fill a card with picture files, you can delete pictures you don't like and transfer the keepers to your computer. Then you just erase the memory card and start over.

Removable camera memory comes in a few different flavors. The next sections introduce you to different types of camera memory and give you the lowdown on using them.

Camera memory: One size doesn't fit all

If you've worked with a computer, you've probably encountered one type of removable camera memory, the floppy disk. Floppy disks — which, by the way, have an inflexible outer shell and so aren't floppy at all — can hold only about 1.4MB (megabytes) of data.

Given this limited capacity, you can't fit more than a handful of pictures on a floppy disk unless you shoot low-resolution images or apply a high degree of file compression. Both options reduce the size of the picture files but also lower picture quality. For this reason, only a few cameras rely on floppies for picture storage. (See Chapter 3 for a more complete explanation of resolution and compression.)

Figure 2-3 offers a look at the most commonly used types of camera memory, shown alongside a floppy disk for size comparison. From left to right, the card types on the bottom row are SmartMedia, Memory Stick, Secure Digital, and CompactFlash.

In the top-left corner of the figure, you can see a miniature CD-ROM, the type of memory used in Sony's CD Mavica line of cameras. Because so few cameras use the miniature CD, this is the only place I mention it in this book. (If you do own a CD Mavica, your camera manual tells you the few important things you need to know about using the miniature CDs.)

Figure 2-3: A floppy disk is physically larger than other types of camera memory, but has the least storage capacity.

Figure 2-4 shows yet another type of card, an xD-Picture Card, which is even tinier than the cards shown in Figure 2-3. (The name *xD* was chosen to represent *extreme digital*.) These cards are often used in small cameras, such as the Olympus Stylus model featured in the figure.

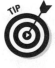

Don't be intimidated by all these varieties of removable picture storage or their techie-talk names. All you need to know is what type of picture storage your camera uses; if you're not sure, check your camera manual. Most cameras work with only one card design, although a few high-priced cameras can accept more than one type of memory. For help with buying and installing the cards, keep reading.

xD-Picture Card

My last paycheck

Figure 2-4: Another type of memory card, the xD-Picture Card is about the size of a quarter.

How much memory do you need?

Camera memory cards come in different capacities, ranging from 8MB and up. Most cameras that accept memory cards ship with a card that offers a storage capacity between 8 and 32MB. Whether you need additional memory depends on the size of the picture files that your camera produces.

The size of a picture file depends on two things: the image *resolution* (number of pixels) and the level of file *compression,* which is a process that reduces file size by eliminating some picture data. Before you take a picture, you can specify both the resolution and the compression amount, which normally is labeled something vague such as *Picture Quality.*

Chapter 3 explains both resolution and compression in more detail, but for now, just know that if you shoot at your camera's highest resolution and picture-quality settings, you need more memory than if you shoot low-resolution, low-quality images.

In your camera manual, you should find a chart that shows you the size of the picture files created at the different resolution and compression settings available on your camera. From that information, you can determine how many pictures you can store on your memory card — and decide whether that limit will be a hassle when you're taking pictures. Remember that when you fill up a memory card, you have to stop and transfer the picture files to your computer before you can take any new pictures using that memory card.

The exact number of pictures you can fit into a megabyte of memory varies from camera to camera, but Table 2-1 gives you a rough approximation. Here are a few words of explanation about the table:

✔ Resolution is stated here in terms of *megapixels* and refers to the total number of pixels in the image. One megapixel equals 1 million pixels.

Many cameras state picture resolution by giving the number of horizontal and vertical pixels; multiply those two values to get the resolution in megapixels. For example, 1600 x 1200 pixels equals 1,920,000, which is just shy of 2 megapixels.

✔ The table assumes the best picture quality, which on most cameras means a minor amount of compression. Some cameras can save a picture file without any compression at all; files taken at that setting will be substantially larger than shown in the table.

Table 2-1 How Many Pictures Fit on a Memory Card?

Resolution	16MB	32MB	64MB
1 megapixel	17	34	68
2 megapixels	12	24	48
3 megapixels	9	18	36
4 megapixels	6	12	24

Values assume minimum file compression (high picture quality); picture totals are rough approximations.

Buying memory cards

Over the past few years, prices of removable camera memory have decreased significantly, from about $3 per megabyte to an average of 50 cents per megabyte. At that price, I recommend that you stock up on more memory than you think you need so that you're never caught short.

As with most products, the cost of memory drops when you buy large-capacity cards — or buy in bulk, if you will. However, the price breaks aren't substantial, and buying two medium-capacity cards instead of one whopper-size card has an advantage: If one card fails — which can happen — or mysteriously walks away from your camera bag, you have a backup. (See the upcoming section "Protecting your memory cards" for advice on keeping memory safe from harm.)

Before you go shopping for memory cards, take in the following buying tips:

✔ Check your camera manual to see whether you are limited to a maximum size of memory card. Some older cameras can't accept anything higher than 32MB, for example.

✔ Several manufacturers make memory cards: SanDisk, Lexar, and PNY are just a few that come to mind. If your camera came with a card, the camera manufacturer's own label may be on the card. You don't have to stick with any one brand, however. What's important is the *type* of card (CompactFlash, SmartMedia, and so on).

✔ The maximum storage capacity depends on the type of card. For example, CompactFlash cards come in capacities of more than 1 gigabyte (100 megabytes), but the top SmartMedia capacity is 128MB. So don't search all over town for a SmartMedia card that holds as much as your neighbor's mondo-capacity CompactFlash card — just buy multiple SmartMedia cards if you want that same picture-storage capacity.

✔ Memory-card manufacturers make a lot of fuss about the *write speeds* of their products. Write speed simply means the amount of time needed to record a picture file on the memory card.

Because you can't take another picture during the file-recording stage, some sports photographers and others

who shoot fast-moving subjects pay attention to write speeds. I don't, however. First, the amount of time you can shave off the write time is measured in fractions of seconds. Second, the speed of the camera plays a large role in write speed, so buying a faster card may not gain you any performance increase. That said, if you're comparing two comparably priced brands of cards and one offers a higher write speed, give the nod to the card with the higher write speed.

✔ Watch the ads in your Sunday newspaper for memory sales. On occasion, retailers throw in a memory card reader, photo printer paper, or other goodies with the price of the card.

Inserting and removing memory cards

As discussed in Chapter 1, the slot where you insert the memory card is hidden under a little door. Check your camera manual to find out where the door is located and how you open it — sometimes, you need to depress a little switch to unlock the door.

Before you insert or remove a memory card, make sure that the camera is turned off. Otherwise, you may damage the card and lose any pictures stored on it.

Here are a few other, less dramatic tips about inserting and removing memory cards:

✔ Somewhere around the slot or on the door, you may see a little diagram that shows you how to orient the card in the slot. Again, check your manual if you don't see or understand the diagram. You can break the card, the camera, or both, if you put the card in the wrong way.

✔ To eject the card from some cameras, you may need to push in a little lever, as shown in Figure 2-5. With other cameras, you just pull the card out. With SmartMedia and xD-Picture Cards, you usually depress the edge of the card to eject it. Again, always make sure that the camera is turned off before you remove any memory card.

✔ After you insert a new memory card, you may need to *format* the card. See the section "Exploring the Setup Menu," later in this chapter, for more information.

Memory card

Card eject button

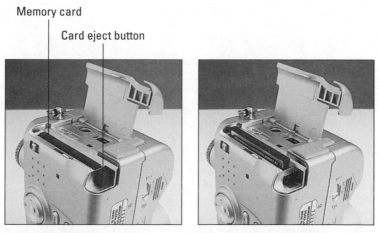

Figure 2-5: On some cameras, you press an eject button to disengage the memory card.

Protecting your memory cards

To protect your memory cards, as well as any picture files stored on them, follow these care instructions:

✔ As I warned in the preceding section, don't remove the card while the camera is turned on. Doing so poses a big risk to the card and all the picture files that it holds.

✔ Don't turn the camera off while it's in the process of writing the last picture file to the memory card, either. An indicator light on the camera should let you know when the camera is done with this step. (See your manual for details on interpreting all the indicator lights on your camera.)

✔ Try not to touch the contact area of the card — that is, the part of the card that interfaces with the camera's recording element. On a SmartMedia card, for example, keep your fingers off the gold area at the top of the card; on a CompactFlash card, stay away from the tiny holes that line one edge of the card. For other types of cards, see the little insert that came with your card (or camera manual information) to find out where the critical area is located.

✔ If your card came with a storage case, keep the card in the case when you're not using your camera. You can also store the card in the camera if you prefer.

✔ Although memory cards aren't exceptionally fragile, they can be damaged by heat, humidity, dirt, static electricity, and a strong magnetic charge. Your puppy's teeth and the heel of your shoe pose bigger hazards than all the above combined, but just to be safe, don't leave your memory card anywhere you wouldn't leave your camera or other sensitive equipment.

✔ Finally, don't use memory cards for long-term storage of your picture files. Instead, archive picture files on a more secure, non-erasable storage medium, such as a CD-ROM disc. Chapter 8 offers more guidance about archiving your photos.

One danger you *don't* have to safeguard against are the x-ray machines at the airport. Security screening devices don't affect camera memory the way they do film.

Exploring the Setup Menu

The next time you turn on your camera, press the Menu button and work your way through all the available menus. In addition to specific photographic settings such as picture quality and exposure, you should find options for customizing certain aspects of the camera's general performance. You may be able to adjust the volume of the sound the camera makes when you take a picture, for example, or change the brightness of the monitor display.

These options vary from camera to camera, of course. Figure 2-6 shows some of the options available on a Minolta DiMAGE model. On this camera, as well as many others, you must switch the camera's main mode dial to the Setup position to access these general options. On other cameras, the general options are combined with the regular photographic-control menus. Check your camera manual to find out what you can adjust and how to specify your preferences.

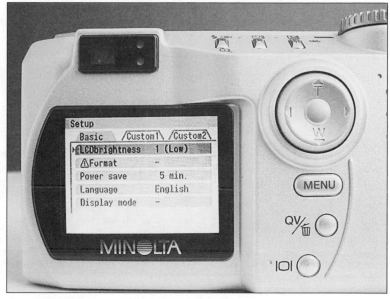

Figure 2-6: You can customize many camera features.

Most of these general options are self-explanatory, but I want to bring a few details to your attention:

✔ **Date/Time:** Even if you ignore all the other options, be sure to set the current date and time. When you take a picture, the date and time are recorded in a hidden part of the picture file. After transferring files to your computer, you can view the date/time data in any regular file browser, including Windows Explorer on a PC and the Finder on a Mac.

Having the date and time information is handy not just for keeping track of when you took each picture but also for locating a particular picture file. For example, in many photo-organizer programs, you can tell the software to display thumbnails of all the pictures taken on a certain date. Figure 2-7 shows this feature as it's implemented in one photo organizer, Adobe Photoshop Album; Chapter 8 introduces you to a few other good organizers. (You also can search for files by date in Windows Explorer and with the Finder on a Mac.)

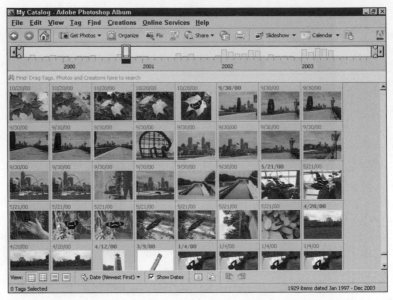

Figure 2-7: Some photo organizers can search for pictures by date.

✔ **File Format:** Some cameras enable you to choose from two or more formats of picture files — JPEG, TIFF, and RAW are three common formats. Before selecting a format, read Chapter 3, which discusses the impact of this decision on picture quality and file size. For most pictures, JPEG is the best choice.

✔ **Format:** *Don't* confuse this option with the File Format option. The plain old Format option erases everything on your memory card. Formatting is sometimes necessary when you install a brand new memory card or insert a card that you've used in another device. (Your camera manual should tell you when formatting is necessary, if at all.) Formatting the card sometimes can also repair a damaged card.

✔ **File Number Memory:** Your camera assigns a numeric file-name to each picture file — for example, PICT001, PICT002, and so on. (The names vary from camera to camera; PICT is just one of various filename prefixes.) Cameras that offer file-number memory can keep track of the last file number used so that when you insert a new (or just erased) memory card, the next image file gets the next file number in the sequence.

When this option is turned off, the camera starts the number-ing sequence over each time you insert the memory card. This duplication of filenames can create problems when you transfer the files to your computer. You can accidentally

overwrite an existing picture file with a new one that has the same name. For this reason, I suggest that you enable the file-number memory feature if your camera offers it.

✔ **File Folders:** Just as you can create multiple folders to store program files and document files on your computer, you can sometimes create separate folders on your camera's memory card. This feature is great for organizing pictures as you shoot. For example, you can create one folder for family pictures and one for business images. If your camera enables you to create multiple folders, check your manual to find out how to name, add, and delete folders and how to send pictures to a specific folder.

✔ **Power Save:** Most cameras shut off automatically after a period of inactivity to save battery power. You may be able to specify how long the camera should wait before deciding that you're no longer in need of its services.

Although the power-saver feature conserves battery power, it can be an annoyance when you're shooting subjects that require some adjustment between shots — for example, to rotate a product to capture it from a different angle. When I'm doing this type of photography, I set the power-save delay to the longest possible time. Some cameras allow you to disable the feature entirely, which is a nice option.

To "wake up" a camera after the auto power-saver does its thing, try pressing the shutter button halfway down. On cameras that don't offer a way to disable the auto-off feature, pressing the shutter halfway down or zooming in or out periodically keeps the feature at bay.

✔ **Video output:** If your camera offers a feature that enables you to display your pictures on a television set, you may have a choice of two video formats: NTSC and PAL. Televisions in North America use the NTSC format; European sets demand PAL. Not sure what standard is in use for your region? Just give one setting a try; if it doesn't work, switch to the other.

Protecting Your Camera

As covered in the preceding pages of this chapter, your camera needs fresh batteries to perform at its best. But satisfying the camera's power craving is just one aspect of keeping your camera in good working condition. Follow these safety and maintenance tips to protect the investment you've made in your camera:

✔ Remember that a digital camera has many electronic components, which means that it's not going to react well to raindrops, spilled coffee, and other liquids seeping into the camera body.

✔ Dust and sand are as hazardous to a digital camera as they are to any camera or sophisticated high-tech device.

✔ Don't put pressure on the camera monitor; you can easily crack it or otherwise inflict damage.

✔ To clean the monitor, use a soft, *dry* cloth — never soap, water, or glass cleaner. If the monitor gets really grungy, you can use special monitor cleaning cloths, such as the ones from Hoodman shown in Figure 2-8 (www.hoodmanusa.com).

✔ The lens on a digital camera is every bit as important as the lens on a film camera. Some cameras ship with a lens cap; others have a built-in cover that slides over the lens housing. Either way, keep the lens covered when you're not using your camera.

✔ Speaking of that lens cap: If your camera box included a little strap for tethering the cap to the camera body, as shown in Figure 2-8, attach that strap straightaway. Then you never have to worry about losing the cap.

Monitor wipes

Lens brush/blower

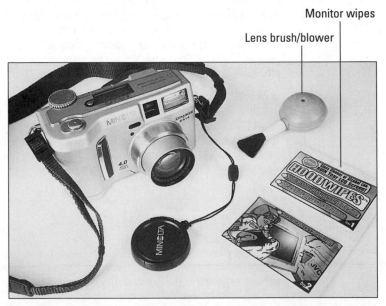

Figure 2-8: Specialty cleaning cloths keep your camera monitor in good shape.

✔ Also attach the camera's carrying strap or neck strap, if available — and use it! Cameras really don't respond well to being dropped onto the pavement or even the carpet, and a neck or hand strap reduces that risk.

✔ To remove dust and other bits of flotsam from the front of the lens, use a brush/blower tool like the one shown at the top of Figure 2-8. A lens-cleaning cloth also comes in handy. Again, you can find these in just about any camera store.

✔ Don't point the camera lens directly at the sun. You can damage the image sensor — not to mention your eyes, if you're also focusing on the sun.

✔ When you bring the camera inside after a few hours in a cold environment, give it a few minutes to get back to normal room temperature before switching it on. Ditto for long exposure to extreme heat.

✔ Don't leave the camera inside your car on a hot summer day, or expose the camera to extreme humidity for a long period of time.

✔ Remove the batteries if you're not going to use your camera for a while. Battery fluid can sometimes leak out of the battery casing and damage the camera.

✔ Finally, get thee to a mall, discount store, or whatever retail outlet you prefer and buy a camera case. You can get a case with a good, protective lining for under $10 — and trust me, that's an investment you'll be glad you made. If your camera happens to tumble out of your backpack, off the car seat, or from any other resting place, it has a far greater chance of survival if it's inside a case.

Chapter 3

Choosing Picture Quality Options

• •

In This Chapter

▶ Getting acquainted with pixels

▶ Understanding the impact of the resolution and compression options

▶ Calculating how many pixels you need for printing and e-mailing photos

▶ Choosing file-compression options

▶ Deciphering camera file formats

• •

*I*f you're used to taking pictures with a point-and-shoot film camera, you're no doubt already familiar with many of the features on your digital camera. Both types of cameras offer the ease of automatic exposure and focusing, for example. And the built-in flash found on most digital models works just like the built-in flash provided on film cameras.

You do encounter a few new twists when you go digital, however. This chapter introduces you to the two most important digital-only options: *image resolution* and *file compression*. Together, these two controls affect both picture quality and file size, so understanding them is critical to getting the best results from your digital camera. Because the compression option often goes hand-in-hand with the camera's file format option, the end of this chapter gives you the lowdown on that subject.

Meet the Digital Duo: Resolution and Compression

When you take pictures with a film camera, picture quality is affected by the size of the film negative. For example, a camera that records images on a 4-x-5-inch negative — known as a *large-format camera* in photo lingo — produces photos that exhibit much higher clarity and detail than an APS (Advanced Photo System) camera, which captures images on small, 24mm negatives.

On a digital camera, picture quality depends on two factors: image resolution and file compression. This duo also affects the size of the image file that the camera creates when you snap a photo.

✔ *Image resolution* refers to the number of image *pixels,* which are the building blocks of every digital image. (You get up close and personal with pixels in the next section.)

With more pixels, your printed photos look better, and your on-screen pictures display at a larger size. But more pixels also means bigger image files, so you can fit fewer pictures in a given amount of camera memory. In addition, if you share the photo via e-mail or post it on a Web page, a large file takes longer to download than a small file.

✔ *Compression* is a bit of digital manipulation done to create smaller image files. Unfortunately, compression can also lower image quality.

On many cameras, the resolution option carries the label *Image Size,* and the compression option is labeled *Picture Quality.* The compression options typically carry vague names — SHQ (Super High Quality), HQ (High Quality) and SQ (Standard Quality), for example, or Fine, Normal, and Basic. Check your camera manual to find out what monikers these options use on your camera. The manual should also contain a chart that shows you the sizes of the picture files created at the available resolution and compression settings.

Because resolution and compression work in tandem to determine picture quality and file size, your camera may offer you a choice of resolution/compression combinations, as shown in Figure 3-1.

On other cameras, you may be able to control resolution and compression separately, as shown in Figure 3-2. On the model shown here, the Image Size control determines the pixel count for the image, and the Quality setting controls compression.

Compression Resolution

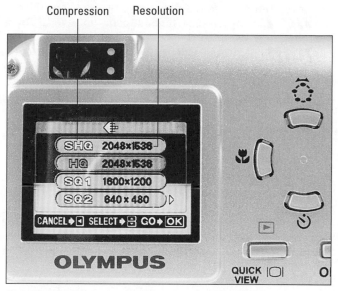

Figure 3-1: Some cameras offer a choice of resolution and compression combinations.

Compression Resolution

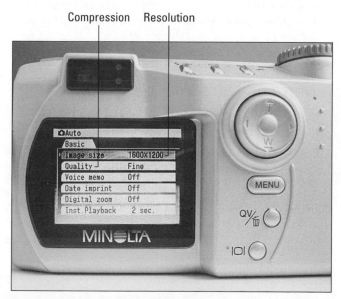

Figure 3-2: Some cameras enable you to control resolution and compression separately.

However your camera handles these two options, the correct resolution and compression settings depend on several considerations, including how you plan to use your picture, how much camera memory you have available, and what level of picture quality you need. The rest of this chapter explores resolution and compression in more detail to help you make the right choices.

Resolution Demystified

For most people, the topic of image resolution is one of the most perplexing aspects of digital photography. Part of the confusion stems from the fact that the term *resolution* means slightly different things depending on whether you're discussing cameras, printers, monitors, or scanners. Adding to the problem, a lot of incorrect information has been spread around over the years — you've probably gotten bad advice yourself from well-meaning but misinformed friends and salespeople.

The next few sections give you the straight scoop, starting with the element that's at the heart of the resolution equation, the pixel.

See Chapter 11 for information about printer resolution; check out Chapter 9 for details about monitor resolution.

What's a pixel?

Your digital camera builds pictures out of tiny blocks of color known as *pixels,* similar to the way an artist creates a mosaic using colored tiles. (Pixel is short for *picture element,* if you care to know.)

Unless you greatly enlarge a digital photo, as I did for the inset area at the top of Figure 3-3, you can't distinguish individual pixels. Instead, your eye perceives the grid of pixels as a continuous image, just as when you view a mosaic from a distance. (The close-up in Figure 3-3 shows the butterfly's head.)

If you want to inspect the pixels in one of your own images, open the picture in your photo editor and use the program's Zoom tool or View menu commands to magnify the display, as shown in Figure 3-4. This figure, like others in this book, features Adobe Photoshop Elements 2. In this program, as in most, the Zoom tool looks like a little magnifying glass. Just click the tool icon in the toolbox and then click on your image to magnify the display.

Figure 3-3: When you enlarge a digital photo, you can see its pixel-based nature.

Toolbox Zoom tool cursor

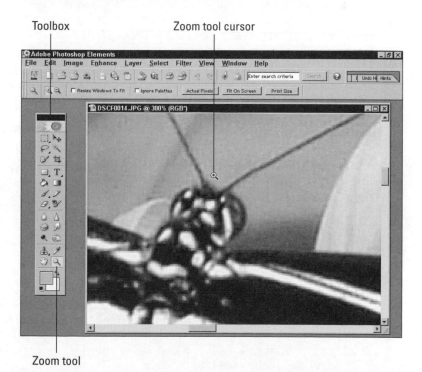

Zoom tool

Figure 3-4: To get a close-up look at pixels, zoom in on a picture in your photo editor.

Why pixel count matters

As explained in the first section of this chapter, the term *image resolution* refers to the number of pixels in a digital photo.

Image resolution is sometimes stated in terms of *pixel dimensions* — the number of pixels tall by the number of pixels wide. Other times, resolution is expressed as the total number of pixels.

For example, one camera maker may describe a camera as offering a top resolution of 1280 x 960 pixels, and another manufacturer may characterize the same resolution as 1.2 *megapixels*. (A megapixel is 1 million pixels.) Both approaches are valid; they're just different ways of saying the same thing.

Whichever terminology you use, more pixels means larger picture files because the camera must generate a specific amount of data to describe each pixel. Aside from file size, however, pixel count has a different impact depending on whether you print the photo or display it on-screen, as explained in the next two sections.

For top-notch prints, capture pixels aplenty

For print photos, an adequate pixel supply is crucial to good picture quality. A print from a high-resolution image rivals anything you can produce from a film camera, as illustrated by the left photo in Figure 3-5. But a print from a low-resolution image looks awful, as shown by the right photo. Curved and diagonal lines have a jagged, stair-stepped appearance, and fine details and subtle color transitions are lost — all a result of too few pixels.

How many image pixels you need depends on the size of the print you want to make. As a rule, you need a minimum of 200 pixels for each linear inch of the print. For example, a good 4-x-6-inch print requires 800 pixels horizontally by 1200 pixels vertically, or a total pixel count of 960,000, which is just shy of 1 megapixel.

Pixels per inch is abbreviated as *ppi*.

With some printers, however, you may get better results with 300 pixels per inch. Check your printer manual for information about the optimum image resolution, or just run your own tests to determine the minimum pixel dimensions that produce acceptable prints on your printer. If you're printing your pictures at a lab, ask the service technician for guidance.

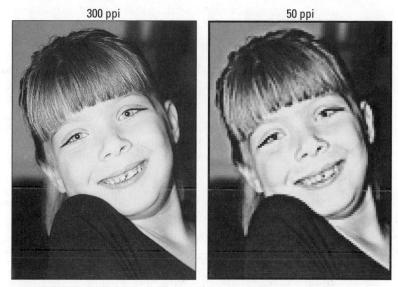

Figure 3-5: A high-resolution image produces excellent print quality (left); an image with too few pixels creates an unacceptable print (right).

For the record, the left image in Figure 3-3 has pixel dimensions of 575 x 805. At the size the picture is printed, that translates to 300 pixels per inch, which happens to match up best with the printer used to produce this book. The right image has roughly one-sixth the pixel count of its high-resolution sibling, which translates to a meager 50 pixels per inch in the printed photo.

Table 3-1 offers a general guide to the pixel population needed to print a digital photo at various sizes at a resolution of 200 ppi and 300 ppi. Again, to convert pixel dimensions to megapixels, just multiply the number of horizontal pixels by the number of vertical pixels.

Table 3-1 Pixels to Prints: Resolution Guidelines

Print Size	Pixels for 200 ppi Printing	Pixels for 300 ppi Printing
4 x 6 inches	800 x 1200	1200 x 1800
5 x 7 inches	1000 x 1400	1500 x 2100
8 x 10 inches	1600 x 2000	2400 x 3000
11 x 14 inches	2200 x 2800	3300 x 4200

Because the *aspect ratio* (width relative to height) of a digital photo is 4:3, which is different from the traditional frame sizes shown in Table 3-1, your camera probably doesn't offer the specific pixel dimensions shown in the table. As long as you set your camera to a pixel count that's equal to or higher than the numbers shown here, you'll be set up for good print quality.

If you're not sure at the time you take a picture what size print you will want to make — which is the case for most of us — you're better off overshooting the pixel mark. As explained in Chapter 11, you can always eliminate excess pixels, but you can't add them after the fact to gain improved print quality.

Chapter 11 also provides detailed information about preparing your pictures for printing and offers some additional tips for improving print quality.

For screen and e-mail images, capture fewer pixels

When you want to display your picture on-screen, whether on a television or computer monitor, you need far fewer pixels than you do when printing your photos.

For screen images, pixel count affects the size at which an image displays, but not the image quality. Chapter 9 explains this issue further, but for a quick preview, see Figure 3-6. The figure shows an e-mail message that has a picture of my sprawling Indiana estate attached. I shot the picture at a resolution of 640 x 480 pixels, which is the lowest-resolution setting on many digital cameras. As you can see, even at this minimal pixel count, the picture is too large to fit entirely on the screen. You can see just the rooftop of the house.

By contrast, check out Figure 3-7. Before attaching the house picture to this message, I opened the photo in my photo editor and cut the pixel count in half, to 320 x 240 pixels. That size is good for e-mail pictures because most people will be able to see the entire image without scrolling the display, as shown here. Notice, too, that the photo *quality* isn't affected by the pixel count — just the size at which the picture appears.

Figure 3-6: A picture with too many pixels is too big to fit on-screen.

Figure 3-7: At a size of 320 x 240 pixels, the entire picture fits within the message window.

Display size isn't the only reason to limit the pixel population of your e-mail pictures. As reported earlier in this broadcast, each pixel adds to the size of the image file, and a larger file takes longer to transmit over the Internet. This caution applies to pictures that you want to use on a Web page, too.

If you want to print your picture as well as share it online, choose the resolution setting appropriate for printing. After downloading the image to your computer, make a copy of the picture file to use for screen purposes. Then reduce the pixel count of the screen copy, following the steps outlined in Chapter 9. Some digital cameras offer a feature that creates an e-mail copy of your image for you — check your manual to find out whether your model offers this option.

Picture Quality (Compression) Options

If you watch a lot of late-night television, you may have seen an infomercial host hawking clothing storage bags that enable you to cram more stuff into less space. After loading your clothes, you attach your vacuum cleaner's hose to an opening in the bag. When you turn on the vacuum, it sucks out all the excess air, and the bag and your clothes collapse to a more compact size.

The compression option on your digital camera serves essentially the same purpose as those vacuum-packed storage bags. Compression reduces the size of your image files by sucking out some of the picture data. Unfortunately, this feature has a drawback: Any time you eliminate picture data, you also lose a little bit of picture quality.

The next few sections explain more about compression and how to keep it from squeezing the life out of your photos.

Where's this compression setting you keep talking about?

Most cameras offer a choice of compression settings, each of which removes a bit more data from the file, thereby reducing the amount of memory needed to store the picture file. The compression controls go by different names depending on the camera manufacturer:

✓ Most cameras assign the name Picture Quality or Quality to the main menu item that controls compression.

✓ The specific compression settings usually have labels something akin to the following:

- SHQ (super high quality), HQ (high quality), and SQ (standard quality)

- Superfine, Fine, Normal, Basic

- Best, Good, Economy

✓ On some cameras, the top quality setting is labeled TIFF. When you choose this option, the camera stores the image file in the TIFF file format rather than the standard JPEG format. Read the next section to find out why TIFF produces better image quality than JPEG. (If you're not sure what I mean by *file format,* see the nearby sidebar "Understanding picture file formats" for a primer.)

Whatever the labels, the camera applies the *least* compression when you choose the *maximum* quality setting. This results in the best picture quality but also the largest file size.

Compression: How much is too much?

Before I answer the question put forth by this section's heading, I need to take a quick technical side trip to give you a brief overview of compression. Two types of compression exist:

✓ **Lossless compression** eliminates only data that isn't essential to maintaining the picture quality. As you can imagine, this type of compression doesn't reduce the file size much.

✓ **Lossy compression** is less discriminating in dumping data, sacrificing some picture quality in the name of smaller file sizes.

The file format that the camera uses to store the picture data determines the type of compression that's applied. Most digital cameras store images in the JPEG file format, which applies lossy (destructive) compression. Some cameras also offer the option of storing pictures in the TIFF format, which applies lossless compression.

If you select TIFF, the amount of compression depends on the picture itself — some images contain more noncritical data than others. You don't have any input in the compression decision.

Understanding picture file formats

File format refers to a method of structuring data within a computer file. Imaging scientists have developed several formats for storing digital picture data, each of which handles the task slightly differently.

Digital cameras typically rely on the following formats:

- **JPEG:** Say "jay-peg," not "J-P-E-G." This format is named after the Joint Photographic Experts Group, the committee that developed it. JPEG is the leading digital-camera file format and is also the best format to use for online photo sharing. As discussed elsewhere in this chapter, JPEG applies *lossy compression,* which eliminates some picture data to reduce the size of the image file. A high degree of JPEG compression results in very low picture quality, but a moderate amount of compression usually is acceptable.

- **TIFF:** Pronounced "tiff," as in nasty little spat, TIFF stands for Tagged Image File Format. TIFF applies a form of file compression that retains top picture quality, which unfortunately also results in very large picture files. In addition, Web browsers and e-mail programs can't open TIFF files, so you need to make a copy of a TIFF picture in the JPEG format before sharing it online. (Chapter 9 shows you how.) You can, however, insert a TIFF file directly into a word-processing document, a page-layout program, or other print-publishing program.

- **RAW:** This format is the only one of the trio that doesn't have an acronym for a name. RAW means *raw,* as in unbaked, unadulterated, fresh from the farm. This format stores picture files without any of the usual color-correction and other adjustments that are done after you press the shutter button. Those in-camera processing steps typically produce a better-looking picture, so unless you're a purist who wants to do that type of correction yourself in a photo editor, stick with JPEG or TIFF. Be aware, also, that most photo editors and other programs can't open RAW files; you need to convert them to JPEG or TIFF first. RAW files also are very large, just like TIFF files. Because of these issues, I don't generally recommend the format and don't discuss it elsewhere in this book.

Only some digital cameras offer a format other than JPEG; check your camera manual to find out what options are available on your model.

For JPEG images, most cameras enable you to vary the amount of compression. As mentioned earlier in this chapter, the control that sets the compression amount normally goes by the name *Quality* or *Picture Quality.* Remember: The more compression you apply, the more data that's sacrificed. A highly compressed image produces a small file size but also a low-quality image.

The exact amount of compression that's applied at each setting depends on the camera. But to get a basic understanding of the file size/quality tradeoff that compression makes, compare the photos in Figure 3-8.

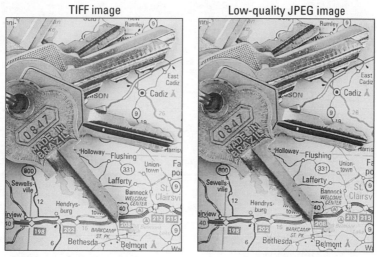

TIFF image Low-quality JPEG image

Figure 3-8: When printed at a small size, a low-quality JPEG image often looks almost as good as the TIFF version.

I captured both images with the same camera, at the same resolution — 1600 x 1200 pixels, or roughly 2 megapixels. I varied only the picture quality setting between shots. I captured the left image as a TIFF file; for the right image, I switched to the JPEG format and selected the lowest quality setting. The difference in file size between the two images is dramatic. The TIFF image has a file size of about 5.6MB (megabytes), and the low-quality JPEG is only 380K (kilobytes).

Because the images in Figure 3-8 are printed at a pretty small size, the difference in image quality isn't readily apparent. But take a look at Figure 3-9, which shows an enlarged area of each image. Now you can clearly see that the low-quality JPEG image is littered with defects — known as *compression artifacts* in the imaging trade. The compression damage would be even more apparent if this image were printed on high-grade, glossy stock or viewed on a monitor.

TIFF image Low-quality JPEG image

Figure 3-9: A close-up look reveals the destructive impact of a high degree of compression.

However, a moderate amount of JPEG compression doesn't significantly destroy image quality, as illustrated by the example in Figure 3-10. For this image, I again used the JPEG format but selected the setting that applied the least amount of compression. The quality difference between this image and the uncompressed TIFF version is barely noticeable, and the JPEG image has a file size of just 980K.

High-quality JPEG image

Figure 3-10: A high-quality JPEG image looks almost as good as an uncompressed TIFF image.

To sum up the compression story: For most pictures, choosing the JPEG format with a minimum amount of compression offers a good tradeoff between picture quality and file size. However, shoot the same image at all the available compression options and compare the results; you may find that you can get away with your camera's second-highest JPEG quality setting.

Also remember that resolution and compression together determine picture quality. If you combine low resolution with maximum compression, don't expect great pictures. Figure 3-11 offers proof of how much you compound the quality problem by skimping on resolution. For this shot, I again used the lowest JPEG quality setting but dialed back the resolution to 640 x 480 pixels. This is a picture that even a mother couldn't love.

One final note on compression: Be especially careful about applying a high degree of compression (choosing a low picture-quality setting) for pictures that you plan to edit before sharing them online. You will need to resave the pictures in the JPEG format after you edit them, and the images will then undergo another round of destructive compression. Each application of compression does further damage to the picture, so if you start with an image that's already of poor quality, it will only look worse after your editing. (Merely opening and viewing the image doesn't do any harm, however.)

Low resolution, low-quality JPEG image

Figure 3-11: Combining low resolution with maximum compression produces miserable photo quality.

Chapter 4

Snapping Quick Shots

● ●

● ●

*Y*our digital camera left the factory set up to offer the conven-
ience of automatic photography. All you need to do is point
and shoot, and the camera takes care of exposure, focus, and other
tasks necessary to capture the scene.

Even in fully automatic mode, however, your camera needs a little
assistance from you. This chapter walks you through the steps you
need to take to enable your camera to perform at its best.

 For times when you can't get the results you want in automatic
mode, see Chapters 5 and 6, which explain how to take advantage
of the advanced photographic controls that may be available on
your camera.

Doing a Preflight Check

To ensure that your camera is set to run on autopilot, do a quick
preflight check of the following settings:

 ✔ **Camera mode:** Set the camera to automatic still-picture mode,
as explained in Chapter 1. In this mode, the camera takes care
of exposure decisions for you.

Consult your camera manual to find out how to select this
mode; the control varies from camera to camera. Some manu-
facturers use a little camera icon to indicate this mode, as
shown here, or the letter P (for programmed autoexposure).

✔ **Image resolution and file compression:** Chapter 3 explains these options, which control the number of pixels in the image (resolution) and the amount of file compression. Together, these two options affect picture quality as well as the size of the picture file.

✔ **Flash mode:** Select the automatic flash mode, which is typically indicated with a little lightning bolt and the word Auto. The camera then fires the flash when needed. See the next chapter to find out about other flash modes.

✔ **Focus modes:** Even basic cameras usually offer you a choice of two or more autofocus modes. These options are critical to the outcome of your picture, so later sections in this chapter discuss them in detail.

For now, leave all the other options, including ISO, white balance, and EV compensation at their original, default settings. You can read more about white balance later in this chapter; for more information about ISO and EV compensation, see Chapter 6.

If your camera uses a lens cap, remember to take the cap off. With many cameras, you can see through the viewfinder even when the lens cap is on because the viewfinder sees the world through a different window than the lens. Don't feel foolish if you forget this essential bit of business — all of us have taken photos of the inside of a lens cap at one time or another!

Setting Up for Sharp Focus

Your focusing options depend on the type of camera you own. Cameras aimed at the casual picture-taker offer autofocusing; models designed for professionals and photography enthusiasts offer a choice of both autofocusing and manual focusing.

The next several sections explain how to get the best results in autofocus mode. For tips on gaining more control over focusing, see Chapter 6.

Choosing an autofocus mode

Most digital cameras offer at least two autofocus modes, normal and macro. Some models offer a third mode, infinity. Here's a quick rundown of these modes:

✔ **Normal** autofocus mode enables you to focus on subjects within a range of distance that's appropriate for normal photography. Usually, that range extends from several feet in front of the lens to infinity. This mode works well for portraits. Typically, you don't choose any special setting to use the standard autofocus range; the camera automatically selects it when you're not using the special modes listed next.

✔ **Macro** focusing enables you to focus on objects very close to the camera lens. The close-up focusing range varies from camera to camera; with some models, you can get as close as an inch from the lens. Most cameras label this focus option with a little flower.

∞ ✔ **Infinity** focusing locks the focus at the far end of the standard autofocus range so that objects at a distance appear in sharp focus. Sometimes labeled with an infinity symbol, this setting is great for landscape photos.

Because the focusing ranges for each mode vary from camera to camera, check your manual to find out what mode is appropriate given the distance between you and your subject.

Finding the focusing area

To set the focus for a picture, your camera calculates the distance between the camera lens and objects within the frame. The specific area of the frame that's used to make this measurement depends on your camera.

Some cameras offer several focus area options:

✔ **Multi-point focusing** considers objects throughout the frame.

✔ **Center-spot focusing** sets the focus only on the object at the center of the frame.

✔ **Adjustable-spot focusing** works just like center-spot focusing, except that you can vary the location of the spot-focus point — moving it from the center of the frame to the left side of the frame, for example.

Most cameras offer the second option — center-spot focusing — as the standard focusing area. The focus point is usually indicated by a marking at the center of the frame — a circle or brackets, for example. The marking appears in the viewfinder and on the monitor, as shown in Figure 4-1.

Focus area marking

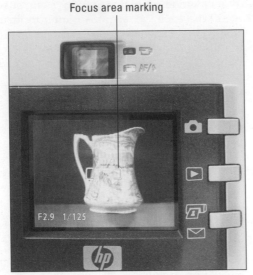

Figure 4-1: Focus markings show the area of the frame used to calculate focusing distance.

Again, the exact markings used to indicate the focusing area vary from camera to camera. Double-check your manual to find out what to look for on your model and how to take advantage of the focusing-area options that are available to you.

 Whatever focusing-area option you choose, be sure that your main subject is located within the boundaries of that area when you compose the picture. Or, if you don't want the subject to appear at the precise location indicated by the focusing area markings, use the focus-lock technique described in the next section.

Using autofocus correctly

 When you take a picture, you must press the shutter button a certain way, or the autofocus mechanism can't do its job correctly. After framing the shot, use this two-step approach to lock in focus:

1. **Press and hold the shutter button halfway down.**

 This step kicks the autofocus mechanism into gear. You usually hear a little whirring or buzzing sound as the camera works to establish the focus point. Some cameras also send out an infrared light beam from the front of the camera to measure the subject distance.

If the camera sets the focus successfully, it signals you via an indicator light near the viewfinder (refer to Figure 4-1) or by sounding a beep, or both.

2. **After the focus indicator signal is given, press the shutter button the rest of the way down.**

Remember that your subject must be within the camera's focusing area in order to be captured in sharp focus. If you want to compose the picture so that the subject is located at some other position in the frame, do this variation on the two-step shutter dance:

1. **Frame the scene so that your subject is within the focus area.**

2. **Press and hold the shutter button halfway down to focus on the subject.**

3. **Reframe the shot to the composition you want.**

4. **Press the shutter button the rest of the way down.**

The camera uses the original focus point you set in Step 2.

What are "scene assist" modes?

As detailed in Chapter 6, exposure is affected by two main camera controls: aperture size (f-stop) and shutter speed. These controls also affect the apparent focus of your photograph. Shutter speed determines whether a moving subject is captured cleanly or appears blurred. Aperture affects *depth of field,* which is the range of distance that appears in sharp focus.

Experienced photographers know how to balance shutter speed and aperture to achieve both correct exposure and a particular focusing effect. For users without a degree in photography, many cameras now offer *scene assist modes.* Each scene assist mode sets the camera to a combination of shutter speed and aperture size appropriate for different types of photography.

Among the most common scene assist modes are Portrait and Landscape. Some cameras also offer an Action mode, for sports photography, and Nighttime mode, for after-dark photography.

Chapter 6 explains more about these modes as well as about exposure controls in general. I mention them here because they can be easily confused with the focus modes (such as Macro focusing mode). In fact, the focus and scene mode controls may be side by side on your camera.

If you're working in autoexposure mode, exposure is also set when you press the shutter button halfway down. See Chapter 6 for more information about exposure.

Solving autofocus problems

You can rely on your camera's autofocus capabilities for most pictures. However, some things can confound autofocus mechanisms.

If you're taking pictures at the zoo and try to photograph a caged or fenced animal, the camera may instead focus on the bars of the cage or the links in the fence. Autofocusing sometimes also goes awry when you shoot highly reflective objects.

In these situations, the following techniques may solve the problem:

- ✓ Use the focus-lock tip described in the preceding section to set the proper focus distance.

- ✓ Switch to manual focus, described in Chapter 6, if your camera offers that option.

- ✓ If you're working in multi-spot focus mode, switch to center-spot or adjustable center-spot mode. (Again, not all cameras offer these options.)

- ✓ If the lighting is dim, add more light. Most cameras have trouble focusing in low lighting because they can't "see" well enough to measure the subject-to-camera distance.

- ✓ When a picture is seriously blurry, as in Figure 4-2, you may have forgotten to set the correct focus mode. In this case, the camera was set to macro focusing, and my subject was well beyond the close-focusing range.

- ✓ For minor blurriness, the problem may not be related to focusing at all. Instead, you may be moving the camera slightly when you take the picture, or your subject may have moved. For tips on keeping the camera still, see the "Taking the Picture" section in this chapter.

Figure 4-2: Extreme blurring usually indicates that the subject is outside the
focus range for the selected focus mode.

Composing the Picture

This book is designed to help you master the technical side of your
digital camera, so I don't go into much detail about the art of pic-
ture composition. I do want to bring to your attention one compo-
sition problem that you may encounter because of a technical
difference between film and digital cameras, however.

You may have noticed that your digital pictures have a different
width-to-height ratio — or *aspect ratio,* in photography lingo —
than pictures taken with a 35mm film camera. Digital cameras pro-
duce images that have an aspect ratio of 4:3, and 35mm film nega-
tive produces pictures that have an aspect ratio of 3:2.

Why the difference? Well, digital cameras were first envisioned
as devices to produce images for display on computer monitors,
which have a 4:3 aspect ratio (as do most television screens).
So matching the monitor aspect ratio made sense.

Today, however, digital cameras offer resolutions high enough to produce excellent prints. But there's a hitch: When you print a digital photo at traditional print sizes — 4 x 6, 5 x 7, 8 x 10, and so on — you lose some of the original image area because of the aspect ratio difference. (If you've ever had your digital files output at a retail lab, you've probably already noticed this change.)

Figure 4-3 and 4-4 show the percentage of image area you can expect to lose when you print your picture at 4 x 6, 5 x 7, or 8 x 10 inches. The left image in Figure 4-3 shows you the digital original; the darkened areas in the three remaining examples represent the lost portion of each picture.

This issue isn't a digital-only phenomenon, by the way. Your print lab must similarly crop away part of your 35mm film photo when making a 5 x 7 or 8 x 10 print, too. The only print size where you don't lose part of your 35mm original is 4 x 6, which has the same aspect ratio as the film negative (3:2).

Digital original

4x6

Figure 4-3: A digital image (left) loses a portion of its original self when printed as a 4-x-6-inch photo (right).

5 x 7 8 x 10

Figure 4-4: You also lose some picture area when the photo is printed at 5 x 7 inches (left) or 8 x 10 inches (right).

 Whether you're shooting digital or film, the problem has an easy solution. Just remember to include a small margin of background when you compose your pictures, as I did when shooting the city scene in Figure 4-3. That way, you won't lose any vital picture elements if you decide to print your photos at the traditional sizes.

 If you're printing your own pictures, you can alternatively choose to reduce the size of your images so that they fit entirely within the 4-x-6-inch, 5-x-7-inch, or 8-x-10-inch boundary. You'll have a blank border along two sides of the photo, as shown in Figure 4-5. For this image, the patterned areas along the left and right sides of the picture represent the percentage of border needed to fill out an 8-x-10-inch print.

Figure 4-5: Another option is to shrink the photo and add a border to fill empty areas.

Getting an Accurate Preview

High-end cameras, whether digital or film, usually offer a *through-the-lens* (TTL) viewfinder. This type of viewfinder offers an exact preview of what the camera lens will capture when you take the picture.

Less sophisticated cameras use a simpler viewfinder design, in which the viewfinder looks out on the scene from its own window. Because the viewfinder has a different perspective than the lens, what you see is slightly different than what you get when you snap the picture. This problem is known as *parallax error.*

To help you deal with parallax error, most cameras that use a non-TTL viewfinder provide little framing markings in the viewfinder. These markings show you the boundaries of the area that the lens can see. When you compose your picture, frame the scene so that your main subject falls within those boundaries. (Don't confuse these markings with the focus-area markings discussed earlier in this chapter.)

You also can sidestep parallax error by composing your shots using the camera monitor, which accurately reflects the perspective of the lens. For reasons discussed in Chapter 1, I'm generally

Why digital zoom is a bad idea

Most digital cameras offer a feature known as *digital zoom.* The name implies that the feature offers the same results as a zoom lens — that is, brings you closer to your subject. In fact, digital zoom does nothing more than trim away the perimeter of your image and enlarge the remaining area to fill the frame.

This bit of digital manipulation leads to lower image quality than you get when capturing the same area with a true zoom lens (referred to as an *optical zoom* in the digital photography lexicon). So when top-notch pictures are in order, avoid digital zoom.

In addition, an optical zoom affects depth of field (range of sharp focus) as well as how much background is included in your shot. A digital zoom does not impact the image in either way.

Check your camera manual to find out how digital zoom is activated and whether you can turn the feature off altogether. For information about how optical zoom affects depth of field, see Chapter 6.

not a fan of using the monitor as a viewfinder, but this option does eliminate parallax problems.

If you do stick with the viewfinder, keep in mind that parallax errors increase as you move the camera lens closer to the subject. For this reason, most digital cameras automatically turn on the monitor when you switch to macro focusing mode. This feature is the camera's way of politely suggesting that you check framing on the monitor before you press the shutter button.

Taking the Picture

After years of watching people take pictures, I've come to the conclusion that the most common cause of unsatisfactory results is poor shutter-button technique. I know that statement sounds incredibly goofy, but it happens to be true.

If you want your pictures to be sharply focused and properly exposed, follow these two vital shutter-pressing guidelines:

 ✔ Always use the two-step technique outlined earlier, in the section "Using autofocus correctly." In case you missed that vital

piece of information, here it is again: After framing your shot, press and hold the shutter button halfway down and wait for the autoexposure and autofocus mechanisms to analyze the scene. When the camera signals you that exposure and focus are in check, press the button the rest of the way down.

✓ Press the shutter button down gently instead of jabbing it forcefully, which can cause the camera to move. Any camera movement may result in a blurry image.

You can further reduce the chances of camera shake and help ensure tack-sharp photos by following these tips as well:

✓ Don't use the camera monitor to frame your photos unless absolutely necessary. Doing so forces you to hold the camera away from your body, as shown in Figure 4-6. Most people can't keep the camera absolutely still in this posture.

Instead, use the camera's viewfinder to frame the shots, as shown in Figure 4-7. With the camera braced against your face, you're much less likely to move the camera. Press your elbows into your side to steady the camera even more.

Figure 4-6: Holding the camera at arm's length increases the chance of camera shake.

Figure 4-7: Use the optical viewfinder and tuck your elbows into your side to steady the camera.

✔ Some digital cameras don't have a traditional optical viewfinder, so you don't have any choice but to use the monitor to frame shots. Again, tuck your elbows into your side to steady the camera as much as possible. Better yet, put the camera on a tripod or other steady surface to take the picture.

✔ Tripods are essential for shooting blur-free photos in dim lighting because the camera needs to use a slow shutter speed to get a good exposure. Depending on the lighting (and your camera's capabilities), the shutter may remain open for several seconds, and if you move the camera at all during that time, you get a fuzzy picture.

 ✔ Most cameras offer a self-timer feature. You can take advantage of this feature not just for times when you want to include yourself in the photo, but also to eliminate any chance that you'll jar the camera when you press the shutter button.

Check your camera manual to find out how to activate the self-timer feature. (Look for a little timer-dial icon like the one shown here.) After switching on the self-timer function, press the shutter button in the normal way — press and hold halfway, wait for the camera to set focus and exposure, and then press the rest of the way down and release. The camera ticks off a few seconds and then captures the shot.

On some cameras, you can specify how many seconds you want the camera to wait to capture the image after you press the shutter button.

✒ A few cameras, including the Olympus model shown in Figure 4-8, offer a remote-control unit that enables you to trigger the shutter button at a distance from the camera. This accessory offers another great way to reduce camera movement. With a remote control, you don't need to touch the shutter button at all, even to establish focus and exposure.

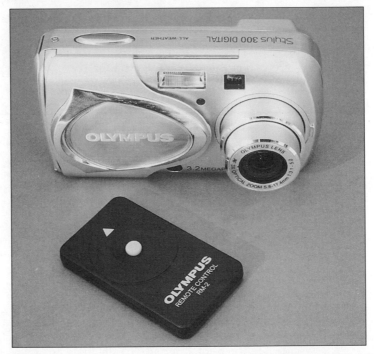

Figure 4-8: Use your camera's self-timer or remote control to shoot a hands-free picture.

Adjusting Colors with White Balance

Like a video camera, a digital camera offers a feature known as *white balancing*.

White balancing is a camera adjustment that compensates for the fact that each light source infuses a scene with its own color cast. For example, the fluorescent lighting used in office buildings adds a yellow-green tint, and candlelight adds a warm, reddish hue. White balancing neutralizes the light so that the colors of your subject are rendered more accurately.

In automatic mode, your digital camera's white-balancing mechanism does its job admirably most of the time. But if your subject is lit by several types of light, the camera may not be able to figure out what color adjustment to make.

If the colors that you see in the camera monitor look odd, a white-balance miscue is the likely cause. Fortunately, most cameras enable you to switch to manual white-balancing mode and select a specific light source, as shown in Figure 4-9.

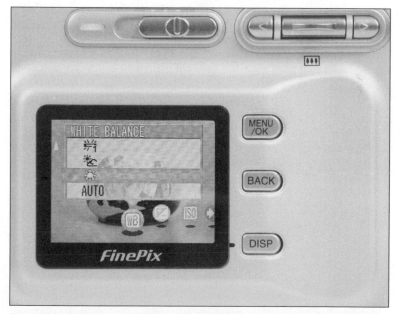

Figure 4-9: If picture colors look odd, try changing the white-balance setting.

Table 4-1 lists the standard white-balance settings and shows the common icons used to represent each setting. Don't spend too much time memorizing the table, though. As you scroll through the settings, you can see the effect of each option in the camera monitor.

Table 4-1	Manual White-Balance Settings
Label or Symbol	*Light Type*
☁	Cloudy daylight
☀	Bright sunshine
💡	Tungsten/incandescent bulbs
⛭	Fluorescent lights

In addition to solving color problems, you sometimes can use the white-balance control to get the same effects produced by traditional color lens filters. For example, the Cloudy setting can create the same effect as a warming filter, which reduces blue tones to give pictures a warm, golden look. The impact that you can make with this technique depends on the light source, however. Again, you can preview the results of each setting in the camera monitor, so just play with the control until you like what you see.

Part II
Exploring Exposure and Focusing Options

The 5th Wave By Rich Tennant

"...and here's me with Cindy Crawford. And this is me with Madonna and Celine Dion..."

In this part . . .

How many times have you looked at a photo that you've taken and thought that it would be a wonderful picture if only it weren't so dark . . . or overexposed . . . or slightly blurry? If you're like most of us, the answer to that question is, "More times than I can count!"

This part of the book helps you get a well-exposed, perfectly focused picture every time by showing you how to take better advantage of your camera's built-in flash, exposure controls, and focusing options. In addition, you can read about techniques that enable you to achieve specific photographic goals, such as throwing the background into soft focus so that the main subject becomes more prominent.

Chapter 5

Working by Flash Light

· ·

In This Chapter

▶ Assessing your camera's flash power and flexibility

▶ Getting brighter backgrounds in nighttime flash photos

▶ Dealing with red-eye

▶ Using flash for better outdoor pictures

· ·

You may find it a little surprising to see a whole chapter dedicated to flash photography. What's the big deal, you wonder? You just switch on the flash, and it goes off when you press the shutter button, right? In some cases, the camera even turns on the flash automatically when needed.

It's true that you don't need to put in much effort to use the built-in flashes found on point-and-shoot digital cameras. If you're like most people, though, you probably aren't taking full advantage of all your camera's flash features. To show you the light (ugh, sorry for that bad pun), this chapter introduces you to some often overlooked flash options, such as *slow-sync flash* and *fill flash*. In addition, this chapter explains how to correct the most common problem in flash photos: the infamous red-eye phenomenon.

Evaluating Basic Flash Options

Most consumer digital cameras offer the following basic settings for controlling the flash.

✔ **Autoflash:** Set the flash to this mode if you want the camera to decide whether the flash is needed.

✔ **Fill (or force) flash:** Use this mode when you want the flash to fire regardless of whether the camera thinks it's appropriate.

✔ **No flash:** I won't insult your intelligence by explaining what this one does. However, if you're at a wedding ceremony or in some other situation where firing a flash would cause unwanted attention, be sure that you double-check the flash setting *before each picture*. Some cameras return to autoflash mode automatically after each picture; others reset to autoflash mode each time you turn the camera on.

✔ **Red-eye reduction flash:** This mode helps reduce the reddish glint that mars the eyes in many flash photos. Depending on your camera, red-eye mode may be combined with an auto-flash function — that is, you can tell the camera that if it thinks the flash is needed, it should use the red-eye reduction setting. Some cameras also offer a fill red-eye mode, in which the flash goes off regardless of the camera's opinion about the lighting situation, again using red-eye mode.

Either way, red-eye reduction is the most misunderstood of flash features, both among photographers and pho-tographees. To get the straight scoop, read the upcoming section "Coping with Red-Eye."

The icons you see in the preceding list and in other areas of this chapter are designed to give you a general idea of the symbols that are commonly used to indicate various camera features. The exact symbol designs vary from manufacturer to manufacturer, so double-check your camera manual to see what the icons on your camera indicate.

Checking for Advanced Flash Features

In addition to the basic flash modes described in the preceding section, you may have access to some advanced flash controls, which expand your creative flexibility. The next three sections explain three of these options.

Lighting up backgrounds with slow-sync flash

 Many digital cameras offer a flash setting that's technically called *slow-sync* or *slow-synchronization* flash. Depending on how user-friendly your camera is designed to be, this mode may instead be presented as a scene assist mode by the name of Nighttime mode or Nighttime Flash mode.

Whatever the name, this mode combines flash lighting with a slow shutter speed. As detailed in Chapter 6, shutter speed is one of three factors that determine image brightness. The slower the shutter speed, the brighter the image. Normally, the camera uses a fast shutter when the flash is enabled because doing so ensures that the subject is lit primarily by the flash, rather than by any surrounding light sources.

In slow-sync mode, the camera reduces the shutter speed to allow more ambient light to make its way through the camera lens. The flash may fire either at the beginning or end of the exposure, depending on the camera. Either way, the result is that the background appears brighter than when you take a picture in normal flash mode, as illustrated by Figures 5-1 and 5-2. I took the first picture in a dimly lit living room using the normal flash; for the second picture, I switched to slow-sync flash.

Figure 5-1: With normal flash, backgrounds in nighttime pictures appear dark.

Figure 5-2: Slow-sync flash produces brighter backgrounds.

I want to point out a few additional issues related to using this special flash mode:

✔ Notice that the illumination of the subjects in the slow-sync example is less contrasty (softer and more even) than in the standard flash mode. Because the camera has more time to drink in ambient light, the flash doesn't have to be as strong as in normal mode, so the burst of light that strikes the subject isn't as harsh.

✔ Now for the bad news: The slower shutter speed of slow-sync flash mode increases the chances for motion-related blurring. Depending on the ambient light, the shutter may remain open for several seconds, during which time your subject must remain absolutely still. Most people can do so, but animals usually aren't so cooperative. The cat in the example photo in Figure 5-2 moved slightly near the end of the exposure, causing blurring around his head.

For your part, you must keep the camera still during the exposure to avoid blurring. Always use a tripod or set the camera on some other steady surface when using slow-sync flash. And be sure to warn your subjects to remain still until you give them the word that the picture has been recorded.

Adjusting flash power

 Flash EV compensation, found mostly on high-end digital cameras, enables you to modify the strength of the flash. (The EV stands for *exposure value,* if you're interested.)

A setting of Flash EV 0.0 indicates no flash adjustment. You typically can increase or decrease the flash output in half- or third-step increments, with a negative Flash EV value reducing the output and a positive value producing a more powerful burst of light. In my experience, you need to dial down flash power more often than raising it, especially with a built-in flash, which produces a pretty strong and very narrowly focused pop of light.

Because few consumer-level digital cameras offer this feature, I won't rattle on any more about it, but Figures 5-3 and 5-4 show an example of its impact. I took all these pictures at dusk, when the daylily was in the shade. The left image in Figure 5-3 shows the flash-free photo, which is underexposed. For the right image, I used the flash at the unadjusted flash-power setting (Flash EV 0.0).

As you can see, the normal-strength flash blasted the flower with too much light, eradicating some of the subtle details. For the shot shown in Figure 5-4, I reduced the Flash EV to –1.0, which added just the right amount of illumination to the scene.

No flash Flash EV 0.0

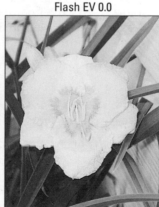

Figure 5-3: Without a flash, the flower is too dark, but normal flash added too much light.

Flash EV -1.0

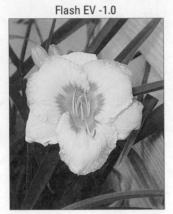

Figure 5-4: Reducing the Flash EV setting to –1.0 brightened the flower without overpowering it.

 Don't confuse Flash EV compensation with standard EV compensation, which *is* found on most digital cameras. Regular EV compensation enables you to force the camera to produce a darker or lighter exposure than the camera's autoexposure brain thinks is appropriate, with or without flash. See Chapter 6 for details about this feature.

 If your camera doesn't offer Flash EV compensation and you want to soften the flash output, try taping a piece of translucent white paper or material over the flash. Also try darkening the exposure through standard EV compensation — again, see Chapter 6 for help with that feature.

Adding an external flash

Some cameras offer a connection for attaching an external flash head like the ones you see professional photographers using out in the field. These larger flash heads produce a less narrowly focused beam of light than a built-in flash and also enable you to control the angle and intensity of the light.

The camera connection for an auxiliary flash head takes one of two forms: a hot shoe, like the one shown in Figure 5-5, or a socket for connecting camera and flash via a cable. Like Flash EV compensation, this feature is limited to pricier digital cameras.

Hot shoe

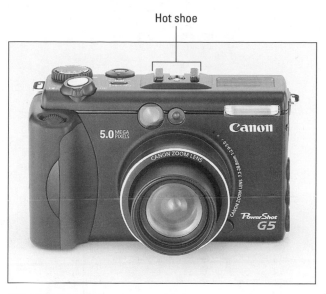

Photo courtesy Canon USA, Inc.

Figure 5-5: Some digital cameras offer a hot shoe for connecting an external flash.

Just because your camera doesn't offer a hot shoe or flash-cord socket doesn't mean that you can't use an external flash head, however. Several companies offer so-called *slave flash* units. These special flash heads don't connect directly to your camera but rather are designed to work in tandem with your camera's built-in flash. They fire automatically when your camera's built-in flash goes off, illuminating your subject with an additional burst of light.

If you're interested in expanding your flash options, check your camera manufacturer's Web site to see whether this type of flash is available for your model. Also check out products from third-party flash manufacturers such as Sunpak (www.sunpak. com), Metz (www.bogenphoto.com), and SR Electronics (www. srelectronics.com).

Figure 5-6 offers a look at the Sunpak Digital Flash, which can work as a slave unit or connect directly to the camera via a hot shoe or cord cable. This unit also comes with a mini-tripod on which you can mount the flash head, as shown in the figure. The tripod has flexible legs so that you can adjust the angle of the flash.

Figure 5-6: This flash unit from Sunpak can be triggered by a camera's built-in flash.

Coping with Red-Eye

Convenient as it is, a built-in flash does have a major drawback when used to photograph people: red-eye.

Red-eye occurs when light from the flash bounces off the subject's retinas and reflects back to the camera lens. Along the way, the light takes on the tint of the blood vessels in the eye, which causes the eyes to appear to be glowing red in the picture. In animal pictures, eyes often have a white, yellow, or green glint, as shown in Figure 5-7.

Red-eye isn't a digital-only issue; you get the same result from any camera with a built-in flash. Why just a built-in flash? Because a built-in flash is positioned very close to the camera lens. When people look into the lens, they're also looking directly at the flash, which means that their retinas pick up and reflect almost all of the flash light. When you use an external flash head, you can position

the flash farther from the lens and also angle the flash so that it's not aimed directly at the eyes.

As discussed in the preceding section, most digital cameras don't have connections for attaching an external flash head, unfortunately. Using a slave flash isn't always a solution, either, because your camera's built-in flash needs to fire to trigger the slave flash. If you stand at a distance from your subject, the built-in flash may be far enough away to prevent red-eye, but if you want to get a close-up, you're right back in red-eye zone. So what's the casual photographer to do?

First, try the tips outlined in the next section to reduce the chances of red-eye as much as possible. Second, accept the fact that despite your best efforts, some pictures will be marred by red-eye (or white-, green-, or yellow-eye, depending on your subject). The good news is that you can fix the problem easily in your photo editor, using the steps outlined in the later section "Correcting red-eye."

Photo courtesy Rachel Wright

Figure 5-7: Animal eyes often take on a ghostly white glow instead of turning red in flash photos.

Reducing red-eye

A couple of tactics help reduce — but may not entirely eliminate — red-eye:

- ✔ **Indoors, turn on as many lights as possible.** In response to the additional light, your subject's eyes will constrict a little, so less flash light will be reflected back to the lens. (This is why you can usually use flash in the daytime without creating red-eye.) Most cameras also adjust flash output based on the ambient room lighting, so the brighter the setting, the weaker the flash needs to be.

- ✔ **If you're shooting indoors during daylight, position your subjects next to a window.** The daylight coming through the window will have the same positive effect as turning on additional room lights.

- ✔ **Switch the flash to red-eye reduction mode.** In red-eye mode, the camera fires a brief, preflash light in advance of the main flash. The idea is the same as turning on lots of room lights — the eyes constrict in response to the preflash so that when the main flash fires, less light is reflected from the retinas. Keep in mind, though, that it's called red-eye *reduction* and not red-eye *prevention* mode for a reason: That little preflash can do only so much, so you may still wind up with some red-eye areas.

Be sure to warn your subjects to expect two bursts of light. Otherwise, they'll think that the preflash is the real flash and assume that they can quit smiling and get back to whatever they were doing before you pestered them for a picture. Some cameras actually emit *three* lights for each shot. The third beam, which the camera sends out when you depress the shutter button halfway, helps the camera's autofocusing mechanism pinpoint the subject-to-camera distance.

- ✔ **Consider posing your subjects so that they're not looking directly into the camera lens.** A profile shot can be every bit as captivating as a regular, face-forward image, as illustrated by Figure 5-8. You also can ask your subjects to look off to one side or slightly up or down. Because the flash light won't be heading straight for the eyes, red-eye reflections will be minimized.

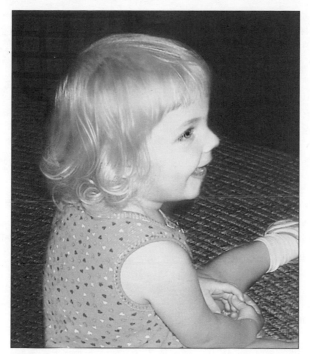

Figure 5-8: Consider shooting subjects in profile to avoid red-eye in flash pictures.

Correcting red-eye

Every camera I own has a red-eye reduction flash mode. I hardly ever bother using it, however. It's not that doing so doesn't have some benefit — you really can reduce red-eye somewhat. But because you still usually wind up with some red-eye areas and because fixing the problem in a photo editor is incredibly easy, I usually just work in regular flash mode. (This approach gives me one less thing to remember when I get ready to take a picture, too.)

Whichever flash option you prefer, the following steps show you how to restore your subject's normal eye color when red-eye occurs. Don't be overwhelmed by the number of steps — the process is really very easy, but I wanted to spell out all the details.

Note, however, that this technique doesn't work on animal eyes that have turned white. To fix those eyeballs, use one of the alternate processes described following the steps.

Also, as with other how-to's in this book, the following steps show how to make the correction in Adobe Photoshop Elements 2.0, but you can take the same general approach in any photo editor that offers a tool set similar to Elements.

1. **With your image open, choose Window⇨Layers to open the Layers palette, shown in Figure 5-9.**

 To keep the Layers palette open, as in the figure, drag its tab from the palette well at the top of the program window.

2. **In the Layers palette, drag the background layer to the New Layer icon, labeled in Figure 5-9.**

 The program creates a duplicate of the original layer, as shown in the figure.

3. **Zoom the image display so that you can clearly see the red-eye pixels.**

 To zoom, click the Zoom tool icon in the toolbox (see Figure 5-9) and then click your image. Keep clicking to keep zooming.

4. **Activate the Sponge tool by clicking its toolbox icon, labeled in Figure 5-9.**

5. **On the Options bar, set the tool options as follows:**

 - **Brush shape:** Select any brush with a soft tip. (The soft-brush icons have blurry edges.)

 - **Brush size:** Select a brush size that's smaller than the red-eye area you need to correct.

 - **Mode:** Desaturate.

 - **Flow:** 100%.

 Don't see the Options bar? Choose Window⇨Options to display it.

 If your brush cursor looks like a paintbrush or a cross-hair, press the Caps Lock key until you see a circular cursor like the one in the figure. This cursor style reflects the actual brush size.

6. **Click on the red areas in the eyeball to turn them gray.**

 When set to Desaturate mode and a Flow setting of 100 percent, the Sponge tool sucks all the color out of a pixel, turning it to a shade of gray. The tool doesn't have any effect on black or white pixels, which are already devoid of color.

7. **In the Layers palette, click the New Layer icon.**

 A new, empty layer appears above your duplicate background layer, as shown in Figure 5-10.

Options bar

Brush Shape control Tool cursor Layers palette

Zoom tool New layer icon

Sponge tool

Figure 5-9: Drag the background layer to the New Layer icon to create a duplicate layer.

8. **Select the Color option from the Layer Blending drop-down list at the top of the Layers palette, as shown in Figure 5-10.**

 This blending mode enables you to paint a new color onto the eyeballs while retaining the original shadows and high-lights, which produces a more natural look.

9. **Click the Foreground Color icon (labeled in Figure 5-10) to open the Color Picker dialog box, shown in Figure 5-11.**

10. **In the Color Picker, select a color that's close to the subject's actual eye color and then click OK.**

11. **Click the Paintbrush toolbox icon (see Figure 5-10) and set the tool options as follows:**

 • **Brush shape:** Select any brush with a soft tip.

 • **Brush size:** Select a brush size that's smaller than the red-eye area you need to correct.

- **Mode:** Normal.

- **Opacity:** 100%.

Also make sure that the Airbrush button appears as shown in Figure 5-10 (that is, the button isn't pressed in).

12. **Click or drag over the desaturated red-eye pixels to restore the original eye color.**

If you spill paint on areas that you don't want to color, select the Eraser tool, labeled in Figure 5-10, and click on the errant paint drops to erase them.

13. **When you're finished with your repair, choose Layer⊅Flatten Image.**

This step merges your three image layers together and makes your change permanent.

14. **Save the edited image.**

If you need help with this step, refer to the Chapter 9 section about saving a copy of your picture.

Figure 5-10: Create an empty layer set to the Color blending mode to hold the new eye color.

Figure 5-11: Click the color that you want to use as the new eye color.

If you are working with animal eyes and need to repair white-eye instead of red-eye, you have to amend this process because you can't alter the color of white pixels by using the Color blending mode that I refer to in Step 8. Here's the workaround: Set the layer blending mode to Normal instead of Color but lower the Opacity setting in the Layers palette to about 50 percent. Now you can tint your critters' gleaming eyes. Adjust the Opacity setting as needed to get a natural effect.

As another option, you can use your photo editor's selection tools to select the bad eye pixels and then use a color-correction filter to adjust the color of the selected pixels. In Photoshop Elements, for example, try using the Hue/Saturation filter, found on the Enhance➪Adjust Color menu, and then dragging the Hue slider. Also experiment with turning on the Colorize option in the Hue/Saturation dialog box. With this option enabled, the selected pixels are desaturated and then recolored, just as in the step-by-step process I outlined.

Using Flash for Better Outdoor Photos

Although most people think of a flash as a tool for nighttime and indoor photography, a flash can also be very beneficial for shooting outdoors in daylight. On an overcast day, using a flash can bring out subtle details in flowers and other natural subjects, as illustrated by Figures 5-3 and 5-4, in the earlier section "Adjusting flash power."

As another example, see Figure 5-12, which shows a young friend displaying a recently earned medal. I posed the subject in a shady area under a tree so that he would be more comfortable and less likely to squint. But the strong shadowing created by the tree left his face underexposed (left). Adding a flash provided the extra lighting needed for a better exposure (right).

If your camera offers a choice of autoexposure metering modes, changing the metering mode may also solve this problem, as explained in Chapter 6. But in many cases, you may need to use a flash to bring a subject out of the shadows even with the change in metering mode. This is especially true when you're taking a picture of someone who's wearing a brimmed hat in strong sunlight — a change in metering mode usually isn't enough to eliminate the strong shadowing caused by the hat.

To use your flash in daylight, you usually need to switch from autoflash mode to fill flash mode. When you're outdoors during the day, the camera's light sensors usually don't perceive the need to trigger the flash, even when skies are cloudy.

Figure 5-12: Use a flash to get a better exposure in shady areas.

Chapter 6

Tweaking Exposure and Focus

*T*oday's digital cameras offer remarkably adept autofocus and autoexposure mechanisms. You can rely on your camera's automatic abilities to produce properly exposed, sharply focused photos in most cases.

If you do have exposure or focus problems — or just want to take more control over these two aspects of your photos — this chapter offers some techniques to try. Among other things, the pages to come show you how to take advantage of features such as EV compensation, ISO adjustment, and scene assist modes.

Exploring Exposure

Several problems can cause a picture to appear *underexposed* (too dark) or *overexposed* (too light). To figure out what may be going wrong, you need a basic understanding of how a digital camera creates a picture.

Like a film camera, a digital camera captures an image by recording the amount of light in a scene. In a film camera, the negative is the light-recording medium. In a digital camera, that task is handled by an *imaging array,* which is a bunch of light-sensitive elements on a computer chip. Most digital cameras use a type of imaging array known as a CCD, which stands for *charge-coupled device.*

Regardless of whether you're working with a film camera or digital camera, three factors affect image exposure: shutter speed, aperture, and ISO. The first two components also play a role in the apparent focus of your photo, and ISO can affect picture quality. The next three sections give you the lowdown on each member of this exposure triad.

Shutter speed

Set behind the camera lens, the *shutter* acts as a light gatekeeper. When the shutter is closed, no light can make its way to the imaging array, just as no sunlight can come through a shuttered window. When you press the shutter button, the shutter opens briefly to allow light to strike the imaging array.

Shutter speed refers to how long the shutter remains open. Shutter speeds are measured in fractions of seconds — for example, a shutter speed of 1/1000 means that the shutter is open for one thousandth of a second.

The longer the shutter remains open, the brighter the exposure. As an example, compare the two images in Figure 6-1. I used the same aperture and ISO setting for both pictures, changing only shutter speed between shots. For the left image, the shutter speed was 1/125 second; for the right image, 1/60 second. The right image is brighter because the imaging array soaked up light for a longer period of time.

Shutter speed also determines whether a moving object appears blurred. At a fast shutter speed, the camera "freezes" the action, so the object doesn't appear to be moving. On the day I shot the pictures in Figure 6-1, for example, a fairly strong breeze was blowing, so the flower was moving at the time I pressed the shutter button. For the two images in Figure 6-1, the shutter speed was fast enough to capture the flower sharply. But at a shutter speed of 1/25 second, the flower appears blurred, as shown in Figure 6-2.

1/125 second 1/60 second

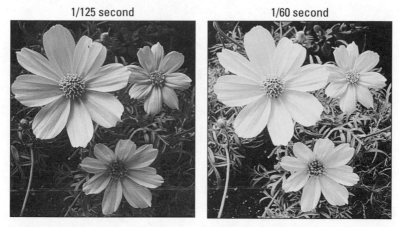

Figure 6-1: Shutter speed plays a major role in image exposure.

Don't forget that camera movement can cause blurry photos, too; see Chapter 4 for tips that will help you keep the camera still when taking pictures.

1/25 second

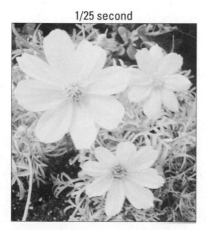

Figure 6-2: A slow shutter speed causes a moving object to appear blurred.

Aperture

Like the shutter, the aperture is a light-control guard. An adjustable iris set between the lens and the shutter, the aperture controls the amount of light that makes its way through the lens when the shutter is open. A wide-open aperture lets in more light, resulting in a brighter exposure.

Aperture sizes are stated as *f-numbers*. The various aperture settings available on a camera are called *f-stops*. A higher f-number indicates a *smaller* aperture size. For example, an f-stop of f/11 allows in less light than an f-stop of f/2, as shown in Figure 6-3.

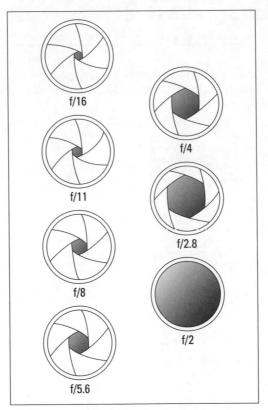

Figure 6-3: The higher the f-stop number, the less light that enters the camera.

In addition to affecting exposure, the aperture setting also deter-
mines *depth of field,* which is the range of distance that appears in
sharp focus. A large aperture (low f-stop number) results in a shal-
low depth of field, so objects at a distance from the main subject
appear slightly blurry, as in the left example in Figure 6-4. For this
image, I set the aperture to f/2. For the right photo, I switched to an
aperture of f/9. Here, the background appears sharply focused due
to the larger depth of field.

f/2 f/9

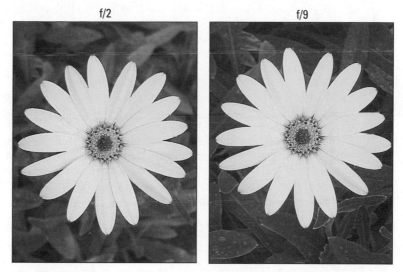

Figure 6-4: Aperture size helps determine whether background objects are
sharply focused.

If your camera has an optical zoom lens, you also can adjust depth
of field by zooming in and out. See the section "Zooming to shift
depth of field," later in this chapter, for more information.

ISO

The third factor that determines exposure, the ISO value, is a meas-
ure of the light sensitivity of the camera's recording element — the
film negative in a traditional camera and the imaging array in a dig-
ital camera.

ISO stands for *International Standards Organization,* the group that developed the rankings.

When you buy film at the drugstore, you usually can choose from ISO 200, 400, or 800 film. Most digital cameras enable you to select these same ISO values, and sometimes one or two notches up or down the scale. The higher the ISO number, the more light-sensitive the film or imaging array.

On your digital camera, using a higher ISO setting enables you to capture poorly lit subjects that the camera otherwise couldn't record. In normal lighting conditions, you can use a faster shutter speed or smaller aperture (higher f-stop number) than you can when the camera is set to a lower ISO.

A high ISO setting has a downside, though: As you increase the ISO setting, you increase image *noise.* Noise is a techie term for defects that give the photo a grainy look, as shown in Figure 6-5. I took this photo just before sunset, cranking the camera's ISO setting to 800 to get a brighter exposure in the diminishing light. Compare the quality of the image with its ISO 100 counterpart in Figure 6-6. The defect becomes more apparent as you enlarge the image, which is true for most photographic flaws.

ISO 800

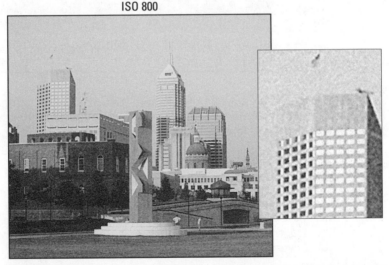

Figure 6-5: A higher ISO setting produces a brighter image but increases noise.

ISO 100

Figure 6-6: At a low ISO, the camera needs more light but produces sharper pictures.

If your camera offers an Auto ISO setting, I suggest that you do not use it for important pictures. When the Auto mode is selected, the camera automatically adjusts ISO as needed to produce a good exposure. ISO is too critical to picture quality to leave to the camera's judgment; you should be the one to decide whether you want to trade off image quality for a brighter exposure. See the upcoming section "Manipulating Exposure" for other ways to deal with dim lighting.

Assessing Your Exposure Options

In normal autoexposure mode, your camera finds the right balance of aperture, shutter speed, and ISO to produce a good exposure. How much control you can take over these decisions depends on your camera.

Most digital cameras offer automatic ISO adjustment as well as manual ISO control. (See my warning in the preceding section about using the auto ISO option.) Aperture and shutter controls vary from camera to camera:

✔ On high-end cameras, you get complete manual control over aperture and shutter speed. In full manual mode, the task of determining what settings are needed to expose the picture falls to you (although many cameras display an exposure guide to help you make your decisions).

✔ Many mid- to low-price cameras don't offer full manual control but offer *aperture-priority autoexposure (AE) mode.* In this exposure mode, you select the f-stop, and the camera chooses the shutter speed appropriate to produce a good exposure. On some cameras, aperture-priority exposure is labeled with the initials *Av* (for *aperture value*).

✔ Some models also offer *shutter-priority AE,* which is the opposite of aperture-priority AE. You set the shutter speed, and the camera determines the proper aperture. This option often goes by the name *Sv (shutter value)* or *Tv (time value).*

✔ Don't have any of these options? Check your camera manual to find out whether your model offers *scene assist modes.* These automatic modes switch the camera to different combinations of shutter speeds and f-stops. The last section in this chapter introduces you to common scene assist modes.

Manipulating Exposure

If your camera offers manual exposure control, you can specify aperture, shutter speed, and ISO to achieve your particular creative goals. But even if you're working with a basic-features camera, you can manipulate exposure to a certain extent by using a feature known as EV compensation. On some cameras, changing the autoexposure metering mode provides yet another way to tweak exposure. The next two sections explain these techniques.

Using EV compensation

Nearly all digital cameras offer a control called *EV compensation.* (The EV stands for *exposure value.*) This control, which usually is labeled with the plus/minus symbol shown here, enables you to produce a brighter or darker exposure than the camera's autoexposure mechanism thinks is appropriate.

Normal EV compensation settings range from +2.0 to –2.0. You usually can notch exposure up or down in one-half or one-third step

increments, although some cameras offer finer adjustments. Regardless of the increments available on your camera, the exposure shifts work as follows:

- To get a brighter picture, raise the EV compensation value.

- For a darker image, lower the value.

- If you don't want any exposure adjustment, set the EV compensation value to 0.0.

Figure 6-7 shows an example of how raising the EV compensation value affects exposure. I positioned the subject, a cardboard marionette, against a bright white background. All that white influenced the camera's autoexposure decision, leaving the marionette too dark. Raising the EV compensation setting to +1.0 solved the problem.

In Figure 6-8, a light subject against a dark background caused the opposite problem. Here, the dark background caused the camera to choose settings that overexposed the salt-and-pepper set. For this picture, lowering the EV compensation value to –1.0 did the trick.

EV 0.0 EV +1.0

Figure 6-7: Raise the EV compensation value if your subject appears underexposed.

EV 0.0 EV -1.0

Figure 6-8: If your subject is overexposed, lower the EV compensation value.

When you shift the EV compensation setting, the camera adjusts shutter speed and aperture as needed to produce the brighter or darker exposure. If you raise the EV compensation value, the camera may switch to a slower shutter speed, which means that you need to keep the camera still for a longer period of time to ensure a sharply focused image. You may want to put the camera on a tripod for best results. If the camera changes the aperture size, on the other hand, depth of field (the zone of sharp focus) will change, as illustrated earlier in this chapter (refer to Figure 6-4).

Finally, if you select the Auto ISO setting, the camera may adjust ISO when you change the EV compensation value, which can lower picture quality. Read the earlier section "ISO" to find out more about ISO and the dangers of the Auto ISO setting.

Switching metering modes

Some cameras offer a choice of *autoexposure metering modes.* The metering mode determines what part of the frame the camera's brain considers when making its exposure decisions. By changing the metering mode, you can sometimes affect the exposure settings that the camera chooses.

Three basic metering modes exist:

 ✔ **Multizone metering:** In this mode, also known as *pattern metering, matrix metering,* and *average metering,* the camera analyzes the entire scene to determine the exposure settings.

 ✔ **Center-weighted metering:** In this mode, the camera considers the entire scene but gives more weight to the area at the center of the frame.

 ✔ **Spot metering:** In this mode, the camera bases its exposure decision on only the center of the frame. On some advanced cameras, you also may be able to vary the position of the spot metering location — so that the camera meters exposure for an object in the upper-left corner of the frame, for example.

 For most subjects, the first mode, which is the default setting on most cameras, works well. But when your subject is *backlit* — that is, set against a bright background, as in Figure 6-9 — multizone metering may leave the subject underexposed.

To remedy the problem, switch to spot metering, as I did for Figure 6-10. Now the camera selects the settings appropriate for your subject only.

Figure 6-9: Multizone metering may leave backlit subjects in the dark.

Tricking your camera's autoexposure eye

When you take a picture in automatic exposure mode, the camera locks in exposure when you depress the shutter button halfway. So in addition to using EV compensation and the other exposure-adjustment techniques discussed in this chapter, you can force a darker exposure by pointing the camera at an object that's *lighter* than your actual subject when you lock in exposure. If you want a brighter exposure, lock in exposure on an object that's darker than your subject. After locking in exposure, reframe the picture without taking your finger off the shutter button and then press the button the rest of the way down to take the picture.

Don't forget, however, that the camera also sets focus when you depress the shutter button halfway, so make sure that the object you use to lock in exposure is approximately the same distance from the camera as your subject.

Adding flash can also help correct exposure problems caused by strong backlighting. For help with using your flash, see Chapter 5.

Figure 6-10: Switch to spot metering to properly expose a backlit subject.

Manipulating Focus

Chapter 4 introduces you to some ways you may be able to adjust focus when working in autofocus mode. For example, on some cameras, you can specify what area of the frame you want the camera to use as the focusing point. And most models offer a standard focus mode for normal shots and macro focus mode for close-up pictures.

Depending on your camera, you also may be able to control focus by switching to manual focusing, changing the aperture, zooming in or out on your subject, and adjusting the shutter speed. The next four sections offer tips for using these techniques.

Don't forget that for tack-sharp pictures, you need to keep the camera absolutely still during the time that the shutter is open. See Chapter 4 for tips on ways to reduce the chance of blur-inducing camera movement.

Using manual focus controls

If your camera offers manual focus control, check the instruction manual to find out how to switch to that mode and set the focus distance. Few digital models offer the traditional focusing design, where you twist the lens barrel to bring the subject into focus. Instead, you usually set focus by selecting a specific subject-to-camera measurement, as shown in Figure 6-11.

Most cameras enable you to specify the focus distance in meters, as shown in the figure, or in inches or feet. Check your camera manual to find out how to establish the unit of measurement that you want to use.

Unless you have an uncanny ability to estimate distance, always use a ruler to measure the exact subject-to-camera distance for important shots, as shown in Figure 6-12. Setting the focusing distance precisely is especially critical for close-up photography because focus problems will be easier to spot than in a long-distance shot.

Evaluating focus by using the camera's viewfinder or monitor isn't easy. If your camera offers a video-playback function, you may want to connect your camera to a television, using the AV cable that shipped in your camera box. The larger screen enables you to see more clearly whether the focus is correct. See Chapter 7 for more information about this feature.

Focus distance

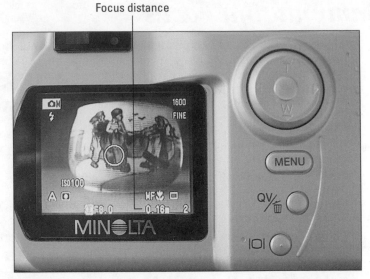

Figure 6-11: Most digital cameras that offer manual focusing require you to enter a specific focus measurement.

Figure 6-12: Use a ruler to accurately measure the focusing distance.

Adjusting depth of field via the aperture setting

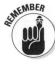

As discussed in the section "Aperture," earlier in this chapter, aperture size affects depth of field, or the range of distance that appears in sharp focus.

✔ If you want the longest possible zone of sharp focus, use a small aperture (a higher f-stop number). Creatively speaking, this option is ideal for landscape photos.

✔ If you want the background to be slightly blurry, use a large aperture (a low f-stop number). This option is a good choice for portraits because the subject becomes more prominent and the background less distracting.

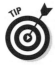 Many cameras don't offer manual aperture control or aperture-priority autoexposure, so you may think that you don't have any input over aperture. However, if your camera offers Portrait and Landscape scene assist modes, you actually do have a way to adjust aperture:

✔ Portrait mode forces the camera to use the largest possible aperture, for the shortest depth of field.

✔ Landscape mode forces the smallest aperture, for the longest depth of field.

I took the pictures shown in Figure 6-13 using these two modes. The left image shows the result of Portrait mode; the right image, Landscape mode. Notice that the overall exposure of both pictures is about the same. The camera automatically adjusted the shutter speed as necessary to properly expose the image at each f-stop. Although the subject appears sharply focused in both pictures, the background in the Portrait example is noticeably softer than in the Landscape example.

Portrait mode Landscape mode

Figure 6-13: Portrait mode results in a blurry background; Landscape mode produces a larger zone of sharp focus.

The last section in this chapter gives you a rundown of the exposure settings you can expect from each of the common scene assist modes.

Zooming to shift depth of field

If your camera offers an optical zoom lens, you can alter depth of field by zooming in and out on your subject.

As explained in Chapter 4, when I speak of an *optical zoom lens,* I'm talking about a traditional zoom lens, the same kind that you may have on your film camera. Digital zoom, a feature found on most digital cameras, is not a zoom lens at all but rather a bit of software manipulation applied by the camera. When you use digital zoom, the camera merely enlarges your picture and then crops away the perimeter. Unlike optical zoom, digital zoom does not produce any change in depth of field (and it also lowers image quality).

With an optical zoom lens, you change the lens *focal length* when you zoom the lens. Focal length is the distance between the center of the lens and the imaging array. On a digital camera, focal lengths are stated in terms of the equivalent focal length on a camera that uses 35mm film. For example, your camera manual may tell you that your lens has a focal range of 5.8–17.44mm, equivalent to 35–105mm on a 35mm-film camera. The higher the number, the longer the focal length. A long focal-length lens is called a *telephoto lens;* a lens with a short focal length is called a *wide-angle lens.*

From a focusing standpoint, the important thing to remember is that focal length, along with aperture, determines depth of field.

- ✔ As you zoom in, focal length increases, which shortens depth of field. Objects at a distance from the subject appear softly focused.

- ✔ As you zoom out, focal length decreases, which increases depth of field. Objects at a distance from the subject appear more sharply focused.

Figure 6-14 shows you an example of how depth of field shifts as you zoom the lens. For the left shot, I stood several feet from the light post and zoomed my camera's lens to its longest focal length, which was 111mm. For the right picture, I zoomed out to the camera's shortest focal length, 37mm, and moved closer to the

light post. I kept the aperture setting the same for both pictures so that any change in depth of field was a result of the focal length adjustment only.

Notice one other important point about these pictures: The right image includes more of the background objects than the left image. This difference occurs because the perspective of the lens also changes when you zoom in and out.

111 mm 37 mm

Figure 6-14: The zoom position of your lens determines how sharply focused the background appears.

The upshot:

- ✔ If you want to minimize a distracting background, move farther from your subject and zoom in.
- ✔ If you want to include as much of the background as possible, zoom out and move closer to the subject.

Controlling focus for action shots

When you photograph a moving subject, whether it's a jump-roping child or a splashing waterfall, the shutter speed determines how sharply focused that subject appears. Figures 6-1 and 6-2, earlier in this chapter, illustrate this issue, but here's a recap:

> ✔ A fast shutter speed stops motion, so the subject appears to be still.
>
> ✔ At a slow shutter speed, a moving subject appears blurred.

Although most people prefer to catch a moving subject in sharp focus, the blurring caused by a slow shutter speed can emphasize motion. For example, I used a shutter speed of about 1/40 second to shoot the picture in Figure 6-15. This slow shutter blurred the waterfall, giving it a misty quality, but the static elements in the background remain in sharp focus. Experiment with this creative choice the next time you snap pictures of your favorite moving target. The exact shutter speed that produces either a sharply focused or intriguingly blurred image depends on how fast the subject is moving.

Whenever you use a slow shutter speed, put the camera on a tripod or other steady surface to avoid camera shake during the exposure. Otherwise, objects that aren't moving may also appear out of focus.

Figure 6-15: A slow shutter speed can emphasize motion, as it did for the waterfall here.

Like aperture controls, shutter-speed controls vary depending on the camera's sophistication (and, unfortunately, price). If your camera doesn't offer manual shutter control or shutter-priority autoexposure but does offer scene assist modes, try these tricks to affect shutter speed:

✔ To capture motion cleanly, look for an Action scene assist mode. This mode tells the camera to use its fastest possible shutter speed.

✔ No Action mode? Try using Portrait mode, if that's available. In this mode, the camera uses its largest aperture. In bright light, the large aperture forces the camera to dial in a fast shutter speed to properly expose the photo.

✔ To blur motion, give Landscape mode a try. This mode selects a small aperture, which usually has the effect of forcing a slower shutter speed.

Your camera may also provide a continuous capture mode, also known as *burst mode,* which snaps off a series of pictures with one press of the shutter button. This mode usually throws your camera into fast-shutter mode, but you may be limited to low-resolution pictures, be forced to work without a flash, or both.

Of course, if your camera offers a movie mode, which records a brief digital movie clip, you may want to consider that option for recording a fast-moving subject as well. However, as with continuous-capture mode, you can usually record only low-resolution, flash-free images. In addition, movie clips create large files, so they consume a lot of space on your camera memory card. Additionally, movie clips aren't practical for Internet sharing because the large files mean long download times.

Taking Advantage of Scene Assist Modes

Throughout this chapter, I mention several exposure and focus tips that involve using *scene assist modes.* These special picture-taking modes, found on many digital cameras, enable you to achieve certain creative effects that are produced by particular combinations of aperture and shutter speed.

The following list provides a summary of the four most common scene assist modes. Note that the icons that represent each mode vary from camera to camera; the ones shown in this list give you a general idea of the standard symbols used to represent the various modes.

 ✔ **Portrait mode:** In this mode, the camera uses the widest possible aperture setting, which produces a short depth of field. The background appears slightly blurry, which is a nice effect for people pictures. Shutter speed varies depending on the lighting; in dim light, the shutter speed may be quite slow, so use a tripod to avoid blurring subject as well as background.

 ✔ **Landscape mode:** This mode forces the smallest possible aperture to achieve a large depth of field. Both foreground and background are in sharp focus, which makes this mode ideal for shooting wide shots of scenic landscapes. Shutter speed is slower than in Portrait mode because of the smaller aperture, which allows less light into the camera. Again, put the camera on a tripod to avoid camera shake during the exposure.

 ✔ **Action mode:** As its name implies, this mode is designed for photographing moving subjects. The camera selects the fastest shutter speed that will produce a good exposure in the current lighting conditions, varying the aperture as needed.

 ✔ **Nighttime mode:** In this mode, which is a special flash photography mode, the camera uses a slower-than-normal shutter speed. The background appears brighter than in normal flash mode. For details, see Chapter 5.

 Many cameras also offer a Macro mode, which isn't a scene assist mode but a focusing mode. See Chapter 4 for more about focusing modes.

Part III
Viewing and Saving Photos

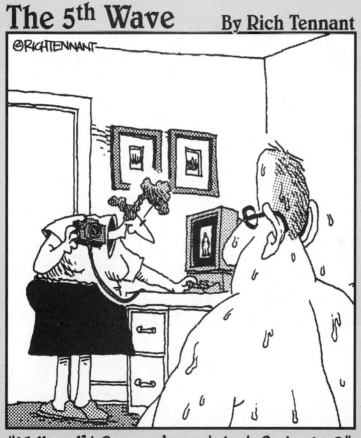

The 5th Wave By Rich Tennant

"Well, well! Guess who just lost 9 pixels?"

In this part . . .

Perhaps the biggest benefit of digital photography is that you can see right away whether you captured the image that you had in mind when you looked through the viewfinder. If the picture doesn't look as good as you hoped, you just erase it and try again.

Chapters in this part of the book help you take full advantage of this aspect of your digital camera, explaining how to review your pictures and erase any photos that aren't worth keeping. When you're ready to transfer pictures to your computer, this part also walks you through that process and tells you how to keep your important picture files safe for years to come.

Chapter 7

Viewing and Erasing Pictures

· ·

· ·

*T*ake a digital camera into a room of toddlers and other young-sters, and you'll notice an interesting phenomenon: Kids who otherwise refuse to interrupt their play for a photograph suddenly become willing subjects. Why? They love seeing their faces appear in the monitor on the back of the camera. Wails of "I don't *want* to say 'cheese'!" suddenly turn into "Take another one of *me!*"

In addition to making restless subjects more cooperative, the play-back feature on your digital camera serves several other functions. You can erase pictures that you don't like, of course, freeing up room in the camera's memory to store new photos. Depending on your camera, you also may be able to add printing or e-mail instructions to a photo, protect special pictures from accidental erasure, and even review the camera settings you used for a partic-ular shot. This chapter explains all these options and also shows you how to review pictures on your television to get a larger view than your camera's monitor provides.

Switching to Playback Mode

Most cameras display an image on the monitor for a few seconds immediately after you take the picture. This feature is known as *instant review*. You may need to turn this feature on via the camera's setup menu. On some cameras, you can adjust the length of time that the instant review image stays on the screen. At maximum, though, the instant review period usually lasts no more than ten seconds.

▶ For a longer look at your pictures, you need to switch the camera to playback mode. On most cameras, the button that activates playback mode is labeled with a green arrowhead. On some models that have a sliding lens cover, you get to playback mode by closing the lens cover partway.

 Whether you do a quick check in instant-review mode or set the camera to playback mode, getting a good look at your photos can be difficult in bright sunlight. The LCD displays used on most digital cameras tend to wash out in bright light, just like the screen on a laptop notebook. To solve this problem, you may want to invest in an accessory known as a *monitor hood*. The hood shields the display from the light, making your pictures easier to see. Figure 7-1 offers a look at a monitor hood from Hoodman (www. hoodmanusa.com). This particular monitor hood, which sells for about $50, features a protective monitor covering as well as a removable insert that magnifies the monitor display. A basic model that provides just the hood costs about $20.

Monitor hood

Figure 7-1: A monitor hood makes pictures easier to view in bright light.

Viewing Pictures in Playback Mode

In playback mode, your camera works something like a digital photo album. To scroll through your pictures, you use two buttons on the back of the camera. One button scrolls the display to the next picture, and the other returns you to the preceding picture.

On cameras that use the four-way rocker switch design (such as the one on the Olympus camera shown in Figure 7-1), the left and right buttons on the switch serve as the backward and forward buttons. If your camera doesn't offer this design, check your manual to find out how to scroll your pictures. The standard labels for the forward/backward buttons are right- and left-pointing arrowheads, respectively, just as on a video player.

Most cameras offer a few picture-viewing options when in playback mode. The next several sections introduce you to the most common of these features.

Reviewing image-capture information

You may be able to set your camera to display information about the settings you used when taking the picture, as shown in Figure 7-2. For example, in the figure, the display shows that I took the picture using the camera's High picture-quality setting (HQ); a resolution of 2048 x 1536 pixels; no EV compensation (0.0); and automatic white balance (WB AUTO). The file number assigned to the picture (100-0007) appears at the bottom of the screen.

The information display may disappear automatically after a few seconds, or you may need to press a button to turn it off. Your camera's setup or playback mode menu may also enable you to turn off the information display permanently or select which items appear.

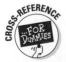

For an explanation of picture quality settings and resolution, see Chapter 3. For details about EV compensation, refer to Chapter 6. And for help understanding white balance, visit Chapter 4.

The capture information that appears on the camera monitor is stored with other capture data as part of the picture file. This information is known as *EXIF metadata*. EXIF stands for Exchangeable Image File format, and metadata means "extra data." After

downloading your pictures to your computer, you can access all the capture information by using an image browser that can read EXIF metadata. Chapter 8 talks more about this feature.

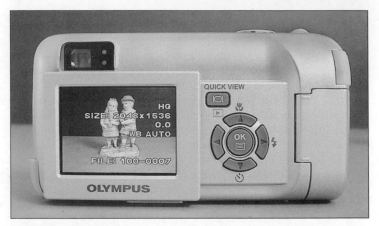

Figure 7-2: Information about the settings you used to take the picture may appear on the monitor.

Viewing multiple photos at a time

Instead of viewing a single picture, you may be able to display small, thumbnail views of several images, as shown in Figure 7-3. How you implement this function depends on the camera, so check your manual to find out how to switch between single-image and thumbnail-image view. Sometimes, this display mode is labeled with a checkerboard symbol.

The actual thumbnail viewing operation also varies from camera to camera, but usually, it works like so:

- ✔ You can advance from one thumbnail to another the same way you scroll through individual pictures.

- ✔ An outline appears around the currently selected image in the group (see Image 7 in Figure 7-3).

- ✔ To see the selected image at full size, switch back to single-picture display mode.

- ✔ You also may be able to perform file-management tasks, such as marking pictures for printing or erasure, in thumbnail view.

Figure 7-3: Some cameras can display small thumbnails for a group of images.

Zooming the display

In single-picture display mode, you may be able to magnify the display, as shown in Figure 7-4. You usually implement this feature by pressing the same buttons you use to zoom in and out when you take pictures.

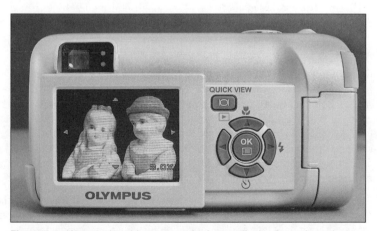

Figure 7-4: You may be able to zoom the image display for a closer look at your photo.

In magnification mode, you can scroll the display up, down, right, or left to inspect a different area of the picture. Again, the buttons that perform this function vary, so at the risk of sounding like a broken record, I have to point you toward your camera manual for specifics. On cameras that have a rocker-switch design like the one in Figure 7-4, you scroll the display by using the four rocker buttons.

Erasing Pictures

 To get rid of pictures that you don't like, find the camera's Delete function, which sometimes goes by the name Erase. On some cameras, you need to press the menu button to find this function, but on many cameras, the feature has its own button. Either way, the universal symbol for the picture-dumping control is a trash can.

Help! I erased a picture by mistake!

When you delete a file by mistake on your computer, you usually have the chance to get it back. In Windows, for example, a deleted file initially goes to the Recycle Bin, where it remains until you choose the Empty Recycle Bin command. Before you do so, you can restore the file by opening the Recycle Bin, clicking the file, and choosing Restore from the File menu. In the Macintosh world, the Trash folder holds deleted files. Until you choose the Empty Trash command, you can rescue files by opening the Trash folder and moving the deleted file to another folder on your hard drive.

Digital cameras don't offer this file-restoration option, so be careful when deleting files. If you accidentally erase a file you really need, you *may* be able to restore it by using a file-recovery program such as MediaRECOVER ($40, www.media recover.com). However, to use this type of tool, you may need a memory card reader because the recovery program needs to perceive the card as a drive installed on your computer. If your camera appears as a hard drive when you connect it to the computer, the software may work without the card reader. (See Chapter 8 for information about connecting your camera to your computer and installing a memory card reader.)

Also — and this is critical — as soon as you realize your mistake, take the card out of the camera and attempt the recovery. If you take additional pictures or perform other in-camera operations, the deleted picture data may be lost forever.

What does this graph tell me?

Some digital cameras offer a playback option that displays a graph like the two shown here. Called a *histogram,* the graph plots the brightness values for the image, with the darkest pixels mapped to the left side of the horizontal axis and the brightest pixels mapped to the right. The vertical axis of the chart indicates the number of pixels at a given brightness value.

Shadows Highlights

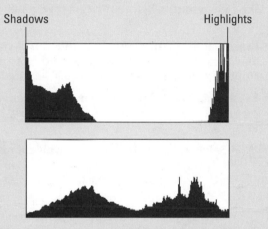

Histograms are useful for evaluating the contrast of a photo. For example, the first histogram here reflects a photo that has lots of dark pixels (shadows), lots of very bright pixels (highlights), but few pixels in the middle of the brightness spectrum (midtones). In other words, the histogram reveals a high-contrast image. If you wanted a less contrasty image, you would look for a more even distribution of pixels across the brightness range, as shown in the second histogram.

You also can get exposure guidance from a histogram. If the chart shows most of the pixels at the dark end of the range, you know that your picture is probably under-exposed (unless you're going for a dark image for creative purposes). If all the pixels are clustered at the right side of the histogram, your photo is probably overexposed.

Of course, you can get a good idea of these characteristics simply by looking at the image in the camera's monitor. But monitors don't always accurately reflect exposure and contrast, which is why experienced photographers also refer to the histogram for this feedback.

Here are few factoids about the delete process:

- **Erasing a single picture:** You usually can erase a single picture either in playback mode or during the instant-review period (the brief display that appears right after you take a picture). I don't usually take advantage of the latter option because it doesn't give me enough time to make a judgment about whether the picture's a keeper — and because my middle-aged reflexes usually aren't fast enough to find the Delete button before the camera cuts off the instant review.

- **Erasing a group of pictures:** In thumbnail-view mode, you may be able to select a group of pictures to delete. Check your camera manual to find out how to select multiple images.

- **Erasing all your pictures:** Your third option is to delete all pictures currently in the camera's memory. You can do this in two ways:

 - Select the Delete All option, which appears either as a separate option on the playback menu or together with the choices that appear when you press the Delete button.

 - Switch the camera to setup mode and select the Format menu option. On some cameras, this option may also be available via the playback menu. Keep in mind that formatting the memory card may also affect the file-naming for future pictures, depending on how your camera handles that function. In addition, if your memory card contains files created on another device, formatting the card erases those files along with your digital images.

However you decide to erase images, most cameras make the process a two-step affair. After you first give the Delete command, the camera presents a confirmation screen like the one shown in Figure 7-5. You then have the option of going forward and erasing the image file or canceling out of the operation. This confirmation step may seem like a pain in the shutter finger, but it's designed to prevent you from accidentally erasing a picture that you like.

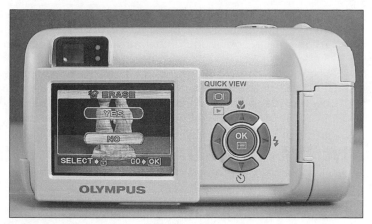

Figure 7-5: Most cameras ask you to confirm your request to delete a picture.

Protecting a Picture

Many digital cameras offer a *protect* feature that eliminates the chance that a picture will be deleted accidentally from the memory card. Normally, this option appears on the playback menu and is labeled with a little key symbol, as shown in Figure 7-6.

Protect icon

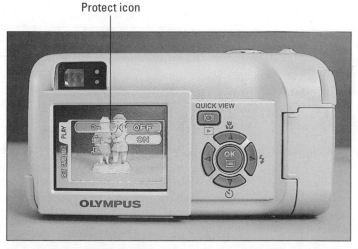

Figure 7-6: Turn on the Protect feature to prevent a picture from being erased.

If you try to delete a protected picture, the camera politely declines your request. You must access the playback menu and turn the protection option off before you can delete the image.

File protection may become null and void when you move your picture files from the camera to the computer. Chapter 8 shows you how to reinstall file protection and unlock protected files.

Marking a Picture for E-Mailing or Printing

Cameras aimed at digital newcomers often offer features that simplify the task of e-mailing and printing pictures. For example, your camera may offer an option that tags a picture as one that you want to e-mail to someone. When you connect your camera to the computer, the camera software automatically produces a screen that walks you through the rest of the e-mail process. Or, if your camera offers a docking station, you may simply need to press an e-mail button to ship the picture into cyberspace.

Similarly, you may be able to mark pictures with printing instructions that can be read by some photo printers. Among other things, you can specify how many copies you want to print.

On some cameras, you access the e-mail and print tagging functions by using exterior buttons, but in most cases, the options await on the playback menu. Either way, see Part IV for details about these and other topics related to printing and sharing your photos via e-mail.

Viewing Pictures on a TV

Although the monitors on digital cameras are terrific tools, their small size makes viewing critical image details a little difficult, even when you can magnify the display. In addition, camera monitors are impractical for showing photos to a group of people — you have to pass the camera from person to person, hovering over each person's shoulder to offer instructions for scrolling through the pictures.

Of course, you can always download your pictures to your computer and gather everyone around your desk for a picture-viewing session. But you have a better alternative: You can display your pictures on a television, offering loved ones the fun of an old-fashioned slide show but without the smoking projector bulb and tipsy pull-up screen.

You have several options for taking advantage of this playback convenience:

✔ If your camera has an *AV-out port* or *video-out port,* you can connect your camera directly to your television's video-in jack, using the AV cable that shipped in your camera box, as shown in Figure 7-7. In case you're confused by the terminology, both *port* and *jack* are just fancy ways of saying *place where you connect a cable.* Computer folks prefer port, and audio/visual types prefer jack. Whatever term you use, the location of the place where you plug the AV cable into the camera varies from model to model.

You also can connect the camera to a DVD player (as in the figure) or VCR, if those devices have video input jacks. The picture signal then runs through the DVD or VCR to the TV, just as when you play a movie.

Video-out port Video-in jack

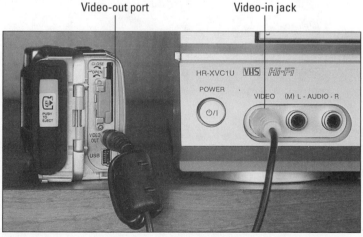

Figure 7-7: Connect one end of the AV cable to the camera and the other to the TV, DVD, or VCR.

Either way, to start viewing your pictures, put the camera in playback mode. You then have access to all the normal playback-mode controls you use when viewing pictures on the camera's monitor.

To communicate with a TV, the camera sends the picture signal in one of two formats. In North America, that format is NTSC; in other areas of the world, the PAL standard is the norm. Some cameras offer a choice of both formats; you usually make your selection via the camera's setup menu.

✔ If your camera's manufacturer offers a camera docking station, you may be able to use it as a playback device, as with the Hewlett-Packard camera and docking-station combo shown in Figure 7-8. In this case, you connect the docking station to the TV, DVD, or VCR. After placing the camera into the dock, you press a button to send the picture signal to the TV. With most docking stations that offer this function, you also get a remote control for scrolling through pictures, rotating sideways images, and magnifying pictures.

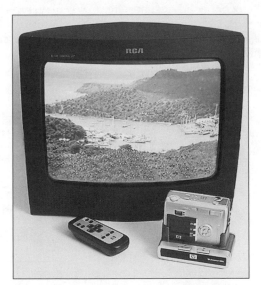

Figure 7-8: Some docking stations can serve as the connection between camera and TV.

In some cases, you may not need to buy the docking station to enjoy picture playback; you may be able to simply connect the camera directly to the TV. (This option isn't available for the camera featured in Figure 7-8, however.) Still, the docking station setup is a handy product if the input jacks for your TV system are difficult to access. You can leave the docking station connected so that you don't have to hassle with finding the right jacks every time you want to play pictures. In addition, most docking stations also serve as battery chargers and can provide automated e-mail and picture transfer to the computer.

✔ No AV-out port or video-out port on your camera? If your camera stores pictures on removable memory cards, you can buy a standalone device such as the SanDisk Digital Photo Viewer shown in Figure 7-9. This product retails for about $80 and can play pictures stored on several types of camera memory cards. Again, you can leave the viewer connected to your TV system so that you don't have to fool around with cables and jacks every time you want to play your pictures.

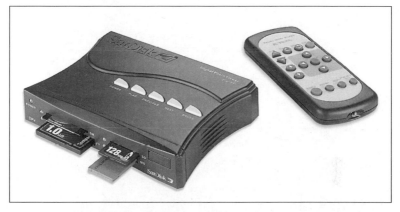

Photo courtesy SanDisk Corporation

Figure 7-9: Image viewers such as this one from SanDisk play pictures stored on memory cards.

With all three playback methods, you also can play audio clips on the TV if your camera offers an audio-recording feature. Cameras that provide this option ship with an AV cable that has two plugs at one end. One plug carries the video signal, and the other carries the audio signal. Plug the audio plug into the audio-in jack on your TV, DVD, or VCR. With most TV setups, you use the left audio-in plug for mono (single channel) audio signals like those that come from digital cameras, but check your manuals to be sure.

While your camera or image-viewer is connected to your TV system and a VCR, you can record your pictures on videotape. Just set the VCR into record mode and scroll through your pictures one by one, keeping each one on-screen for a few seconds. This option is a great alternative to e-mail when you want to share pictures with folks who either don't have Internet access or are intimidated by computer technology.

Chapter 8

Working with Picture Files

*F*or many people, the most challenging aspect of digital photography is the process of moving picture files from the camera to the computer — and for good reason. Despite new camera features designed to make things easier, some aspects of the transfer process can be baffling, especially if you're fairly new to computers as well as to digital photography.

This chapter helps you sort out the steps you need to take to get your pictures onto your computer, from installing the necessary software to setting up an area on your hard drive to store your photo files. In addition, you can find out how to protect important picture files from harm.

Sending Photos to the Computer

In the first years of digital photography, getting photos from the camera to the computer was a major headache, even for experienced geeks like me. The two devices often refused to talk to each other, and if they did cooperate, the file transfer took a *loooong* time, thanks to the slow data-shipping speed of the serial cable that was used to handle the task. On top of that, you had to completely shut down both computer and camera before you connected the two and then turn them both off again when you were ready to separate them.

Today, files travel to the computer via a USB (Universal Serial Bus) connection, which makes the transfer process much easier, faster, and more convenient. Still, a few details may trip you up the first few times you transfer picture files. The next few sections guide you through the process.

Some information in this chapter is by necessity generic. Although the basic concepts apply to all digital cameras, you also need to read through the file-transfer information in your manual because the process varies slightly from model to model.

Exploring file-transfer options

You have several options for moving files from your camera to your computer. The next section offers details to help you decide on which method is right for you, but here's a general overview of your choices:

- ✔ **Direct camera-to-computer connection:** You can connect the camera directly to the computer by using the cable that came in the camera box.

- ✔ **Docking station:** For some cameras, you can buy a *docking station*. You connect the docking station to the computer, and when you're ready to transfer files, you put the camera into the dock. The docking station then serves as a middleman between camera and computer. Figure 8-1 shows a Hewlett-Packard digital camera with its docking station.

- ✔ **Memory card reader:** If your camera stores pictures on removable camera memory, such as a CompactFlash or SmartMedia card, you can transfer files via a *memory card reader*. This device works like the CD-ROM drive on your computer, except that it enables you to access files on the memory card instead of a CD. Figure 8-2 shows the ImageMate 6-in-1 card reader from SanDisk (www.sandisk.com), which can read six types of memory cards and sells for about $40. You can buy a single-card reader for about $20.

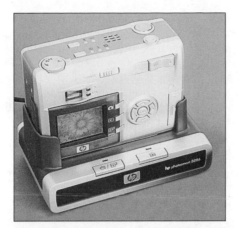

Figure 8-1: To transfer files using a docking station, you set the camera into the dock.

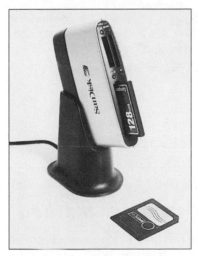

Figure 8-2: This card reader works with six types of camera memory cards.

✔ **Card adapter:** For some types of memory cards, you can buy a *card adapter* that enables you to transfer files via your computer's floppy disk drive, if your system has that drive. If you own a laptop computer that has a slot that accepts PCMCIA Cards — PC Cards, for short — you also can buy adapters that fit that slot. Figure 8-3 shows a PC Card adapter for a CompactFlash card. Adapters run anywhere from $10 to $70, depending on the type you need.

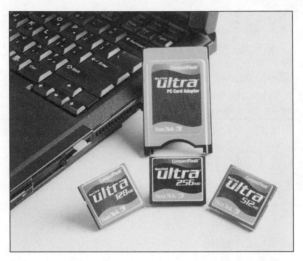

Photo courtesy SanDisk Corporation

Figure 8-3: With an adapter, you can transfer files via the PC Card slot on a laptop computer.

Deciding on a transfer method

Which method of sending pictures to the computer is best? That depends on your computer setup and how you use your camera. For example, I often take fairly complex product photos with my camera, and I need to download and check the images frequently during a shooting session. I prefer a card reader for these transfers because I don't have to remove the camera from my tripod or otherwise reposition the camera between shots. But when I travel with my laptop, I take along either a PC Card adapter or the camera's USB cable because those components take up less room in my computer bag than my card reader.

Here are a few other issues to consider:

 ✔ To transfer files directly from your camera, a docking station, or a card reader, your computer must have a USB *port* (connection socket). Your computer's operating system must also support USB. Figure 8-4 offers a close-up look at a USB port, which is always labeled with the symbol you see here.

 If your system doesn't offer a USB port, you can buy an adapter cable that allows you to connect USB devices to a parallel port or serial port. If your system does offer USB ports but they're already being used by other devices, you can buy a USB hub, which gives you additional ports.

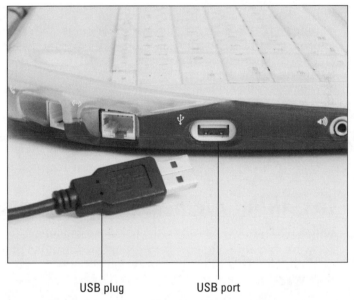

USB plug USB port

Figure 8-4: A USB port is the connection point for digital cameras and other devices.

✔ When you transfer pictures directly from the camera, you usually have to turn the camera on, which drains batteries. You may want to invest in an AC adapter, if one didn't come with your camera, for this purpose.

✔ Card readers and adapters have a use beyond photo transfer; you can use them to transfer files between two computers. For example, suppose that you want to move a file from your

laptop computer to your desktop machine. You can attach a card reader to the laptop, insert your memory card into the reader, and then copy the file to the memory card. Then you remove the card reader, connect it to your desktop computer, and transfer the file from the card to that system's hard drive. You can move any type of file this way, not just digital photo files.

✔ Most docking stations also are multipurpose devices. They often serve as battery chargers and work as devices for playing photos on a television.

✔ As for transfer speed, you won't notice a huge difference between any of these methods.

With all that in mind, here's my best advice: Try out the least expensive option first. Assuming that your computer has the appropriate USB support, see whether you can get by with the standard camera-to-computer connection. If that setup becomes cumbersome, invest in one of the alternative transfer solutions.

Here's one other picture-transfer alternative: Some photo printers that can print directly from a memory card can double as a card reader. While the printer is connected to your computer, you can transfer files from the card to the computer, using the printer as the middleman.

Installing the necessary software

Whichever transfer method you choose, you need to install some software on your computer before you can download pictures for the first time. This software is provided either with your camera or with your dock, card reader, or card adapter.

The key software is called a *driver,* which simply is a bit of code that enables your computer to communicate with your camera or the other transfer device you use. Depending on the device, this software may be called a *TWAIN driver.*

On the CD that shipped with your camera, you also may find a program that you can use to access and download picture files, view photos, and perform some editing tasks, such as cropping and exposure correction. This software may provide tools for e-mailing and printing photos as well. Figure 8-5 shows you the main screen from an Olympus version of this software.

Figure 8-5: You can use the manufacturer's software to access your picture files.

If you already have a photo viewer or editing program that you like, you may be able to use that program to access files instead of using the one that came with your camera. You do need to install the camera's driver software, though, regardless of what photo programs you choose.

At this point in the discussion, I need to send you off to the manual that came with your camera or transfer device for specific instructions on installing the necessary software. The exact directions vary depending on your camera and computer system.

Creating an image storage closet

One additional pretransfer step isn't absolutely critical but eliminates some headaches down the road. Creating a separate folder on your computer's hard drive to hold all your picture files makes those pictures easier to find later.

On my system, for example, I created a folder named Images, being the inventive sort that I am. Within that main folder, I created many subfolders for different categories of pictures: Family, Friends, Travel, Flowers, and the like.

On a Windows-based PC, you can create your new folder by using Windows Explorer; on a Macintosh computer, you can get the job done via the Finder. (If you need help with these basic file-creation and management tasks, pick up a copy of one of the many *For Dummies* books that covers your particular operating system.)

For a more powerful organizational tool, you may want to get a photo-management program such as ACDSee ($50, www.acdsystems.com), shown in Figure 8-6. With this type of program, you can browse thumbnails of your photos and tag pictures with category keywords to make finding specific images a breeze. Some programs can even hunt down all the pictures taken on a specific date. You also can perform the same basic file and folder management tasks as you can in Explorer or the Finder, and, in many cases, do simple image-editing.

A screenshot of another popular stand-alone organizer, ThumbsPlus ($80, www.thumbsplus.com), appears in the sidebar "Studying picture-capture settings" later in this chapter. To find out more about ThumbsPlus and ACDSee, visit the manufacturers' Web sites. You can download free demos to see whether either meets your needs before you buy.

Figure 8-6: Photo-management programs such as ACDSee give you tons of cataloging tools.

Your photo editor may also offer some basic image-management tools. Figure 8-9 (later in this chapter) shows you the organizer built into Adobe Photoshop Elements (www.adobe.com), for example. Again, you can download a free demo at the Adobe Web site; the full program retails for about $90.

Finally, if you own a Macintosh computer that runs system OS X Version 10.1.5 or later, you can download a free basic organizer, iPhoto 2, from the Apple Web site (www.apple.com). Be sure to read the system requirements before you download the program; it requires a hefty amount of RAM and a high-speed processor.

Transferring photos

After installing the required software, your next step in moving pictures to your computer depends on the transfer option you use. The next four sections walk you through the basics of each method.

Downloading from the camera

Check your camera manual to find out two important bits of information:

- ✔ Whether you should turn your camera on before or after connecting it to the computer.

- ✔ What camera mode to use for the transfer. In most cases, the camera needs to be either in PC mode or playback mode.

With the camera properly set up, insert the smaller plug on the USB cable to the camera's USB port and then insert the larger plug into the computer's USB port (refer to Figure 8-4).

If you installed the manufacturer's photo software, it may automatically appear on your computer screen after you connect the camera. Otherwise, launch the program just as you start any program on your computer. Either way, you then can follow the instructions on the screen or in your camera manual to access and transfer the files.

Alternatively, you can transfer files by using the steps laid out in the upcoming sections "Dragging and dropping picture files" and "Opening files from inside photo programs."

Studying picture-capture settings

Most cameras store bits of information called *EXIF metadata* with each picture file. This EXIF data includes such information as the type of camera, the camera settings, and the date.

After you transfer pictures to your computer, you can view the EXIF metadata in a photo-organizer program that understands the EXIF language. The following figure shows one such program, ThumbsPlus (www.thumbsplus.com). Figure 8-6, elsewhere in this chapter, shows ACDSee, another program with EXIF capabilities.

If your photo-editing software has a built-in image browser, it may also give you access to the EXIF information. The manufacturer software that shipped with your camera may provide this function as well.

Downloading via a camera docking station

If you purchased a camera dock, the process of transferring pictures typically is a simple two-step affair: You set the camera in the dock and press a button on the dock to start the transfer. The dock then automatically launches a program that enables you to access and transfer files. In some cases, you don't even need to press a button — as soon as the dock senses the camera, it starts the

transfer operation. (You may or may not need to turn the camera on before the dock can recognize it.)

The software varies from manufacturer to manufacturer, but often, you can choose options that not only transfer files, but also print or e-mail selected pictures.

Unfortunately, that's as specific as I can get for using your camera dock because features and operating instructions vary depending on the camera and dock. Check your dock manual for details, including information on whether you can bypass the docking software and use the alternative methods described in the upcoming sections "Dragging and dropping picture files" and "Opening files from inside a photo program."

Downloading via a card reader or adapter

If you're using a card reader to transfer files, follow these simple steps to send files to the computer:

1. **Before removing the card from the camera, turn the camera off.**

 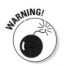

 This step is very important — you can damage the card or camera if you remove the card while the camera is turned on. Also, be sure that the camera has completed the process of storing the last picture you took before you turn the camera off.

2. **Remove the memory card.**

3. **Insert the card into the card reader.**

 Check the card reader manual or diagrams on the reader itself to find out the correct orientation for the card.

4. **Follow the steps outlined in either of the next two sections to access and transfer the pictures on the card.**

The steps for transferring pictures using a card adapter are the same, except that after you insert the card in the adapter, you put the adapter in the appropriate drive on your computer. If you're using a floppy disk adapter, for example, you put the adapter in the floppy disk drive.

Dragging and dropping picture files

Your computer has a built-in file manager that you can use for transferring photos from camera to computer, just as you work with any other files on your system. On a Windows-based

computer, Windows Explorer serves this purpose. On a Macintosh computer, the Finder provides access to all your files.

As discussed earlier in the section "Creating an image storage closet," you can also perform the transfer function from inside a photo-management program. Regardless of the tool you use, you can simply drag and drop files from their current location on the camera memory card to a folder on your hard drive, just as you do with other files that you move from place to place.

When you connect your camera, camera dock, or card reader to the computer, the computer should recognize the attached device as it does any other drive (hard drive, floppy drive, CD-ROM). For example, I have a multicard reader attached to my desktop computer. As shown in Figure 8-7, Windows Explorer recognizes each of the four slots on the reader as a separate drive. Figure 8-8 shows the drive icon that appears at the Finder level when I cable a camera directly to my Macintosh system. (Your screen may look slightly different if you use another version of either of these operating systems than I do.)

Card reader drives

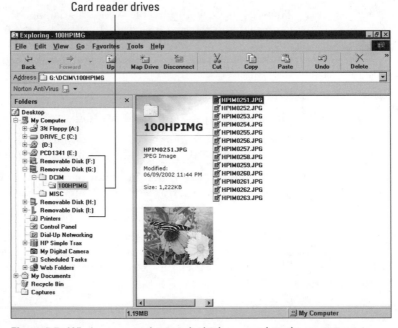

Figure 8-7: Windows recognizes each slot in my card reader as a separate drive.

To access and transfer your picture files, take these steps:

1. **Double-click the drive letter or icon that represents your camera or card reader.**

 In most cases, you then see two folders: DCIM (digital camera images) and MISC.

2. **Double-click the DCIM folder to open it.**

 You now see either a list of your picture files or another folder that has your camera name. If you see the second folder, double-click it to display the list of picture files.

3. **Select all the picture files that you want to transfer.**

 To select all the files, click the first filename and then press and hold the Shift key as you click the last filename.

4. **Drag the files to the folder on your hard drive where you want to store them.**

 Your system copies the files and puts the copies in the folder. The original files remain on the memory card.

Camera icon

Figure 8-8: When connected to a Macintosh computer, the camera appears as a drive at the Finder level.

When you use a card adapter, the computer perceives the adapter as the standard media that goes in the drive. For example, if you're using a floppy disk adapter, the computer thinks that the adapter is just another floppy disk full of files. Again, you can just drag-and-drop files as outlined in the preceding steps to transfer them.

Opening files from inside a photo program

Most photo-editing software today is *TWAIN-compliant*. That's the geek way of saying that the software can communicate directly with your camera after you install the camera's driver software. (See the earlier section "Installing the necessary software" for details.)

What this TWAIN stuff means in practical terms is that you can open pictures that are stored on your camera by using a menu command within your photo software. In Adobe Photoshop Elements, for example, you use the File⇨Import command. When you choose the command, you see a list of all the TWAIN components installed on your system, and you just select your camera from the list to access your pictures.

However, in many cases, you have an easier option: Assuming that your camera, card reader, card adapter, or dock shows up as a drive on your system, as explained in the preceding section, you can simply use the standard File⇨Open command. After you choose the command, just track down the drive and the file that you want to open, just as you would for a file stored on your hard drive. To then save the picture to your hard drive, use the Save As command, following the steps provided in the upcoming section "Saving a copy of a picture file."

Doing this one-by-one process to transfer files is a bit cumbersome, as you can imagine. Fortunately, many photo editors offer a built-in organizer that enables you to drag and drop a batch of files, as explained in the preceding section. For example, Figure 8-9 shows the built-in organizer in Photoshop Elements. To display it, choose Window⇨File Browser. Select all the thumbnails for the pictures you want to transfer and then drag them into the folder where you want to store them, as illustrated in the figure.

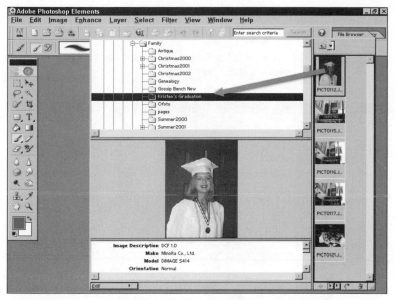

Figure 8-9: In Photoshop Elements, you can transfer files by using the File Browser.

Preserving Picture Files

After you transfer pictures to your computer, you should take some steps to protect the files. Otherwise, your photos can easily be sucked into the digital abyss. The remaining sections in this chapter give you some tips that will keep your files safe for years to come.

Saving a copy of a picture file

After you edit a digital photo, even if you just crop the image or do some other minor correction, you should immediately save the altered picture under a different name. That way, your original image file remains untouched.

The following steps show you how to save a picture in Photoshop Elements; the steps are the same in virtually any photo editor. Note

that the dialog box shows the Windows version of the program, but the Mac dialog box is similar.

1. **Choose File⇨Save As to display the Save As dialog box shown in Figure 8-10.**

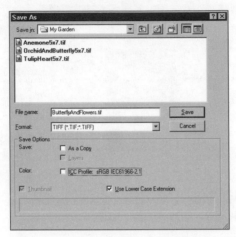

Figure 8-10: After you alter a photo, save it under a new name so that your original remains intact.

2. **Enter a name for the edited file in the File Name box.**

 Make sure that the name is different from the original.

3. **Select a non-destructive format from the Format drop-down list.**

 A couple of formats fit the bill: In Elements, select PSD, which is the Photoshop Elements format. If you're using some other software, you can use your software's format or select TIFF. Both PSD and TIFF preserve the maximum image quality.

 Don't select JPEG or GIF! Both formats destroy some picture data. For that reason, you should save a picture in that format only after you're done editing and only if you need to use the picture on the Web or for some other screen use. See Chapter 9 for details.

4. **Select the drive and folder where you want to store the new file.**

5. **Click Save or press Enter to save the file and close the Save As dialog box.**

After you close the Save As dialog box, the title on the image window changes to reflect the new filename.

If you merely want to make a backup copy of your original file, without editing the photo, don't go to the trouble of opening the picture in your photo software. Instead, just select the file in your operating system file-manager (Windows Explorer or Macintosh Finder) and use the normal process for duplicating a file. You can also find tools in any photo-organizer software to make backup copies of files.

Preventing changes to a picture

Chapter 7 explains how you can "lock" a picture file that's on your camera to prevent the picture from being deleted. To apply the same sort of protection to a picture that's on your computer, you need to set its *file attributes* to *read-only.* Doing so prevents the picture not only from being erased but also from being edited. (You can always remove the protection if you want to edit the photo.)

Here's how to prevent anyone (including you) from fiddling with your picture:

- ✔ In Windows, open Windows Explorer and right-click the filename. Choose Properties from the resulting menu to open the Properties dialog box. Select the Read-Only box and then click OK.

- ✔ On a Macintosh computer, locate the file at the Finder level. Click the file and then choose File⇨Get Info. In the resulting Info dialog box, select the Locked check box and then click OK.

Locking a picture file *does not* protect it from being destroyed if your computer's hard drive (or other storage device) goes kaplooey. For information on how to safeguard important picture files over the long haul, see the next section.

Archiving files to a CD or DVD

For long-term protection of important digital photo files, don't rely on your computer's hard drive, a floppy disk, a Zip disk, or camera memory cards. Without going into the boring details, suffice it to say that the technology used in all these storage devices can put your data at risk.

The best solution for archiving your files is to copy them to a CD-ROM disc, using a CD recorder, or *burner,* in popular phraseology. Use the type of blank CD-ROM that has the designation CD-R, not CD-RW. CD-R discs can't be erased or overwritten, unlike CD-RW. Also be sure to use name-brand discs, not the 400-for-five-dollars off-brands that are so tempting.

If you have a new computer that has a DVD recorder, you also can consider DVD discs as a storage option. However, at present, a single DVD format hasn't been established, which means that DVDs you burn today may not be readable by DVD players of the future. Of course, as technology changes, every media type risks becoming obsolete at some point. Just be aware of the potential problem so that if the format you choose looks like it's headed the way of the Betamax videotape or Laserdisc, you can copy your files onto the next greatest media.

Part IV
Sharing and Printing Photos

The 5th Wave By Rich Tennant

Okay, enlarge the chicken bone by 900 percent and attach it to an e-mail to the museum saying, "Getting close...send more money."

In this part . . .

*T*his part tells you what you need to know to experience the real joy of photography: sharing your pictures with others!

Look here for information about preparing your pictures for display on the Web or on a television screen, attaching photos to an e-mail message, and joining an online picture-sharing community. For times when you want good, old-fashioned "hard copies" to pass around at your next party or meeting, this part also shows you how to get the best possible prints of your pictures.

Chapter 9

Preparing Pictures for Cyberspace

- -

In This Chapter

▶ Getting your pictures in shape for e-mail or a Web page

▶ Setting picture display size

▶ Keeping file sizes small for faster downloads

▶ Saving a picture in a screen-friendly file format

▶ Understanding JPEG file-saving options

- -

*B*eing able to share photos over the Internet is one of the biggest benefits of owning a digital camera. Minutes after snapping a picture, you can e-mail it to friends and family or add it to your Web page.

Before sending pictures into cyberspace, you need to do a quick preflight check. Otherwise, your pictures may be too large to fit on the screen, take forever to download, be impossible for people to open, or look like a blocky mess — or all of the above. This chapter walks you through the picture-preparation steps that help you avoid these online pitfalls.

The picture-sizing information in this chapter also applies to photos that you want to use for offline screen purposes, such as adding an image to a multimedia presentation.

Getting a Photo into Online Shape

Prepping a picture for the Internet involves two steps:

✔ Setting the display size of the picture

✔ Saving the resized picture in the JPEG file format

Information about setting the display size starts in the next section. For help with the file-saving step, see the section "Saving Photos in the JPEG Format," later in this chapter.

Some cameras offer an "instant share" feature that takes care of both of these issues for you. If you use a camera-docking station, for example, the dock may have a button that automates the process of sharing pictures via e-mail. You may also find a feature that serves this purpose in the software provided with your camera, your photo-editing program, or your image-cataloging program.

Even so, I recommend that you read the rest of this chapter so that you understand what goes on behind the scenes when your camera handles your e-mail transactions. Having that background will help you solve any problems that may crop up. You also need to take over the sizing and file-saving tasks if you want to post a picture on a Web site or use the picture for some screen purpose other than e-mail sharing.

Shrinking Pictures to Screen Size

Have your friends ever e-mailed you photos that exceed the boundaries of your computer monitor, such as the photo in Figure 9-1? Or worse, have your friends complained about the size of photos that *you've* sent? Either way, the problem is caused by an overabundance of pixels.

In addition to producing pictures that don't fit on-screen, having too many pixels creates another problem for Internet photosharing. Every pixel adds to the picture file size, which increases the time that it takes for your photos to make their way through the Internet pipeline. Large files not only eat up your time when you send them out into cyberspace, but also try the patience of anyone who receives your pictures or visits your Web site.

As covered in Chapter 3, your camera's resolution setting determines how many pixels a photo contains. Even if you shoot a picture using your camera's lowest resolution setting, you probably will need to dump some pixels from your photo to shrink it to an appropriate size. The next two sections explain how to determine the right number of pixels for your Internet photos and how to trim the pixel count to that number.

Figure 9-1: Photos with too many pixels are too big to fit on the screen.

How many pixels are enough?

To figure out how many pixels your e-mail or Web picture needs, you first need to understand how a computer monitor displays what you see on-screen.

Like your digital camera, a monitor displays text and images using pixels. And just as you can select from different resolution settings on your camera, you can choose from a variety of monitor resolution settings, each of which results in a specific number of screen pixels. For example, on my monitor, I can choose from screen resolution settings of 640 x 480 pixels, 800 x 600 pixels, 1024 x 768 pixels, 1280 x 960 pixels, and so on.

When you display a digital photo, the monitor uses one screen pixel to reproduce one photo pixel. This one-to-one relationship between screen and picture pixels means that if the pixel dimensions of your picture — pixels wide by pixels tall — match the screen resolution, your photo fills the screen.

As an example, take a look at Figure 9-2. I created a 640-x-480-pixel image to use as the Windows wallpaper (desktop background). Then I set the screen resolution of my monitor to 640 x 480. At that screen resolution, the picture consumes the entire screen (with the exception of the Windows taskbar, which I left visible for this illustration).

Figure 9-2: A 640-x-480-pixel photo consumes the screen when the monitor resolution is also 640 x 480.

Now compare Figure 9-2 with Figure 9-3. For this second figure, I changed the monitor's screen resolution to 1280 x 960. At this screen resolution, the 640 x 480 photo consumes only 25 percent of the screen.

The upshot is that to set the screen display size, you simply decide how much screen-pixel territory you want your photo to consume and then change the image pixel count to match. Keep in mind, though, that people who view your pictures have control over the screen resolution setting on their monitors, and so ultimately have control over the display size of your images. Most people use a monitor resolution setting of 800 x 600, but some users will view your photos on screens using a lower or higher resolution.

Given that you can't predict the monitor resolution that will be in use when your pictures are viewed, here's my best advice:

 ✔ Size your pictures with the lowest common denominator in mind. Keep the image small enough that someone viewing the

photo at a screen resolution of 640 x 480 can see the whole picture without scrolling the display.

✔ Remember, too, that the Web browser and e-mail window themselves eat up some of the available screen space.

✔ For pictures that you plan to attach to an e-mail message, limit the picture height to 300 pixels and the picture width to 400 pixels. This allows enough room for the picture to display in the message window even on a monitor set to a resolution of 640 x 480, as shown in Figure 9-4.

✔ For Web pages, the same pixel dimensions work fine as long as your page has only one image. If you have multiple photos on a page, you should keep your pictures even smaller. Each photo you put on the page adds to the page download time, and you don't want visitors to your site to have to wait several minutes to display the page.

Figure 9-3: At a monitor resolution of 1280 x 960, the 640-x-480-pixel photo covers one-fourth of the screen.

These guidelines assume that you're preparing your picture for on-screen viewing only. If you want people to be able to print a good copy of a picture, you need to provide them with a much higher pixel count. Chapter 11 explains how to calculate the number of pixels you need to print a photo at a particular size. Unfortunately, you then have to accept the fact that the picture will take longer to download and may exceed the viewable area of the screen.

Figure 9-4: Limit e-mail photos to 300 pixels tall by 400 pixels wide to ensure that they fit on the screen.

You can reduce the file size of any photo, regardless of pixel count, by increasing the amount of file compression that's applied when you save the image in the JPEG format. For more on this aspect of the screen prep process, see the section "Saving Photos in the JPEG Format," later in this chapter.

Trimming the pixel count

Your photo-editing software should offer a command that enables you to check the pixel count of your photo and eliminate any excess pixels. The following steps show you how to get the job done in Photoshop Elements, but the basic concepts apply no matter what software you're using:

1. **With your picture open, choose Image⇔Resize⇔Image Size.**

 The Image Size dialog box, shown in Figure 9-5, appears.

2. **Select the Resample Image check box, as shown in the figure.**

 When the box is selected, the Width and Height options in the Pixel Dimensions area at the top of the dialog box become available.

3. **Select Bicubic from the drop-down list next to the Resample Image check box.**

4. **Select the Constrain Proportions check box.**

5. **Enter the desired horizontal pixel count in the Width box at the top of the dialog box.**

 Or enter the vertical pixel count in the Height box, again using the box in the Pixel Dimensions area at the top of the dialog box. When you change one value, the program automatically adjusts the other value to keep the original image proportions intact.

6. **Click OK to close the dialog box.**

7. **Choose View⇨Actual Pixels to see the image displayed at its new size.**

 Remember that the picture will display at a different size when viewed on a monitor that doesn't use the same screen resolution that you're currently using.

 If you don't like the new size, choose Edit⇨Undo and try again.

8. **Save your resized picture file.**

 If you want to make additional changes to the picture, choose File⇨Save As and save the photo in a non-destructive file format, such as PSD or TIFF, as explained in Chapter 8.

 If you're ready to take the final step to get your photo in Internet shape, keep reading to find out how to save your picture in the JPEG file format.

Set pixel count here

Figure 9-5: Adjust the pixel count in the Image Size dialog box.

Saving Photos in the JPEG Format

Pictures destined for the Web or e-mail must be saved in an Internet-friendly file format. The best format to use for digital photos is the JPEG format. Other Internet formats, including GIF, PNG, and JPEG 2000, either destroy picture quality (GIF) or can't be read by all Web browsers and e-mail programs (PNG and JPEG 2000).

As covered in Chapter 3, JPEG is the default format that most digital cameras use when creating a picture file. If you captured your picture using the JPEG format and discovered in your preflight check that your original image contains the right number of pixels, your picture is already good to go. But if you eliminated some pixels or otherwise edited the photo, you need to resave it in the JPEG format.

Chapter 3 details the JPEG format, so I won't repeat all the information here. But here are the important highlights:

- ✔ When you save your picture file in this format, the software applies *lossy compression*.

- ✔ The *lossy* in *lossy compression* refers to the fact that this type of compression eliminates some picture data.

- ✔ JPEG compression results in smaller file sizes but also reduces picture quality.

- ✔ The higher the degree of compression, the smaller the file size and the lower the picture quality.

Figure 9-6 shows you an example of just how badly you can mess up a nice picture if you apply too much compression. Overly compressed photos take on a blocky look. (Refer to the inset area if you can't make out the defects in the larger image.) In addition, highly compressed pictures often are littered with random color defects.

These compression defects are referred to as *JPEG artifacts* in imaging circles. The blocky appearance of a highly compressed picture stems from the fact that the JPEG format evaluates and compresses photos in 8-pixel-square units.

As you can when taking a picture, you can specify what level of JPEG compression you want to apply when saving a picture in your photo editor. You also have access to a few additional options that aren't available on your camera.

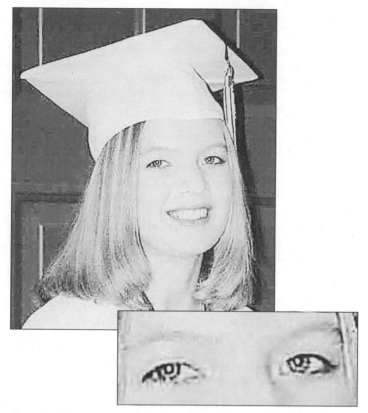

Figure 9-6: Too much compression gives pictures a blocky look.

The next sections explain these options and show you two alternative file-saving approaches. The first approach features a JPEG optimization tool, which enables you to preview the effects of compression before you save the file. The second approach features the standard Save As command and dialog box. Depending on your software, you may or may not be able to preview compression effects using the Save As command. (You can do so in Photoshop Elements.)

Whichever approach you prefer, never save your picture in the JPEG format between editing sessions. Instead, select a non-destructive format, such as TIFF or PSD (in Photoshop Elements). Save in the JPEG format only when you're finished making all other changes to the picture. Each time you edit and then resave your photo in the JPEG format, you apply a new round of compression, destroying the picture further. (You don't damage the photo if you merely open and close it.)

Getting a compression preview

Some photo-editing programs, including Photoshop Elements, offer a great feature known as a *JPEG optimization tool*. This tool enables you to preview the effects of different levels of JPEG compression so that you can find the optimum balance between file size and picture quality.

Despite its technno-babble name, a JPEG optimization tool is simple to use. The following steps show you how to take advantage of the Photoshop Elements version of the tool. All JPEG optimization utilities offer the same basic options, although you may implement them slightly differently than these steps describe.

One caveat before you work your way though the steps: When you get to Step 8, be sure to give your file a different name than the original. Remember, applying JPEG compression eliminates some image data, and you may need all the original data some day.

1. **With your photo open, choose File⇨Save for Web.**

 The Save for Web dialog box comes to life, as shown in Figure 9-7. Two preview panes display your photo, with the left pane showing the original, uncompressed image and the right pane showing how your picture will look if you save it at the current dialog box settings.

2. **Select JPEG from the Format drop-down list (labeled in Figure 9-7).**

3. **Click the Preview button and select Size/Download Time (28.8 Kbps Modem) from the menu, as shown in Figure 9-8.**

 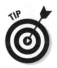

 At the bottom of the preview panes, you see an estimate of the image download time, as shown in Figure 9-9. The program bases this estimate on the modem speed that you select from the Preview menu. I recommend that you select 28.8 Kbps because that is the slowest modem speed currently in widespread use. Many people who view your picture may have faster Internet connections, but using a conservative estimate ensures that download times are acceptable for everyone who wants to view your photo.

4. **Uncheck the Optimized and Progressive check boxes, as shown in Figure 9-9.**

 These features save your file using features that aren't supported by some Web browsers, so you should keep them turned off.

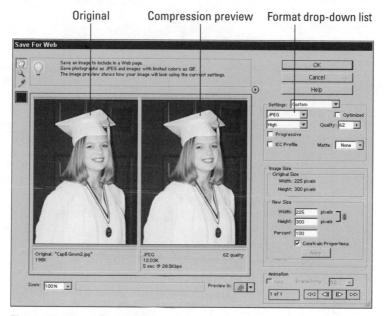

Figure 9-7: The right preview pane shows you the impact of the current compression setting.

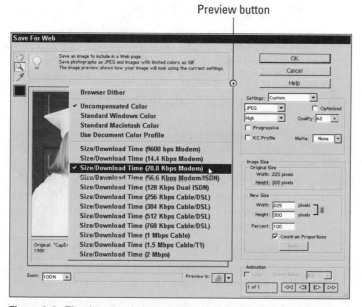

Figure 9-8: The download-time estimate is based on the modem speed you select.

Hand tool

Zoom tool

Quality options

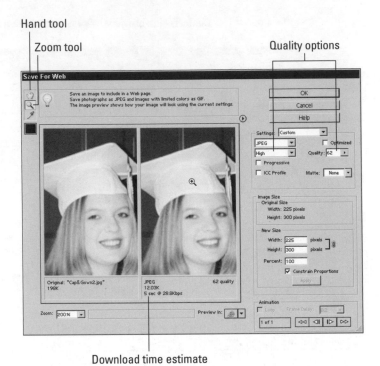

Download time estimate

Figure 9-9: Click the preview pane with the Zoom tool to magnify the view.

5. **Use the two picture-quality options labeled in Figure 9-9 to adjust the amount of JPEG compression.**

As on your camera, a higher quality setting results in less compression and, therefore, a larger file but better picture quality.

In Elements, you can select from four main quality levels — Maximum, High, Minimum, and Low — by using the left of the two quality options. Or use the rightmost quality option to get more specific. The values range from 0, for the highest amount of compression and unspeakably ugly picture quality, to 100, for the minimum amount of compression, best picture quality, and largest file size.

6. **Experiment with the quality settings.**

Watch the right preview pane to gauge the impact on picture quality and download time.

• To magnify the preview, click the Zoom tool, labeled in Figure 9-9, and then click the preview. To zoom out, press the Alt key as you click the preview. (Press Option on a Macintosh computer.)

• To scroll the display so that you can see another part of your photo, click the Hand tool, also labeled in the figure. Then drag with the tool in the preview pane.

7. When you find a good balance between download time and picture quality, click OK.

You then see the Save Optimized As dialog box, shown in Figure 9-10. This dialog box is just your average, everyday file-saving dialog box, stripped of a few options that aren't relevant to JPEG files.

Figure 9-10: Be sure to save your picture under a different name than the original!

8. Enter a new name for the picture in the File Name box.

Again, be sure to give the file a new name — if you don't, you overwrite your original picture file.

9. Click Save.

The program saves your optimized JPEG image. Your original image remains on-screen in the Elements program window. If you want to see how your new JPEG picture looks, use the File⇨Open command to open it.

The New Size area in the lower-right quadrant of the Save for Web dialog box enables you to save a step in the screen-prep process by setting the image pixel count at the same time you save your file. Be sure to select the Constrain Proportions check box so that you don't screw up the original proportions of the photo. Review the section "Shrinking Pictures to Screen Size," earlier in this chapter, for more information about sizing screen pictures.

Using the regular Save As command

You also can save a file in the JPEG format by using the File⇨Save As command. In Photoshop Elements 2.0, this approach enables you to preview the results of your compression settings, but that isn't the case in all programs.

Be sure to choose Save *As* from the File menu, not the plain old Save command! The latter resaves your picture under its current name, overwriting your original image. Also, as with any JPEG save, wait until you're finished making changes to the photo before you save the image as a JPEG file.

Here are the steps to take if you want to use the Save As command in Photoshop Elements:

1. **Choose File⇨Save As to display the Save As dialog box, shown in Figure 9-11.**

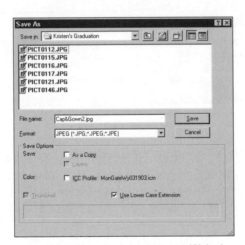

Figure 9-11: You also can save your Web picture using the Save As command.

2. **Enter a new name for the photo in the File Name box.**

 Don't skip this step! If you don't change the name, you overwrite your original photo.

3. **Select the folder where you want to store the picture.**

4. **Select JPEG from the Format drop-down list.**

5. **Click Save to display the JPEG Options dialog box, shown in Figure 9-12.**

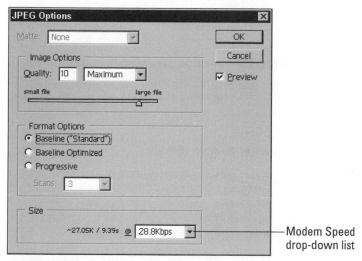

— Modem Speed
drop-down list

Figure 9-12: Set the compression amount by using the
Image Options controls.

6. **Select 28.8Kbps from the Modem Speed drop-down list,
 labeled in Figure 9-11.**

7. **Select the Preview check box, as shown in the figure.**

 Selecting this check box enables you to preview the effects
 of the selected compression settings in the image window
 and also displays a file-download time estimate in the Size
 area at the bottom of the dialog box. (In the figure, the esti-
 mated file size is 27.05K and the estimated download time
 is 9.39 seconds.) The download estimate is based on the
 modem speed you selected in Step 6. As explained in the
 preceding section, I recommend 28.8 Kbps because that's
 the slowest Internet connection speed commonly used.

8. **Use the controls in the Image Options section of the
 dialog box to set the Quality level.**

 Remember, the higher the Quality setting, the less com-
 pression that's applied. Less compression results in better
 picture quality but a larger file and longer download time.

 In this dialog box, the maximum Quality value is 12, not 100
 as in the Save for Web dialog box. Don't ponder this incon-
 sistency too long — just select 12 if you want the least
 amount of compression and 0 if you want the maximum
 amount of compression. Alternatively, you can drag the
 slider underneath the Quality option all the way to the

right or left, respectively. Or, if you're not a control freak, just choose one of the four general Quality levels from the drop-down list next to the Quality box.

9. **Select the Baseline "Standard" option.**

Selecting this option does the same thing as turning off the Optimized and Progressive options in the Save for Web dialog box — that is, it ensures the maximum compatibility with older Web browsers.

10. **Click OK to save the file.**

After the JPEG Options dialog box closes, your newly saved JPEG copy remains on-screen, but the compression effects are no longer visible. To see the "real" version of your JPEG copy, compression warts and all, close and reopen the image.

Chapter 10

Sharing Pictures Online

· ·

· ·

*I*n the pre-Internet age, sharing pictures with distant friends, family, colleagues, or clients involved time, money, and hassle. You had to hunt down the right negatives, trek to the photo lab, buy reprints, and then spend more cash on postage and envelopes. And that's not including the toll taken on your mood while waiting in line at the post office to find out exactly how many stamps were required to get the pictures into the recipient's mailbox.

With your digital camera and an Internet connection, you now can share images with people around the world in minutes — no postage or post-office lines required. Even people who don't have Internet connections at home or at work can view your pictures at a library or café that offers Web access to the public.

This chapter explains the two popular options for Internet photo swapping. In the first part of the chapter, you can find instructions for sending your pictures via e-mail. For times when you have more than a few photos to share, the last part of the chapter introduces you to online photo-sharing sites where you can create and post digital photo albums.

Before sending your pictures through the Internet pipeline, refer to Chapter 9 to find out how to set the photo display size and save images in an Internet-friendly file format. These two steps are critical to preventing problems with file downloading and picture-viewing.

E-Mailing Pictures

Like everyone with an e-mail address, I get tons of spam every day. So it's especially sweet when something that really interests me — a photo sent from a family member or friend — shows up amid all the unwanted offers for a better mortgage rate, a sure-fire way to meet my soul mate, or an herbal pill that promises to enlarge a body part that my gender doesn't even possess.

When you want to brighten someone's inbox with a photo — and I trust that your photo is not of the spam category and *absolutely* not of any body parts, enlarged or otherwise — the next several sections explain your options. You can either send the photo through your regular e-mail program or take advantage of auto-mated e-mail tools provided with some camera software and photo-editing programs.

Sending photos using your e-mail program

Every e-mail program has a feature that enables you to send a file along with your message. You use the same approach regardless of whether you want to send a text document, a digital photo, or any other type of file.

The following steps show you how to attach a picture to an e-mail message in Microsoft Outlook Express 6. If you use some other e-mail program or version of Outlook Express, the basics are the same, but some button or command names may be different.

1. **After starting Outlook Express, click the Create Mail button on the toolbar.**

 Figure 10-1 points you toward this button. As an alternative to using the toolbar button, you can choose File⇨New⇨Mail Message. Either way, a new message composition window appears in front of the main Outlook Express window, as shown in the figure.

2. **Enter the recipient's e-mail address into the To box.**

3. **Add a subject line into the Subject box.**

4. **Type any comments that you want to send in the message area.**

5. Click the Attach button, labeled in Figure 10-1.

Or choose Insert⇨File Attachment. Either way, you see the Insert Attachment dialog box shown in Figure 10-2.

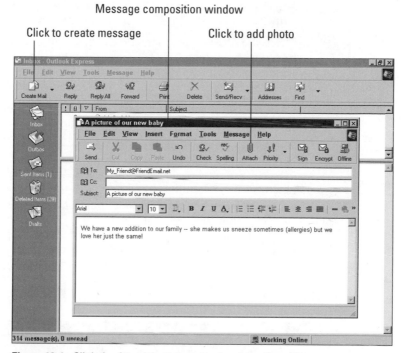

Message composition window

Click to create message Click to add photo

Figure 10-1: Click the Attach button to send a photo file with your message.

Figure 10-2: Select the photo file that you want to send.

Don't choose Insert⇨Picture rather than Insert⇨File Attachment! Although the Picture command seems like the logical choice, it sends your photo in a way that can create problems for people using some other e-mail programs.

6. **Select the photo file that you want to send and click Attach.**

 (Click the Attach button inside the Insert Attachment dialog box, not the one on the toolbar of the message composition window.) The Insert Attachment dialog box closes, and the message composition window becomes active again.

7. **Click the Send button on the toolbar or choose File⇨Send Message to send the message and picture file.**

 The message composition window closes, and your e-mail scurries off toward the recipient's inbox.

To "check your work," switch to the Sent Items folder of your e-mail program. You then can see the message that you sent, as shown in Figure 10-3. Note that the way that the text and photo display may look slightly different if the recipient uses a different e-mail program than you. For example, instead of displaying the actual photo, the window may display a link that the user clicks to view the picture. As explained in Chapter 9, the display size of the photo may also vary, depending on the monitor resolution that the recipient uses.

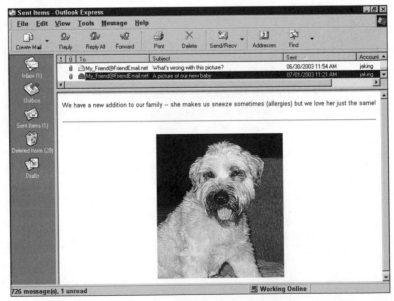

Figure 10-3: Display the Sent Items folder to see how your message will appear.

 You can attach more than one picture to a message. In Step 6, click the filename of the first photo you want to send and then press and hold the Ctrl key as you click the other filenames. (On a Macintosh computer, press ⌘ rather than Ctrl.)

 Don't attach more than a couple of photos to a single message. If you do, the file size of the message may exceed the limits enforced by some Internet providers. Also, don't forget to shrink the file sizes of the photos as much as possible before sending them; Chapter 9 shows you how.

As an alternative to filling up someone's mailbox with dozens of pictures, consider using an online photo-sharing service, discussed later in this chapter. With these services, people can not only view your pictures, but also order prints of their favorite images.

Using automated e-mail tools

Sending photos via e-mail isn't difficult, but if you're new to the whole Internet thing, you may prefer to use one of the many tools that assist you with the process. Your head probably is already about to explode from all the camera-related stuff you've crammed into it, so give yourself a break and take advantage of these e-mail helpers. You can leave the joys of mastering your e-mail program for some other day.

Because e-mailing photos is a major reason why people buy digital cameras, most camera manufacturers now provide a software tool that walks you through the steps of sharing your photos. In computer lingo, this type of tool is known as a *wizard*. You still have to fill in the recipient's e-mail address and select the photos that you want to send, but the wizard does the rest.

You can get your hands on an e-mail wizard several ways:

✔ The software CD that shipped with your camera may include wizards for sending photos (as well as for printing and editing pictures). Often, the wizards are part of the utility that the manufacturer provides for downloading and managing your picture files.

For example, Figure 10-4 shows the software that's provided with some Hewlett-Packard digital cameras. To send a picture to someone, you click the thumbnail for the picture and then click the E-Mail button. The software then walks you through the process of sending the photo.

✔ If you purchased a docking station, it also may come with soft-
 ware that simplifies photo sharing. The software typically
 launches automatically when you put the camera in the camera
 dock, but check the dock manual for specifics. In some cases,
 you just press a button on the dock or camera to start the
 e-mail wizard.

✔ Many photo-editing and photo-cataloging programs also offer
 e-mail wizards. In Photoshop Elements, for example, choosing
 File⇨Attach to E-Mail displays the same message composition
 window that you get when you create a new message in your
 e-mail program. If you display the How To palette (Window⇨
 How To), you can get step-by-step guidance with attaching
 and sending your photo, as shown in Figure 10-5. You may
 need to have a standard e-mail program, such as Outlook
 Express, installed on your computer for this type of wizard
 to work.

Figure 10-4: Most cameras ship with software
that offers an e-mail wizard.

I can't be too specific about working with an e-mail wizard because
every program works a little differently. The on-screen prompts tell
you what to do, so you don't really need my assistance anyway.
However, I want to point out a few tidbits that may help you take
the best advantage of your software:

✔ Most wizards not only can get your messages out to the world,
 but also handle the steps involved in setting the picture display
 size and file format. (Chapter 9 explains these tasks.)

✔ If you ask the wizard to take care of the sizing and format
 chores, the program may or may not keep a copy of the new,

e-mail version of the picture file. Check the software's manual or Help system to find out whether you can specify how the program handles this issue. Unless you need the resized picture for some other purpose, there's no reason to clutter up your computer's hard drive with the e-mail versions of your pictures.

✔ When saving an e-mail copy of a picture, be sure to give the picture a name that's different from the original. Otherwise, that original picture file is destroyed.

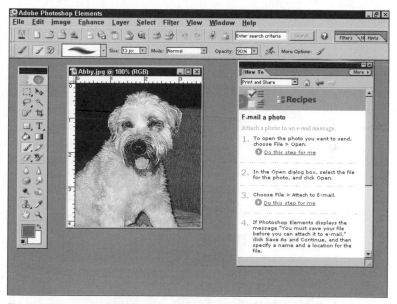

Figure 10-5: Display the How To palette for help with sending a photo via e-mail in Photoshop Elements.

Solving e-mail snags

When all the e-mail planets are properly aligned, your message arrives in the recipient's inbox, with the photo appearing in one of two forms:

✔ The message text and photo appear together in the window, similar to the layout shown in Figure 10-3, earlier in this chapter.

Computer folk use the phrase *viewing attachments inline* to describe this display setup.

✔ The message text appears along with a link identifying the photo filename. Clicking the link displays the photo, sometimes in a separate window.

Some e-mail programs enable the user to switch between these two viewing options. In some versions of Netscape Navigator, for example, the View Attachments Inline command on the View menu toggles between the two displays.

If the recipient has trouble displaying the photo, receiving the photo, or receiving the entire message, the following problems may be to blame:

✔ The photo file isn't in the JPEG file format. See Chapter 9 for more about this format. If you sent the file in some other format, such as TIFF, the picture file appears as a link that the e-mail program can't open. People who receive the file must save it to their computers' hard drive and then open and view it in a photo editor or viewer.

✔ The e-mail program is set up to prevent the user from opening attached files. In Version 6 of Outlook Express, for example, this is the default setting; you can change the setting in the Options dialog box, shown in Figure 10-6. (Choose Tools⇨Options, click the Security tab, and uncheck the option that's circled in the figure.) The feature is designed to help users avoid malicious messages that contain viruses, but it unfortunately also blocks photos and other innocent file attachments.

Figure 10-6: This Outlook Express 6 option, designed to prevent viruses, also blocks picture files.

✔ Antivirus software installed on a computer may also be block-
ing e-mail attachments. Again, the user typically can turn this
function off via the program's Preferences or Options controls.

✔ The size of the picture file (or combined size of all attached
files) exceeds a limit set by the recipient's e-mail provider. See
Chapter 9 to find out how to reduce file size by eliminating
some pixels or increasing the amount of JPEG file compression.

✔ If the picture appears on the monitor but exceeds the avail-
able screen space, the picture contains too many pixels.
Again, Chapter 9 explains how to solve this problem.

Saving and Printing Photos from an E-Mail Message

When someone e-mails you a photo, you can save and print the
image separate from the accompanying text message as follows:

✔ **To save the picture:** Look under the File menu for a command
related to saving attachments. In Outlook Express, choose
File⇨Save Attachments. In Netscape Navigator, choose
File⇨Attachments, select the picture name from the submenu,
and then choose Save As. You then see the standard file-saving
dialog box, where you can enter a name for the picture and
choose the folder where you want to store it.

As an alternative approach, just put the mouse cursor over the
photo and click the right mouse button to display a pop-up
menu. (If you're using a Macintosh computer with a one-button
mouse, press the Ctrl key as you click the mouse button.) The
pop-up menu contains an option for saving the image. The com-
mand name varies depending on the program — look for some-
thing like Save Image As or Save Picture As.

Note that if someone sent you the picture formatted using
HTML coding (the Web-page creation language), you may not
be able to save the picture separately from the message text.

✔ **To print the photo:** Unfortunately, most e-mail programs don't
offer a command for printing a photo without its accompanying
message text. You need to save the picture to your computer's
hard drive and then open and print the picture using your
photo editor or other software for working with picture files.

Remember that photos sized to display at a reasonable size
on-screen don't contain enough pixels to produce quality
prints unless you make the print size very small. Chapter 11
provides more information about this aspect of printing.

Taking Advantage of Photo-Sharing Services

Online photo-sharing sites offer a great alternative to distributing pictures via e-mail. At these Web sites, you can post a batch of photos, organize pictures into albums, and then invite other people to view the albums at their leisure.

Figure 10-7 offers a look at an album page from one leading photo-sharing site, Ofoto (www.ofoto.com). Other sites to investigate include Shutterfly (www.shutterfly.com), Snapfish (www.snapfish.com), and Club Photo (www.clubphoto.com). Your camera manufacturer may offer its own photo-sharing site, too.

Figure 10-7: Web sites such as Ofoto offer free online photo-sharing.

Among other benefits, this option enables you to share photos with people who don't have an Internet connection at home or at work. They can visit a local library or Internet café, log into the Web site, and browse through your photos. Don't worry about strangers having access to your pictures, by the way — you can put a password on each photo album to restrict viewing to people who know your password.

In addition to viewing photos, anyone with access to your albums can order prints of their favorite photos, which saves you the time

and expense of making and sending the prints yourself. You can also order photo calendars, mugs, greeting cards, and other specialty items featuring your images.

The cost, you ask? In most cases, you pay nothing to join the site and post albums. You incur a cost only if you order prints or other products.

To post an album, you typically need to download some software from the site — again, the software is free. Figure 10-8 offers a look at the Ofoto software. If you use a site provided by your camera manufacturer, the necessary software is likely on the CD that came with your camera.

Figure 10-8: Most online sites provide free software for uploading pictures and creating albums.

After installing the software on your computer, follow the instructions on the Web site to upload your pictures and arrange them into albums. After you create an album, you can visit the site at any time to add more photos, reorganize your albums, or remove pictures from the site.

Pay special attention to the pixel-count and file-format guidelines given at the Web site so that your pictures display as they should. If you think that people will want to order prints, you need to provide high-resolution images to ensure good print quality. See Chapter 11 to find out more about this issue.

Most sites also offer a feature that sends out e-mail announce-ments to let your friends and family know that new pictures are available for viewing, as shown in Figure 10-9. (You give the site a list of the people to contact for each album.) When people visit the site for the first time, they may need to join as members before they can view the albums; again, membership is free, and there's no obligation to buy prints or any other services.

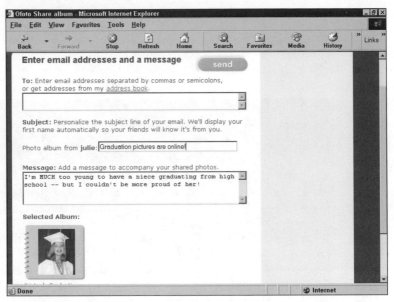

Figure 10-9: After creating an album, you can send e-mail announcements to invite people to view it.

Although online services that offer free photo album space for your digital photographs are convenient, do not use such services to permanently archive your pictures. They may initially seem like an attractive alternative for image storage because they don't require you to use up valuable space on your hard drive for hun-dreds of photos. But beware: During the dot.com crash a few years ago, several online photo-sharing/photo-finishing sites went belly-up overnight. Some closed down their operations without giving consumers an opportunity to download the images they posted on Web sites and the photos were lost. A better solution is to invest in a CD burner and store your images permanently on CD-ROM discs. For more information, see Chapter 8.

Chapter 11

Printing Your Pictures

• •

• •

*D*igital cameras used to be known as great screen performers but less-than-ideal for producing printed photos. First-generation digital cameras simply didn't capture enough pixels to produce prints that matched the quality that you got from a film camera.

All that changed with the introduction of megapixel digital models. Prints from digital cameras now look as good as anything a film camera can turn out. And digital offers you the option of printing your photos yourself, giving your more control over how your images are translated to paper.

This chapter tells you everything you need to know to get the best prints of your digital photos. It explains the steps involved in do-it-yourself printing, offers pointers for getting good results when you take your image files to a retail lab for printing, and discusses the pros and cons of different types of photo printers.

Exploring Your Printing Options

When you take pictures with a film camera, you have to shoot the entire roll of film and then take the roll to a photo lab for processing and printing. With digital, you can stop shooting and start printing whenever you want, and you have multiple choices for getting the prints made. The next several sections explore your options.

Printing from your computer

If you're the do-it-yourself type and comfortable behind the keyboard, you can transfer your photos from the camera to your computer and then output them on your printer as you would any other document.

When you go this route, you need to specify the print size and output resolution before printing the image. For specifics, see the section "Preparing a Photo for Printing," later in this chapter. The section "Sending the Picture to the Printer" walks you through the printing process.

If you're interested in adding a new printer to your computer system, check out the sidebar "What type of printer should I buy?" for tips on what printer technology best suits your needs.

Printing directly from the camera

If you like the convenience of printing your own photos, but don't want to mess with the computer side of the job, you can buy a printer that offers direct printing from your camera. Figure 11-1 shows a Canon printer and camera combination that offer this option. (In most cases, the camera and printer must come from the same manufacturer to work together.)

Figure 11-1: Some printers can output pictures directly from the camera.

With this setup, you just connect the camera to the printer and select the print options using the menus on the camera, as shown in Figure 11-2. The camera and printer take things from there.

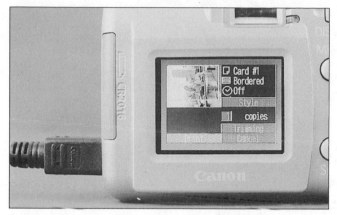

Figure 11-2: You select the number of copies and other print options via camera menus.

Printing from a memory card

For another automatic printing alternative, you can buy a printer that can output pictures from a memory card. You can see this type of printer in Figure 11-3. This particular model, from Hewlett-Packard, accepts several types of memory cards and includes a monitor on which you can see thumbnails of your images. Although this printer is a snapshot printer, limited to a print size of 4 x 6 inches, full-size printers that offer memory-card printing are also available.

Whatever the printer size, models that offer card printing all work the same way. When you're ready to print a photo, you take the memory card out of the camera and insert it into the card slot on the printer, as shown in Figure 11-4.

With some cameras, you can specify print options by using the camera menus before removing the card from the camera. You also can use the printer menus to select print options. You can even print an index card that shows thumbnails of all the images on the card, similar to the index prints that you sometimes get when having film negatives printed at a photo lab.

Figure 11-3: Many photo printers can output pictures from a memory card.

Figure 11-4: This model has slots for several types of memory cards.

Getting prints from a photo lab

Just about every retail outlet that offers film processing also can make prints from your camera memory card. In fact, you have several options for getting your prints:

> ✔ You can hand over your memory card to the lab technician for printing. In some cases, you can get one-hour prints, just as with a roll of film; other outlets do overnight printing. Prints cost about 30 cents apiece.

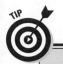

What type of printer should I buy?

In the market for a new printer? When you hit the stores, you'll encounter three printer technologies: inkjet, laser, and dye-sub (or dye-sublimation). Here's the low-down on each to help you pick the right one for the type of printing that you want to do:

✔ **Inkjet:** Inkjet printers are the best solution if you want to print occasional text documents as well as photos. You can get a great printer for around $150, with models ranging from snapshot-size printers to all-in-one machines that offer scanning and faxing as well as printing. Some models offer direct printing from either a compatible camera or from memory cards. Print quality varies widely, so read reviews in photo magazines and on the Internet to find the best bargains.

✔ **Laser:** If you need to print large quantities of text documents as well as photographs, a color laser is a better choice than an inkjet. Print quality for photographs is not quite as good as from an inkjet printer, although the latest crop of color lasers comes pretty close. For text printing, however, lasers surpass inkjets. Expect to pay $700 and up.

✔ **Dye-sub:** This type of printer is for photos only. You must use specially-coated dye-sub paper; you can't print on plain paper. In addition, most dye-sub models can print snapshot-size photos only. These limitations make dye-sub models an inappropriate choice as the sole printer in your home or office. But if you want a second printer to use just for photos, dye-sub print quality is excellent, on par with the best inkjet models. Some models offer direct printing from a camera or memory card, too. Prices range from about $150 to $500.

✔ You can print the pictures at a do-it-yourself kiosk. You get the pictures immediately, and you can even do some minor image editing, such as cropping the picture and removing red-eye. This method, although faster, is a little more expensive than having the technician make your prints. Expect to pay about $6 for an 8-x-10-inch sheet of photos. How many photos you can fit on a page depends on the size at which you print each image.

✔ You can order prints from an online photo service such as Ofoto or Shutterfly. You log on to the company's Web site and use provided software tools to send your picture files and submit your order. Your printer photos arrive in the mail. Prices are competitive with what you'd pay at your local lab for overnight service.

For more information about online photo sites, including details about posting and sharing photos, see Chapter 10.

Why is my picture cropped in this print?

You may have noticed that when you print a digital photo at the standard snapshot print size — 4 x 6 inches — the print doesn't include the entire original image. This occurs whether you take advantage of direct printing from a camera or memory card using your own photo printer, or have your pictures output at a lab or through an online service.

This image-cropping is necessary because the *aspect ratio* (width compared to height) of a digital image is 4:3. A 4-x-6-inch print has an aspect ratio of 3:2, the same as a 35mm film negative. To fit your 4:3 original onto a 4-x-6-inch area, the picture must be cropped.

Don't get too bugged about this issue, though. First of all, the same thing happens when you have a film negative enlarged to a 5 x 7 or 8 x 10 print, both of which have different aspect ratios than that 3:2 film negative. Second, if you simply remember to leave a little margin around your subject when shooting your pictures, as illustrated in Chapter 4, you retain the important parts of the photo when it's printed.

If you forget that shooting suggestion and really want to retain the entire original image area, you can reduce the print size of the image as necessary to fit within the boundaries of the print. You need to print your photos from your photo editor or other program that can make this size change for you; see the section "Setting print size and resolution" for how-to's. When you print your photo, you wind up with a blank border along two edges of the image, which you can trim away. Again, see Chapter 4 for an illustration of this option.

Most online labs and retail photofinishing labs output your pictures on the same archival-quality paper as traditional film prints. That means that in addition to excellent print quality, you can expect the same print life as for your film prints — about 10 to 60 years, depending on how much you expose the print to light, humidity, and environmental pollutants. Some self-service printing kiosks also offer this print technology, but others output inkjet or dye-sub prints, which may not offer the same life span. (Life expectancy varies depending on paper, ink, and dye formulations.) If this issue is a concern, ask before you buy — but in a drugstore or other outlet that isn't focused primarily on photo processing, don't be surprised if the staff doesn't have an answer. You may want to look for a professional imaging lab that can provide more technical guidance when you're printing special photos.

See Chapter 13 for tips about preserving your prints, no matter what printing technology you choose.

Preparing a Photo for Printing

If you're printing your photos from inside your photo editor or some other photo software, you need to do a little prep work before selecting the Print command, which sends the image file to the printer. You need to set the image output resolution — pixels per inch — and specify the print size. The next two sections explain both parts of the process.

You can skip these steps if you're printing your pictures directly from the camera or from a memory card, using the printer or camera menus to set up the print job. The printer and camera take care of the resolution and size changes for you. (Refer to the earlier sections "Printing directly from a camera" and "Printing from a memory card" for more information about these options.)

You also don't have to worry about these tasks if you're having your pictures printed at a retail photo lab or through an online service. You can just hand over your raw images to the lab, specify the print size on the order form, and let the lab technician worry about output resolution.

However, I suggest that you read through these next two sections even if you decide to use direct printing or take your pictures to a lab. Understanding the issues discussed here will help you get the best prints from your digital photos.

Understanding output resolution

Chapter 3 introduces you to the subject of image *resolution*. Image resolution refers to the number of pixels in an image. On most cameras, you can choose from a few different resolution settings, each of which captures the picture using a different number of pixels.

As explained in Chapter 3, the print quality of your photos depends in part on how many pixels are available to produce that print. To get good-looking prints, you need between 200 and 300 pixels for each linear inch of the print. For example, if you want a 4-x-6-inch print, you need a minimum pixel count of 800 x 1200 pixels, which gives you 200 pixels per inch, or *ppi*.

Some people use the term *image resolution* to mean pixels per inch. To avoid confusion caused by so many varied usages of the term, I refer to the print ppi value as the *output resolution* and the total pixel count of the original photo as image resolution.

Resolution confusion: ppi versus dpi

Like digital cameras, printers can be described in terms of resolution. But for a printer, resolution refers to how many dots of color the machine can distribute over a linear inch of the paper. This value is stated as *dots per inch,* or *dpi.*

Many people confuse dpi with ppi (the number of image pixels per inch), in part because printer manufacturers sometimes mistakenly use the label *ppi* to describe their printers' capabilities when they really should use *dpi.* Despite this unfortunate practice, dpi and ppi are not the same thing. A printer does not produce pixels; it creates dots of ink to reproduce a pixel on paper. Many printers use multiple dots to reproduce a single image pixel.

Exactly how many pixels per inch are required for optimum print quality varies from printer to printer. Check your printer manual for guidelines or do some tests of your own, printing the same photo at several different ppi settings. (See the upcoming section "Setting print size and resolution" to find out how to adjust ppi.) If you're sending your pictures to a lab, check with the lab for resolution guidelines.

Dealing with a low pixel count

Chapter 3 includes a table that tells you how many pixels you need to produce good prints at various traditional print sizes. The idea behind the table is to help you to set your camera to capture the right number of pixels before you press the shutter button.

Of course, when you take a picture, you don't always know how large you will want to print the photo. And even if you do, your camera may not offer a resolution setting high enough to capture the required number of pixels for the print size you want.

Either way, if you wind up with a photo that doesn't have enough pixels to produce the right output resolution (ppi) at the print size you have in mind, you have two choices.

If print quality is your main concern, reduce the print size. As you shrink the print size, ppi goes up, which should improve print quality. As an example, see Figure 11-5. This image contains 400 x 400

pixels, resulting in 100 ppi when printed at this size. That resolution is too low to produce acceptable photo quality.

For Figure 11-6, I reduced the print size of the photo to one-quarter of the original. This change raised the output resolution to 200 ppi, producing a much higher-quality photo.

For the image in Figure 11-7, I reduced the print size enough to bring the output resolution up to 300 ppi. This size reduction results in an even sharper image (although the variation from the 200 ppi version is subtle).

Don't want to shrink the print size? Your other option is to add more pixels in your photo editor — a process known as *resampling*.

Figure 11-5: An output resolution of 100 ppi is too low to produce good-looking prints.

Figure 11-6: At 200 ppi, the print size is smaller, but the quality is higher.

Figure 11-7: Here, I reduced the print size enough to get an output resolution of 300 ppi.

In theory, adding pixels sounds like a good idea. However, you usually don't improve picture quality and may actually *lower* quality when you do this, as illustrated by Figure 11-8. Starting with the original, 400-pixel-square photo from Figure 11-5, I added enough pixels to raise the output resolution to 300 ppi. You can see that there's little difference between this version of the printed image and the one in Figure 11-5.

Feel free to try adding pixels if you like, but don't be surprised if your original, lower-resolution photo prints better than your resampled, higher-resolution versions.

Figure 11-8: Adding new pixels raises the output resolution but doesn't improve print quality.

Setting print size and resolution

When you first open a digital photo in your photo editor, the program assigns a default output resolution (ppi) value. Typically, the value is either 72 ppi or 300 ppi.

This default output resolution determines the default print size for the photo. The software arrives at the print width by dividing the number of horizontal image pixels by the default ppi value; print height is calculated by dividing the number of vertical pixels by the ppi value.

Before you choose the Print command, you must specify the print size and output resolution that you want to use. Otherwise, the printer will print the photo according to the default output resolution and print size.

The following steps show you how to establish the print size and output resolution in Photoshop Elements. If you're using some other software, look for an Image Size or Size command (check the program's Help system or manual for guidance).

1. **Choose Size⇨Resize⇨Image Size to display the Image Size dialog box.**

 Figure 11-9 shows this dialog box. The default print dimensions and output resolution appear in the Width, Height, and Resolution boxes.

2. **Uncheck the Resample Image check box, if it's selected.**

 Notice the line and the chain-link symbol that appear to the right of the Width, Height, and Resolution boxes in the Document Size area of the dialog box? That link reminds you that print size and output resolution are, well, linked. When you change the print size, the output resolution changes, and vice versa, because you're keeping the pixel count the same.

3. **Enter the desired print width in the Width box.**

 Or enter the print height in the Height box. When you change one value, the other one changes automatically so that the original proportions of the image are maintained.

 If you prefer, you instead can enter a Resolution value and let the program automatically adjust the Width and Height values to show you how large you can print the photo at that output resolution.

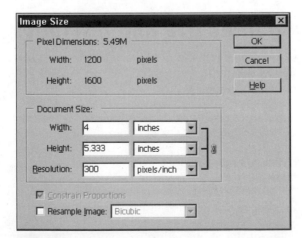

Figure 11-9: Set print size and output resolution here.

You can select a different unit of measurement than inches by selecting it from the drop-down list next to the Width or Height box.

4. Click OK to close the dialog box.

Because you haven't changed the pixel count of the photo, the picture doesn't appear to have changed size in the image window. But it will print at the size you specified in the Image Size dialog box. You can choose View➪Print Size to see the photo on-screen at the approximate size that it will print.

5. Save the image to retain the print size and resolution settings.

Otherwise, the program will return to the default settings the next time you open the picture.

To retain the best image quality, select the PSD or TIFF file format instead of JPEG when you save the photo. As covered in Chapter 9, each time you edit and resave a picture in the JPEG format, you destroy some image data, which can lower picture quality.

Note that in these steps, I'm assuming that you *do not* want to add pixels to the photo to raise the output resolution. As explained earlier, doing so does not improve print quality in most cases.

If you do want to try adding pixels, select the Resample Image check box in Step 2 and then enter your desired Width, Height, and Resolution values. Now when you change the Resolution value, the print dimensions don't change; instead, the program adds pixels as necessary to achieve the output resolution you entered. By the same token, when you adjust the print dimensions, the Resolution value doesn't change. Again, the program adds the pixels needed to print the photo at the current Resolution value.

Sending the Picture to the Printer

After setting the print size and output resolution for your picture, as described in the preceding section, you print your photo by choosing the File➪Print command. The command is the same whether you're printing the picture from inside your photo editor or some other photo software.

If you're working on a Windows-based PC, choosing the Print command results in a dialog box that looks something like the one in Figure 11-10. This Print dialog box is from Photoshop Elements, but you find the same basic controls for any Windows-based software. (More about the Mac side of things in a moment.)

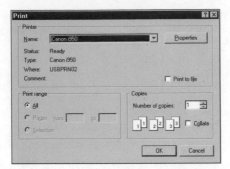

Figure 11-10: Establish basic print settings in the Print dialog box.

✔ If you have more than one printer installed on your computer, select the printer you want to use from the Name drop-down list.

✔ Specify how many copies you want to print in the Number of Copies box.

✔ Click the Properties button to set the options available for your selected printer. The Printer Properties dialog box appears, containing all sorts of controls that enable you to fine-tune the print settings. The controls vary depending on your printer; Figure 11-11 shows some of the options available for a Canon photo printer.

✔ Click OK to start the print job.

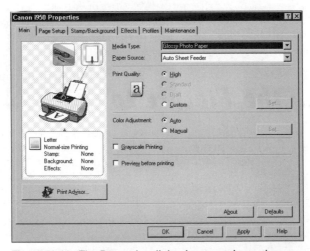

Figure 11-11: The Properties dialog box contains options related to your specific printer.

On a Macintosh computer, you have access to all these same options, but they're arranged a little differently. Here's the scoop:

 ✔ To select a printer, open the Chooser from the Apple menu. Click the icon for the printer that you want to use and then close the Chooser.

 ✔ To start the printing process in your photo editor (or other software), choose File⇨Print.

 ✔ The dialog box that appears after you choose the Print command varies depending on the printer you selected, but always contains an option for setting the number of prints. Other printer-related options may also appear in the dialog box. You may also find an Options button that you can click to uncover additional printing controls.

 ✔ Click Print to send the file to the printer.

Because every printer offers a different assortment of controls, I can't give you clear instructions on which settings to use, regardless of whether you're working on a Windows-based or Macintosh computer. The following list offers some basic guidelines, but read your printer manual carefully for specifics:

 ✔ **Paper type:** Often labeled *Media Type,* this control tells the printer what kind of paper you're using — glossy photo stock, plain paper, and so on. The printer uses this information to deliver the right amount of ink or toner onto the paper, so selecting the correct option is crucial. (You normally don't have to worry about this option with a dye-sub printer because that type of printer typically can use only one type of paper.)

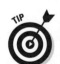

 Most paper manufacturers include a guide that tells you what setting to select with various types of printers.

 ✔ **Print quality:** You usually can opt to print a draft copy, which produces a quick, low-quality print; or a high-quality print, which takes longer to produce but results in the best-looking photos. This option isn't available if you use a dye-sub printer, which can print only at the high-quality setting.

 ✔ **Orientation:** This setting controls whether your picture prints sideways on the paper or in normal vertical orientation. For sideways printing, choose Landscape; for normal printing, choose Portrait.

 ✔ **Color controls:** Most photo printers offer controls for tweaking color, saturation (color intensity), and contrast. These controls affect only the current print; to change these aspects of your picture permanently, you must use the editing tools in your photo editor.

✓ **Print scaling:** You may be able to *scale* the picture up or down, which simply means to increase or reduce the print size from what you had originally specified in your photo editor. Again, this option affects only the current print. Remember that when you increase the photo size, you may reduce print quality because you are also lowering output resolution. Refer to the section "Understanding output resolution" for more about how output resolution is related to print size and picture quality.

Your photo software may offer additional print options, which you may or may not be able to access via the Print dialog box. In Photoshop Elements, for example, if you choose File⇨Print Preview (instead of File⇨Print) to start the printing process, the program displays the options shown in Figure 11-12. When you're ready to print, you can click the Print button to get the regular Print dialog box.

Figure 11-12: Photoshop Elements offers these options via the File⇨Print Preview command.

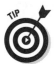

For quick-and-easy printing, check the software that came with your camera, camera dock, or printer. Most manufacturers provide a wizard or utility that automates the printing process. Often, you can even find wizards for printing a batch of pictures together on the same page, as shown in Figure 11-13, which features software provided with some Canon printers. These tools also usually provide options that print a single picture at an assortment of sizes or print thumbnails for all the photos in a folder or on a memory card. Some photo-editing and photo-cataloging programs offer these features as well.

Figure 11-13: Your printer may come with software that simplifies some printing projects.

Part V

The Part of Tens

The 5th Wave By Rich Tennant

THE GLACIER MOVEMENT PROJECT UPDATE THEIR WEBSITE

Camera ready? Wait a minute, hold it. Ready? Wait for the action... steady... steady... not yet... eeeasy. Hold it. Okay, stay focused. Ready? Not yet... steeeady... eeeasy...

In this part . . .

*N*eed quick answers or ideas? Looking for a little nugget of data to add to your digital photography knowledge base? You've come to the right place.

This part of the book offers quick bits of information presented in that famous format known as the top-ten list. You can find answers to frequently asked digital photography questions, discover solutions to common printing problems, get advice about buying your next piece of digital photography equipment, and see some products that will enhance your digital photography studio.

Chapter 12

Ten Digital Photography FAQs

*A*fter you answer the most critical question about digital photography — whether you should make the leap to this new picture-taking technology (yes) — dozens more questions spring up. What are megapixels? What's JPEG? Why do the sales ads talk about "digital film" when digital cameras don't use film? It's like playing a game of intellectual whack-a-mole, with each answer leading to another question.

This chapter helps you smack down some of these digital photography puzzlers, providing answers to ten most frequently asked questions, or FAQs, in Internet lingo. (Say it F-A-Q, not *fax*.) In case the information you read here sparks a thirst for additional knowledge, the Cross-Reference icons point you to chapters that offer more details.

What's a Megapixel?

The term *megapixel* means 1 million pixels. A *pixel,* in case you're new to that word as well, is the basic building block of a digital photo. It's nothing more than a tiny colored square — you can compare it to a tile in a mosaic. Your digital camera builds photographs by arranging pixels in a rectangular grid.

Most digital cameras today can generate at least 1-megapixel images. The more megapixels your camera offers, the larger you can print your photos without noticing any drop-off in photo quality.

To discover more about pixels and their impact on print quality and on Web photos, read Chapter 3.

What Resolution and Picture Quality Settings Should I Use?

Most digital cameras offer you a choice of *resolution* and *picture quality* settings. The resolution setting determines how many pixels your photo contains; the picture quality setting affects, er, picture quality. Both settings also affect the file size of your photos and, therefore, how many pictures you can fit in a given amount of camera memory.

Chapter 3 offers details on both of these options. But in general, follow these guidelines:

✔ For top-quality prints at the largest possible print size, select the highest resolution setting that your camera offers. This setting captures the image using the maximum number of pixels, which translates to better prints. Remember, though, that more pixels means bigger picture files, so you can fit fewer pictures on your camera memory card.

✔ For Web photos, you can use the camera's lowest resolution setting because you need very few pixels for screen images. The pixel count affects only the size at which the picture displays, not the image quality.

✔ As for the picture quality option, the right setting depends on how demanding you are about picture sharpness and detail. For the best pictures that your camera can produce, you should, of course, select the highest quality setting. But on many cameras, you can use the second-highest setting and still get very good pictures, at much smaller file sizes.

What's JPEG?

JPEG (pronounced "jay-peg") is a computer file format developed specifically to store digital picture data. The format is named for the Joint Photographic Experts Group, the brain trust that created it.

Most digital cameras store picture files in the JPEG format, which is handy because JPEG happens to be the format you need to use to share photos through e-mail or put pictures on a Web page. JPEG also offers a feature known as *compression,* which shrinks the size of the picture file by eliminating some image data. Compression enables you to fit more pictures on a camera memory card, but it also has a negative side: You lose some picture quality when you toss out image data.

Chapter 3 delves deeper into the subject of compression, including how to use the picture quality option on your camera to specify the amount of compression. Chapter 9 provides information about options that you encounter when you save a picture in the JPEG file format in your photo editor.

What Is "Digital Film?"

The phrase *digital film* is an outgrowth of a marketing strategy designed to make you more comfortable with digital photography. See, manufacturers decided that if they describe digital components using traditional photography terms, you'll be less intimidated by the new technology.

When manufacturers talk about digital film, they're referring to camera memory cards. On a digital camera, the memory card serves the same function as a film negative does on a traditional camera: It records the image. But there's no film or film processing involved — just some memory chips and other computerized bits and pieces.

How Many Pictures Can 1 Fit on a Memory Card?

When you buy a roll of film, you can take a specific number of pictures — 12, 24, or 36, depending on the number of exposures on the roll. Digital memory cards, too, come in different capacities, ranging from 8MB (megabytes) on up. But the number of pictures you can store on a particular memory card varies depending on what camera settings you use.

As mentioned a few paragraphs ago, the size of a digital picture file depends on the camera resolution and picture quality settings you select before you snap the photo. A high-resolution, high-quality

picture has a larger file size and, therefore, takes up more space on the memory card than a low-resolution, low-quality image.

The exact file size produced by specific resolution and picture quality settings varies from camera to camera. Most camera manuals provide a chart that gives you a general idea of the file sizes to expect and how many pictures fit in a given amount of camera memory.

Is Digital Zoom as Great as the Salesperson Said?

Nyet. Nein. A world of no. In fact, digital zoom is a feature to be *avoided* because it lowers image quality.

Using digital zoom accomplishes the same thing as enlarging your picture in a photo editor and then trimming away the edges. You're tossing away some of the original image pixels, which causes untold suffering to your picture.

Okay, so maybe digital zoom isn't as bad as all that, but I still suggest that you avoid using it if you want your photos to look their best. See Chapter 4 for more about the differences between digital zoom and a true, optical zoom lens.

What Does White Balancing Do?

Like video cameras, digital cameras offer an adjustment known as *white balancing.* This feature is designed to eliminate the color casts produced by different light sources. For example, fluorescent lights emit a yellow-green tint, and candlelight has a reddish tint.

In automatic mode, the camera's white-balancing control works behind the scenes to neutralize the light color so that the your subjects are rendered accurately. Because multiple light sources can sometimes confuse the white-balancing mechanism, however, most cameras also enable you to make manual adjustments to white balance.

Chapter 4 offers more details about white balancing.

What ISO Setting Is Best?

Many digital cameras offer an ISO control. This control enables you to adjust the light sensitivity of the camera's imaging sensor.

As you raise the ISO setting, you increase the camera's light sensitivity, which enables you to take pictures in less light. The drawback is that increasing ISO also introduces a visual defect known as *noise*. So for the best picture quality, stick with the lowest ISO setting.

Chapter 6 includes an example of ISO-related noise and explains more about this option, including what the acronym *ISO* means.

How Can I Make the Camera Batteries Last Longer?

You probably noticed right away that your digital camera sucks up battery power at a more rapid pace than your film camera. The difference is logical because a digital camera has more components that require power.

The biggest drain on your camera batteries comes from the monitor. So to preserve battery life, turn the monitor off when you're not using it. Also turn the camera itself off if you won't be taking any pictures for several minutes. (Many cameras shut down automatically if they're idle for more than a couple of minutes.)

For more battery-conservation tips, see Chapter 2.

Do Airport X-Ray Scanners Hurt My Camera or Memory Cards?

The new, super-powered x-ray scanners found in today's airports may spoil the mood of impatient travelers and ruin high-speed film. But running your digital camera and memory cards through the scanner is perfectly harmless — assuming that the camera doesn't drop off the scanner belt onto the floor or into the hands of some low-life airport thief.

I don't recommend packing memory cards in your checked luggage, however. Although the even higher doses of radiation used to screen checked bags shouldn't do any damage to your picture cards, it is conceivable that a card tumbling around your suitcase could get banged around enough to be injured. (Keeping your memory cards in your carry-on bags also ensures that if your checked luggage falls into the Bermuda triangle of misdirected bags, you don't lose your picture files along with your shirts, shoes, and unmentionables.)

Chapter 13

Ten Printing Problems (And How to Solve Them)

*Y*ou shot your first batch of digital photos. And they're good — so good, in fact, that you can't wait to make prints so that you can show them off, especially to your annoying neighbors who are always bragging about what great prints they get from *their* camera.

When you print your pictures, though, you're more than a little disappointed. The colors aren't right, details that should be sharp look blurry, areas that should be smooth have jagged edges, and parts of the photos didn't even print.

Whether your prints suffer from these common printing problems or some malady I haven't mentioned yet, this chapter offers solutions. And I emphasize the phrase *common printing problems*. Trust me, everyone who's ever printed their digital photos has encountered these issues — even those know-it-all neighbors of yours.

This Printer Got Good Reviews — But My Prints Look Lousy!

You splurged on a new photo printer. You did your homework, reading product reviews and studying sample printouts to make sure that you bought a great machine. So why are the prints you make less than wonderful?

Several issues may be involved. Follow these guidelines to help your printer do its best work:

✔ When you set up the print job, be careful to select the right paper type — plain paper, glossy photo paper, and so on. This setting often goes by the name *Media Type,* but check your printer manual for specifics. Whatever the name, this setting makes a big impact on how the printer outputs the image.

✔ Use paper recommended by the printer manufacturer. The manufacturer has engineered the printer around specific paper qualities, so it stands to reason that you get the best results when you use that paper.

✔ Upgrade to the highest-quality paper stock that the manufacturer offers. The better the paper, the better the prints.

✔ If you're printing with an inkjet printer, don't try to save money by purchasing third-party inks or ink refills. Again, the print heads on your printer are designed around a specific ink formula, and any variation can lead to poor results. (Using other inks also can ruin the print heads.)

✔ Finally, remember that no printer can produce good prints unless the image contains an adequate pixel supply. The next section provides basic pixel-count guidelines; check out Chapters 3 and 11 for details.

My Picture Has the Jaggies

Digital photos are made up of square tiles of color known as pixels. When you don't have enough pixels, the print takes on a blocky, jagged look. Digital-imaging gurus use the term *jaggies* to describe this defect; you can see an example in Figure 3-5, in Chapter 3.

For a smooth, seamless photo, you need 200 to 300 pixels per linear inch of the print, depending on the printer. For a 4-x-6-inch print, for example, you need at least 800 x 1200 pixels.

Unfortunately, you can't improve print quality by adding more pixels in your photo editor. So the only way to get a good print is to reduce the print size enough to reach the 200 pixels per inch (ppi) minimum.

See Chapter 3 for a thorough explanation of how pixels work, and check out Chapter 11 for more details about ppi, including how to alter the print size to raise the ppi value.

Details Aren't Sharp

If your picture appears perfectly focused when you view it on your computer monitor but loses some sharpness when printed, try these solutions:

- Check the output resolution (ppi), following the steps outlined in Chapter 11. If the resolution is less than 200 ppi, reduce the print size. Too few pixels per inch can cause a slightly blurred effect in addition to making some parts of the picture jagged.

- Apply a *sharpening filter* in your photo editor. This type of filter creates the illusion of sharper focus by manipulating contrast in some parts of the image.

 Make a backup copy of your unsharpened photo before you apply the filter. A picture that's appropriately sharpened for printing may have a rough appearance when displayed on-screen.

- For an inkjet or laser printer, use high-grade, glossy photo stock, not plain paper. Again, for the sharpest prints, you need great paper.

Screen and Print Colors Don't Match

A printer, which creates colors using ink, toner, or dye, can produce a smaller spectrum of colors than a monitor, which creates colors out of red, green, and blue light. Because of this fundamental difference between printers and monitors, the colors in your printed photos will never match on-screen colors exactly.

That said, use these techniques to get printer and screen colors in closer sync:

✔ First, use a monitor-calibration utility to remove any color bias from your monitor. This adjustment gives you a neutral canvas on which to view your photos so that you know whether the problem is your printed colors or your actual image colors.

If you own Photoshop Elements, a calibration utility called Adobe Gamma is installed automatically when you install Elements on a Windows-based system. On a Macintosh computer, the operating system includes a calibration tool called Apple ColorSync. Check the appropriate manual or Help system to find out how to use these tools.

You also can find free and low-cost calibration utilities on the Web by doing a search for "monitor calibration" with your favorite search engine. I use the search engine Google (www. google.com).

✔ As mentioned earlier, be sure to use the correct media settings when you print the photo, stick with the manufacturer's brand of paper and ink (or toner), and use high-quality paper. Color-matching is usually better with glossy photo stock than with plain paper.

✔ Most printer software includes one or more controls for tweaking print colors. (Chapter 11 shows you how to access the controls.) Try fiddling with these settings to get your prints more in line with the colors you're after. Write down the settings that work so that you can use them the next time you print.

✔ Before judging the colors of an inkjet print, give the print time to dry. Colors shift slightly as the inks dry. With any printer, remember that the light in which you evaluate the print affects how your eyes perceive the colors.

The Print Has a Tint

An inkjet print that appears with a solid-colored tint — for example, it prints with an overall green or magenta tint — indicates that one of your ink cartridges is depleted. Buy and install a new cartridge to fix the problem.

This advice applies even when you try to print a black-and-white photo. Most people assume that when a black-and-white picture prints with a tint, the black cartridge is empty. But a dry color cartridge is usually to blame.

Part of the Picture Is Missing

When you take your picture files to a photo lab for printing, you may notice that the entire original image doesn't print. This happens because the proportions of a digital photo aren't the same as the proportions of standard photo sizes (4 x 6, 5 x 7, 8 x 10, and so on). The lab has to crop away part of the picture to make it fit those traditional photo dimensions.

The same problem occurs when you print your own pictures with a printer that outputs the images directly from a memory card or camera. If you're printing from your photo software instead, you must do the cropping yourself.

Chapter 4 explains this issue in detail and shows you how to compose your pictures to avoid the problem.

The Print Is Smeared or Streaked

To avoid smeared or streaked photos, take these precautions:

- ✔ For an inkjet print, give the photo a few minutes to dry before you touch it.

- ✔ Be sure to load the paper into the printer correctly. Some printers require the printable side of the paper to be loaded face up, and others need the printable side facing downward. If you use the opposite orientation, the ink, toner, or dye may not adhere to the paper as it should.

- ✔ Again, check that all-important media type setting when you set up the print job on an inkjet or laser printer. The printer may lay down too much toner or ink, causing smearing, when the setting doesn't match the actual paper type.

- ✔ If your print appears streaked, with some areas printing normally and others appearing as if the color was raked off, an empty ink or toner cartridge may be to blame.

- ✔ On an inkjet printer, streaked prints may also indicate that the print heads need to be cleaned or aligned. Check your printer manual to find out how to do this.

Black-and-White Prints Look Worse Than Color Prints

Most color inkjets struggle when printing black-and-white photos. Areas that should be neutral gray often appear to have a slight color tint. This problem occurs because a color printer produces shades of gray by blending equal amounts of each ink color. As you can imagine, keeping that mixture exactly balanced over the expanse of a large photo is a difficult proposition.

For tint-free black-and-white photos, try these solutions:

✔ Your printer software likely has a setting that tells the printer to use only the black ink cartridge, which eliminates the tint. (Look for an option that includes the word *Grayscale.*) However, print quality may be lower than normal. When using just the one print head, the printer can't render details as finely as when all the print heads are involved.

✔ If your printer has controls that allow you to adjust colors, try fiddling with those options. By increasing the amount of one or more ink colors, you may be able to neutralize the tint.

✔ For sure-fire tint-free pictures, take your image files to a photo lab for printing. Before you do so, though, call the lab and find out whether you should convert the picture from a full-color image to a grayscale image in your photo editor.

My Prints Fade and Change Colors

All photographic prints, whether from digital or film originals, fade and exhibit color shifts over time. These changes are caused by exposure to light, humidity, and environmental pollutants.

To ensure the longest life span for your digital prints, take these precautions:

✔ When you buy paper, check the package for a lightfast rating or other print-life information. Understand that these claims are based on using specific printers, however.

For impartial information about specific papers and printers, visit the Web site of Wilhelm Imaging Research (www.wilhelm-research.com). This company is the leading source of print-life data in the photographic industry.

✔ Frame prints behind glass, using mattes to keep the prints from sticking to the glass. Store prints that you don't care to frame in archival storage boxes or albums.

✔ Display prints in a location that doesn't receive heavy doses of sunlight or artificial light.

✔ Don't keep important photos in areas subject to intense heat or high humidity.

✔ Keep in mind that dirt, dust, and the invisible pollutants found in the air are probably more damaging to photographs than light exposure. By the way, the kitchen refrigerator is just about the worst place in the house to hang an unframed photo — over time, the paper will suck up grease, grime, and other kitchen flotsam.

The Printer and Computer Are Fighting!

Computers are finicky beasts. On occasion — usually, on the occasion when you need to get something done quickly — your computer may decide that it's not going to cooperate with your printer. You may get an error message that says that the computer can't communicate with the printer, that your photo software has performed an illegal operation, or that some other digital roadblock has sprung up.

This type of problem occurs even on the best-maintained systems, operated by people who have achieved the highest level of geekdom. But you can keep things running as smoothly as possible by following these tips:

✔ Visit the printer manufacturer's Web site periodically to check for updated *printer drivers*. A driver is the piece of software that your printer and computer need to communicate.

✔ If the printer connects to the computer via a parallel port, be sure that you use the right kind of cable. For most printers, you need an IEEE 1284-compliant bidirectional cable. This type of cable is more expensive than a regular parallel-port printer cable, but it enables the computer and printer to share information better.

✔ Make sure that your computer's hard drive isn't filled to the brim; the system needs some empty hard drive space to use for temporary data storage when it performs operations such as printing.

✔ You also may want to upgrade the computer's memory (RAM) if the system freezes repeatedly or otherwise refuses to do your bidding when you try to print (or edit your photos). Also try closing all programs other than the one you're using to print your photos; shutting down those other programs frees up system resources.

Chapter 14

Ten Digital Photography Shopping Tips

In This Chapter

▶ Study reviews

▶ Buy from a reputable dealer

▶ Don't put too much emphasis on resolution

▶ Download free software trials

▶ Ask about the return policy!

*W*alk through any computer or electronics superstore, office-supply outlet, or camera shop, and you can find a daunting array of products aimed at the digital photographer. Many of the items vying for your dollar are terrific, some are so-so, and a few . . . well, let's just say that you could get the same return on your investment if you just tossed your money in the trash can.

This chapter offers ten shopping tips to help you track down the best products and avoid the clunkers. Whether you're in the market for a new camera, a printer, or accessories to make photography easier and more enjoyable, don't hand over your cash until you take in this information.

Head for the Newsstand First

Most photography and computer magazines regularly review new products and also publish "round-up" articles that compare all the leading products in a particular category. Reading these reports gives you a huge advantage when you head to the store.

If issues currently on the newsstand don't cover the product you're considering, head to the library or the Internet to look for back issues. Many magazines make archives of past issues available for free on their Web sites.

Check Out Online Reviews

In addition to studying magazine reviews, spend an hour or two browsing online photography sites. Most sites offer in-depth product reviews and also have discussion forums where people debate the pros and cons of various products and technologies. You can learn a lot just by reading the forum postings; real-life users often uncover benefits or drawbacks that reviewers miss.

The following list points you toward some of my favorite sites:

- www.imaging-resource.com
- www.dpreview.com
- www.pcphotoreview.com
- www.photo.net
- www.megapixel.net

Run a Discussion-Group Search

After you narrow down your shopping list to two or three products, log on to the Internet and search Web discussion groups for mentions of those products. Discussion groups, also known as *newsgroups,* are the digital equivalent of a community bulletin board. People post messages asking questions about a product or problem, and other people respond with their advice.

The search engine Google (www.google.com) offers a convenient way to find relevant discussion-group postings. After making your way to the site, click the Groups tab at the top of the page. Type the product name in the search box and then click the Search button to display a list of all messages related to that product.

If you want to post a question on a newsgroup, you can do it via the Google Groups page as well. After you run your product search, a list of links to related discussion groups appears at the top of the page. Click a link to see all the current messages for that discussion group and then post your question. (Try rec. photo.digital for general digital photography questions and comp.periphs.printers for printer queries.)

Beware of Lowball Prices

Digital photography equipment isn't cheap, so many people are tempted by mail-order stores and Web sites that promise deep discounting of products. Nearly everyone who gives into the lure of too-good-to-be-true prices regrets it.

Outfits that sell cameras, printers, and other equipment at below-market prices may be selling so-called *gray-market goods.* These products were manufactured for sale in a foreign market and in fact shipped to that foreign destination — and then reimported back into your country, without the manufacturer's consent.

The gray-market dealer can sell the goods for less because they cost less to buy overseas. As a buyer, though, you take a big risk. The owner's manuals probably aren't in your language, parts may be missing or incompatible with your electrical system, and you sure as heck can't take advantage of any warranties.

Another scam of lowball-price shops is to tack on extra costs for items that are normally provided for free by the manufacturer. In the end, you can wind up paying *more,* not less, for your equipment.

Buy from a Reputable Dealer

If you're in the market for a camera and this is your first foray into digital photography, I recommend that you buy from a camera store. The salespeople tend to be more knowledgeable about photography than at other types of stores, and a good salesperson is critical to selecting a camera that suits the type of photography you want to do. You won't pay any more for your camera, either; prices for current models are pretty much the same anywhere you shop.

For printers and other peripherals, however, most camera stores don't offer as broad a selection as computer and office stores. Unfortunately, getting good information from salespeople in these stores can be hit or miss, so educating yourself before you shop is important.

What about buying at warehouse shopping clubs? If you know exactly what you want and the store has it in stock, you can sometimes get a good deal, although usually not at a huge savings over other retail outlets.

Finally, if you live in a remote area or just prefer mail-order or online buying, check out these companies:

- ✔ B & H Photo-Video-Pro Audio (www.bhphotovideo.com)
- ✔ Calumet Photographic (www.calumetphoto.com)
- ✔ Norman Camera and Video (www.normancamera.com)
- ✔ Porter's Camera Store (www.porters.com)
- ✔ Samy's Camera (www.samyscamera.com)
- ✔ Robert's Imaging (www.robertsimaging.com)

With mail-order and online buying, don't forget to factor in the cost of shipping and handling when comparing prices.

Save with Bundling Deals and Rebates

Every Sunday morning, I browse through the newspaper ads to check out the current prices on digital cameras, printers, and other photography goodies. (Okay, so I'm a nerd, but isn't that what you want from an author?) Anyway, I can tell you from this endeavor that prices for cameras, printers, and software are fairly consistent no matter where you shop, assuming that you stay away from the shady-deals spots I warned you about earlier.

However, reputable stores do sometimes offer special deals that throw in a few extra goodies either for free or at a reduced price when you purchase a particular product. For example, when you buy a camera memory card, the store may give you a card reader at no charge. Or a camera store that has an in-house photo lab may give you some free prints of your digital images when you buy a camera.

To uncover these deals — known as *bundling deals* in the trade — you'll have to take up Sunday-morning newspaper reading because that's when most stores make these offers. If you're shopping online stores that don't advertise in local papers, check the stores' Web sites regularly to look for special offers. Also visit product manufacturers' Web sites; you may find rebate coupons that can save you additional money.

Don't Put Too Much Emphasis on Resolution

Product ads and store salespeople make a huge deal about digital camera and printer resolution. The higher the resolution, the closer you can get to true inner peace and enlightenment, or so you're led to believe.

Of course, higher resolution also translates to higher prices. Whether or not that additional investment means greater satisfaction with your purchase is debatable, however. Here's my take:

- ✔ **Camera resolution:** For most users, 2 or 3 megapixels is plenty. With 2 megapixels, you can make excellent 4-x-6-inch prints, good 5 x 7s, and acceptable 8 x 10s. With 3 megapixels, you get excellent print quality as large as 8 x 10 inches. If you're a photography buff who likes to make larger prints and also to crop and enlarge your photos, you may need more resolution, but even then, 4 to 5 megapixels is adequate.

 Chapter 3 explains more about camera resolution and its impact on print quality as well as on file size, which in turn affects how many pictures you can fit on a camera memory card.

- ✔ **Printer resolution:** Printer resolution is measured in dots per inch, or dpi. With inkjet and laser printers, a higher dpi does translate to better print quality — in theory. But because other factors in the printer design also affect print quality, you shouldn't buy on the resolution spec alone. Also note that the resolution scale changes depending on the printer technology. A dye-sub printer with a resolution of just 300 ppi can output prints as good or better than some inkjets that offer twice the resolution.

 For more details about printers and printing, see Chapter 11.

Consider Ease of Use

One of the biggest mistakes people make when buying a digital camera is focusing so much on the technical specs that they forget to evaluate how easy the camera is to use.

Never buy without actually holding the camera in your hand and taking a few pictures. Then ask yourself: Does the shape of the camera fit your hand well? Can you see through the viewfinder

easily? Are the controls for key features accessible via external buttons or dials, so that you can access them quickly between shots? Or do you have to scroll through several levels of menus to get to those options — wasting time and energy, and possibly missing great photo opporunities in the process?

All the technical specs in the world can't make up for a camera that's poorly designed in these areas. If the camera isn't easy to operate, you simply aren't going to enjoy using it.

Download Free Software Trials

Most digital cameras and printers ship with some basic photo-editing software and a tool for managing your picture files. But you may find that these free programs don't offer all the features you want.

Reading reviews can help you put together a list of programs that better suit your needs, but don't stop there. Most software companies offer free, try-before-you-buy versions of their products on their Web sites. After downloading and installing the programs, you typically have 15 to 30 days to try them out.

Ask about the Return Policy!

My final bit of buying advice — and perhaps the most important — involves store return policies. Most computer- and electronics-superstores, whether online or in your neighborhood, do not accept returns of cameras or printers without charging you a *restocking fee*. This fee typically is 10 to 15 percent of the purchase price. You can exchange a defective item for the same item, but if you decide that you just don't like the product, the fee applies.

Office-supply stores vary on this issue; some charge restocking fees for some products but not for others. Camera stores usually do not charge restocking fees, but check with the salesperson to be sure. Online camera stores are more likely to charge the fee than a local retail store.

Software, unfortunately, can almost never be returned once opened, no matter where you buy it. This makes testing out the programs through free trials, as suggested in the preceding tip, doubly important.

Chapter 15

Ten Cool (And Useful) Digital Photography Accessories

1 am convinced that one reason for the increasing sales of digital cameras — aside from the obvious benefits of instant feedback and easy online photo sharing — is that they make great gifts for the difficult-to-buy-for mother, father, or significant other. Father's Day is rolling around, and dad already has more ties, tools, and golf balls than he can use? Your wife's birthday is tomorrow, and she's warned you not to wrap up a vacuum cleaner, skillet, or ridiculous lingerie? For once, you have a gift idea that you know is sure to please.

Even better, oodles of digital-photography accessories are available. So after you indulge your loved one with a digital camera for *this* special occasion, gift-giving becomes a cinch for years to come. You just head to your camera or electronics store and browse the digital photography aisles. It's never been so easy to be a hero.

To help the gift-givers in *your* life be heroes, this chapter introduces you to ten products that can enhance your digital photography studio. I suggest that you circle the products that interest you most and then leave the book out on your kitchen table, open to this chapter, for a few weeks before your next special day. Unless your loved ones are complete lunkheads, they'll get the hint — and thank you for making their lives easier, too.

You can find information about other accessories, including memory card readers, photo-organizer software, and battery chargers, scattered throughout the rest of the book. If you're in the market for a camera, check out Chapter 14 for some buying advice. For help with choosing a photo printer, see Chapter 11.

Memory Card Protection

Chapter 2 introduces you to digital memory cards, the picture-storage media used by most digital cameras. (Check out Figures 2-3 and 2-4 for a look at the most commonly used types of cards.)

Because they're small, memory cards are easy to lose. They also can be damaged by dust, dirt, and moisture. To help you safeguard your cards from these hazards, most manufacturers provide a protective sleeve or plastic case with every card. Always store the cards in those cases or sleeves when they're not in use.

If you own multiple memory cards, I recommend buying a camera case or bag that has special storage pockets designed just for the cards. The pockets prevent the cards from falling out of your camera case and make them easy to find when you're ready to swap cards. Figure 15-1 gives you a look at one such case, from Tamrac (www.tamrac.com). This particular case, which sells for about $25, has pockets for two cards, as well as an area for storing a spare set of camera batteries.

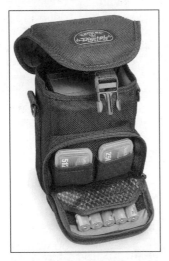

Photo courtesy Tamrac, Inc.

Figure 15-1: Look for a camera case that has pockets for stowing memory cards.

Already have a camera bag that you love? Several manufacturers sell memory-card wallets, which are stand-alone carrying cases for your cards. Figure 15-2 shows a Tamrac wallet; like the camera case shown in Figure 15-1, this wallet includes stowage for batteries as well as cards. Wallets range in price from about $8 to $25, depending on capacity and design. The Tamrac model shown in the figure sells for $25.

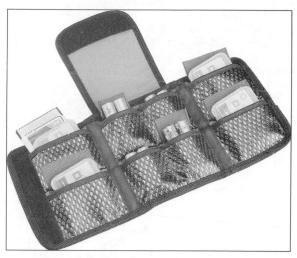

Photo courtesy Tamrac, Inc.

Figure 15-2: You also can buy stand-alone carrying cases for cards and batteries.

You can find digital camera cases, bags, and card wallets at just about any place that sells digital cameras, but camera stores typically offer a bigger selection than computer and electronics stores. Some camera manufacturers also offer digital-camera starter kits that include a camera case, a wallet, and a few other accessories bundled together. The cases in these kits typically are custom-designed for specific camera models.

For more information about using and protecting memory cards, see Chapter 2.

Drawing Tablets

If you're interested in photo editing, whether you want to repair problem pictures or explore creative projects such as building photo collages, I recommend one tool above all others: a drawing tablet.

With a drawing tablet, you trade in your mouse for a pressure-sensitive pen stylus, which makes wielding your photo software's editing tools much easier. Not only does working with a stylus feel more natural to most people than using a mouse, it also provides a degree of precision that is difficult to achieve with a mouse. You can vary the impact of your photo-editing tools just by putting more or less pressure on the stylus, for example.

Figure 15-3 shows a popular drawing tablet, the Graphire2 from Wacom Technology (www.wacom.com). Wacom has been the leader in tablet technology for so long that few other companies even care to compete. Fortunately, that virtual lock on the market doesn't translate to sky-high prices. You can buy the Graphire2, which is the company's basic model, for about $80 if you watch the sale ads. The tablet has an active drawing area of 3.65 x 5 inches and comes with both a stylus and a cordless mouse so that you can take your usual point-and-click approach when you're using other programs. Wacom also includes photo-editing and painting software to get you started on your creative journey.

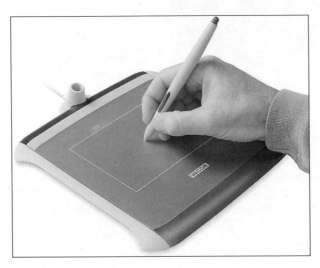

Photo courtesy Wacom Technology Corporation.

Figure 15-3: For less-cumbersome photo editing, use a pen stylus and drawing tablet.

Serious imaging artists may want to move up to a tablet in Wacom's Intuos line. These tablets come in several sizes and offer some customizable features and specialized tools that professionals appreciate; prices start at $200. (For the record, I've been using the 4-x-5-inch tablet, the smallest in the Intuos line, for years and never longed for a larger drawing surface.)

If you have no budget concerns at all (will you adopt me?), feast your eyes on Figure 15-4, which shows you the cream of the Wacom crop, the Cintiq. With this product, which is a blend of monitor and tablet, you draw right on the monitor. It's undeniably cool, but, sadly, also undeniably expensive, with prices starting at $1,900.

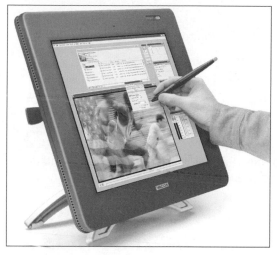

Photo courtesy Wacom Technology Corporation.

Figure 15-4: Part monitor, part tablet, the Cintiq enables you to draw right on your photo.

Before you invest in any tablet, be sure that it's compatible with the software that you want to use. Not all photo-editing and paint-ing programs support all the features of a drawing tablet. Most mainstream programs do accept tablet input, but just to be sure, check the software manufacturer's Web site. Look for information related to pressure-sensitive pen support.

Art Papers for Inkjet Printers

With an inkjet printer and high-quality, glossy photo stock, you can print photos that look just like the ones you've brought home from the photo lab for years. But to give special pictures a different cre-ative touch, veer off the glossy track and experiment with the many specialty art papers that are compatible with inkjet printers.

You can print your photos on papers that have the look of linen, canvas, silk, or watercolor paper, for example. These and other special papers are available in standard photo-size sheets (8 x 10,

11 x 14, and so on) as well as in foldable sheets that you can use to make lovely, personalized greeting cards.

Many printer manufacturers sell their own branded art papers, but don't overlook papers from third-party manufacturers. Check out the Web sites of the following paper-makers to get an idea of what's available:

- ✔ Pictorico (www.pictorico.com)
- ✔ Lumijet (www.lumijet.com)
- ✔ Legion Paper (www.legionpaper.com)
- ✔ Ilford (www.ilford.com)

Although some computer and electronics stores offer a limited supply of specialty papers, camera and art-supply stores are better bets for finding the broadest range of products. Regardless of what brand you buy, be sure to follow the paper manufacturer's advice about the correct printer settings to use.

Tripods and Camera Stands

When you take a picture, any camera movement during the length of the exposure causes blurry images. If you're snapping photos in very bright light, the exposure time is minimal, so you probably can get away with hand-holding the camera. Use the techniques discussed in Chapter 4 to keep the camera as still as possible. In dim lighting or any other condition that requires a slow-shutter speed (longer exposure time), the best way to avoid camera shake is to mount your camera on a tripod.

Tripods come in all sizes and configurations, with prices ranging from a few bucks to over $400. As you move up the price scale, tripods get sturdier and include features such as built-in levels and more sophisticated heads (the part of the tripod that attaches to the camera). Fortunately for the digital photographer, most digital cameras are small and lightweight, which means that you don't need a massive, expensive tripod. Most people are perfectly happy with a model costing $100 or less.

Do be careful, though, that the tripod is substantial enough to support your camera; a heavy camera can easily cause a light-weight tripod to tip over. When shooting outdoors, use beanbags or some other weighted objects to anchor the tripod so that the wind doesn't blow the thing over. (A purse or backpack can serve as a good anchor.)

As for tripod design, a standard-height, collapsible tripod such as the one shown in Figure 15-5 works well for everyday picture-taking. This model, from Manfrotto (www.bogenphoto.com) sells for about $100 and extends to a maximum height of approximately 48 inches and a minimum height of just under 13 inches.

Photo courtesy Bogen Photo.

Figure 15-5: A tripod helps you avoid camera shake, which causes blurry photos.

If you routinely need to shoot tabletop photographs of small objects, invest in a mini-tripod like the one shown on the left in Figure 15-6. These tripods enable you to get the camera closer to your subject than you usually can with a normal-height model. The tripod shown in the figure, from Sunpak (www.sunpak.com), sells for about $15. It offers a maximum height of 11½ inches and a minimum height of just under 7 inches.

A variation on the table-top theme, the Sunpak camera stand on the right side of Figure 15-6 also works well for close-up photography. You can clamp the stand onto any surface — including a car window. The vertical support is flexible so that you can position the camera at just about any angle. This product also sells for about $15.

I've introduced you to just some of the tripod and camera stand products on the market. To explore the many other styles available, visit your local camera store or check out the online dealers listed in Chapter 14.

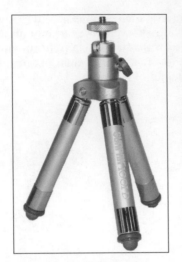 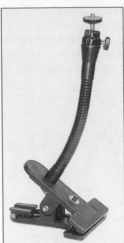

Photo courtesy Tocad America Inc.

Figure 15-6: Mini-tripods are useful for close-up photography.

Accessory Lenses

Every camera lens has a specific *focal length,* which determines angle of view, the size at which subjects appear in the frame, and focusing range. (Chapter 6 explains focal length in more detail.)

With an SLR (single-lens reflex) camera, you can swap out lenses, giving you great shooting flexibility. Suppose that you want to get close-ups of a bear in the wild, but because you value your life, you need to stay a safe distance from the beast. You can use a tele-photo lens, which makes distant objects appear closer and larger in the frame. If you instead want to capture an extreme close-up of a flower petal in your garden, you can remove the telephoto lens and pop on a macro lens, which enables you to fill the frame with an object that's just inches away. And if you want to capture a broad landscape scene, you can switch to a wide-angle lens, which makes things appear smaller and farther away, so that you can squeeze more area into the frame.

With a point-and-shoot camera, of course, you can't change lenses, although many cameras do offer a zoom lens that offers you some focal-length flexibility. If your digital camera doesn't offer a zoom lens or you just want to expand your options, you can purchase telephoto, close-up, and wide-angle add-on lenses. These lenses mount in front of your camera's built-in lens to change its perspec-tive on the world.

Figure 15-7 shows an assortment of these lenses from one well-known manufacturer, Tiffen (www.tiffen.com). Other manufacturers include Kenko (www.thkphoto.com) and Cokin (www.cokin.com). Your camera manufacturer may also offer its own assortment of lenses for your model.

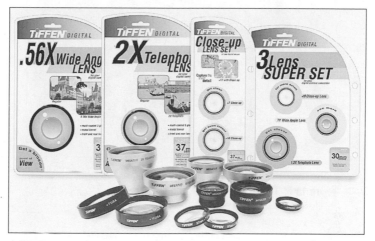

©The Tiffen Company, LLC

Figure 15-7: Lens adapters enable you to change the perspective and reach of your camera lens.

Prices range from about $15 to $200, depending on the type of lens you buy. Depending on your camera, you may also need to buy a special adapter to connect your camera lens to the accessory lens.

Underwater Camera Housings

Love exploring the deep blue sea on your travels? With an underwater camera housing, you can take your camera with you on your next scuba or snorkeling adventure.

Figure 15-8 offers a look at one type of underwater housing. This style, from Olympus, is a hard-shelled housing designed to fit certain Olympus digital cameras. It features external buttons that you use to trigger the shutter button and other camera functions. This $300 housing is watertight to depths of 130 feet, has thread adapters for screwing on accessory lenses, and also can accept an auxiliary flash.

You also can buy third-party housings and watertight camera bags from companies such as ewa-marine (www.ewamarine.com) and

Ikelite (www.ikelite.com). Prices range from about $80 to $600, depending on the unit's sophistication.

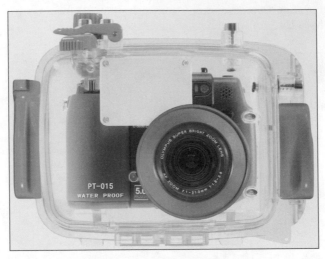

Photo courtesy Olympus America.

Figure 15-8: An underwater camera housing enables you to take pictures while snorkeling or scuba diving.

Light Domes and Tents

Digital cameras are ideal for taking product photos for a Web site or for listing on eBay or another online auction site. You can post your pictures within minutes of pressing the shutter button, getting your goods to market faster than is possible with film.

When you're selling products that have a reflective surface, such as glassware, metal objects, or sparkling jewelry, getting a good picture can be tough, however. Unless the photography gods are on your side, the surface of the product will reflect your lights or flash, as well as surrounding objects in the room. Those reflections show up in your photo, whether you're shooting digital or film.

Products such as the Cloud Dome, shown in Figure 15-9, offer a solution to this problem. The Cloud Dome is a translucent, white dome that you place over the object that you want to photograph, as shown in the figure. You mount your camera on a bracket at the top of the dome, which has an opening just large enough for your camera lens. Then you position lights around the dome to provide illumination. The dome diffuses the light, eliminating reflections, and the camera bracket eliminates the need for a tripod.

Figure 15-9: The Cloud Dome is a handy product for eliminating reflections in shiny objects.

Several variations of this product are available, with prices starting at $219. For details, visit the company's Web site, www.clouddome.com.

As an alternative, you can buy a light tent, which looks sort of like a teepee, only made out of translucent white material and without the hole at the top. As with the Cloud Dome, you arrange your product inside the tent and then shoot through an opening in the side of the tent. Prices start at about $60 and depend on the size of the tent. Well-known manufacturers include Westcott (www.fjwestcott.com) and Lastolite (www.lastolite.com).

Noise Removal Software

Digital photos taken in dim lighting or with a high ISO setting selected often suffer from *noise,* a defect that looks like grains of colored sand. You sometimes can remove noise by applying a blur filter in a photo editor. Unfortunately, blurring usually eradicates image detail in the process of eliminating noise.

For a more sophisticated solution, investigate a noise-removal *plug-in.* A plug-in is a small utility that works in conjunction with a larger program. Most plug-ins are so-called *Photoshop-compatible plug-ins.* That means that they work with Adobe Photoshop as well

as any other program than accepts this type of plug-in (which includes Photoshop Elements and other major photo-editing programs.) After installing the plug-in, you can access its tools by using the menus in the larger program.

Figure 15-10 shows a screen from one good noise-removal plug-in, Dfine, from nik multimedia ($100, www.nikmultimedia.com). Also check out Digital GEM, from Applied Science Fiction ($80, www.asf.com). Both companies offer free, downloadable demos at their Web sites.

Figure 15-10: To solve tough noise problems, try products such as Dfine.

Photo Slide-Show Software

Chapter 7 discusses ways to view your pictures on a TV and on a computer monitor. To jazz up your on-screen presentations, you can create a multimedia slide show with programs such as PhotoShow, a $30 program from Simple Star (www.simplestar.com). With this program, shown in Figure 15-11, you can add transitions, effects, and even a soundtrack to your photo shows.

After you create your show, you can copy it to a CD for distribution to all your fans. They can play your show on a computer that has a CD-ROM drive or on a DVD player that supports video CDs. You also can upload the album to the PhotoShow Web site for online viewing.

Figure 15-11: Create a multimedia slide show featuring your digital photos.

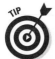 Before investing in an album or slide-show program, check the software CD that came with your camera; it may contain tools that offer these functions. Some photo-editing software also includes album and slide-show features.

Magazines and Other Information Resources

This book contains the information you need to start shooting and sharing photos with your digital camera. When you're ready to expand your digital-photography knowledge or just want some creative inspiration, the following resources are worth your consumer dollars:

- ✔ *Shutterbug* magazine (www.shutterbug.net) and *Petersen's Photographic* magazine (www.photographic.com) offer information and ideas for both digital and film photographers.

- ✔ *PCPhoto* (www.pcphotomag.com) is a magazine devoted entirely to digital imaging. Geared to novices, it provides digital photography tips as well as help with scanning and editing photos.

- *Outdoor Photographer* magazine (www.outdoorphotographer. com) covers film and digital photography and, despite its name, includes plenty for the photographer who prefers to stay indoors.

- Web Photo School (www.webphotoschool.com) is an online learning center that's especially geared toward helping photographers improve lighting skills.

All the magazines charge a subscription fee, of course, but they make some articles from past editions available at their Web sites at no charge. Web Photo School provides free access to some basic lessons; you can get access to all the lessons for $20 a month or $60 a year.

Also check out the additional information sites listed in Chapter 14.

Appendix

Digital Photography Glossary

● ●

8-bit image: An image containing 256 colors.

16-bit image: An image containing roughly 32,000 colors.

24-bit image: An image containing approximately 64.7 million colors.

aliasing: Random color defects, usually caused by too much JPEG compression.

aperture: An adjustable iris between the camera lens and shutter; opens to control the amount of light that enters the camera.

aperture-priority autoexposure: A semiautomatic exposure mode in which the user selects the aperture and the camera selects the appropriate shutter speed to properly expose the image.

artifact: Noise, an unwanted pattern, or some other defect caused by an image capture or processing problem.

aspect ratio: The ratio between image width and height.

bit: Stands for *binary digit;* the basic unit of digital information. Eight bits equals one *byte.*

BMP: The Windows bitmap graphics format. Reserved today for images that will be used as system resources on PCs, such as screen savers or desktop wallpaper.

burst mode: A special capture setting, offered on some digital cameras, that records several images in rapid succession with one press of the shutter button. Also called *continuous capture* mode.

byte: Eight bits. See *bit.*

CCD: Short for *charge-coupled device.* One of two types of imaging sensors used in digital cameras.

CIE Lab: A color model developed by the Commission Internationale de l'Eclairage. Used mostly by digital-imaging professionals.

cloning: The process of copying one area of a digital photo and "painting" the copy onto another area or picture.

CMOS: Pronounced "see-moss." A much easier way to say *complementary metal-oxide semiconductor.* A type of imaging sensor used in digital cameras; used less often than CCD chips.

CMYK: The print color model in which cyan, magenta, yellow, and black are the primary colors.

color correction: The process of fixing color problems in a photograph.

color model: A formula for mixing primary color elements to create or define a spectrum of colors. In the RGB color model, for example, all colors are created by blending red, green, and blue light. In the CMYK model, colors are defined by mixing cyan, magenta, yellow, and black ink.

color temperature: Refers to the color cast emitted by a light source; measured on the Kelvin scale.

CompactFlash: A type of removable memory card used in many digital cameras. A miniature version of a PC Card — about the size and thickness of a matchbook.

compositing: Combining two or more images in a photo-editing program.

compression: A process that reduces the size of the image file by eliminating some image data.

depth of field: The distance over which sharp focus is maintained in a photograph. Sometimes abbreviated as DOF.

digital zoom: A misnamed feature found on most digital cameras; not a real zoom lens at all, but rather an in-camera process that enlarges a picture and crops away the perimeter. Picture quality is lowered when this feature is used.

downloading: Transferring data from one computer device to another.

dpi: Short for *dots per inch*. A measurement of how many dots of color a printer can create per linear inch. Higher dpi means better print quality on some types of printers, but on other printers, dpi is not as crucial.

DPOF: Stands for *digital print order format*. A feature found in some digital cameras that enables you to add print instructions to the image file; some photo printers can read that information when printing your pictures directly from a memory card.

driver: A piece of software that enables a computer to communicate with digital cameras, printers, and other devices.

dye-sub: Short for *dye-sublimation*. A type of printer that produces excellent digital prints.

edges: Areas where neighboring image pixels are significantly different in color; in other words, areas of high contrast.

EV compensation: A control that slightly increases or decreases the exposure chosen by the camera's autoexposure mechanism. EV stands for exposure value; EV settings typically appear as EV 1.0, EV 0.0, EV –1.0, and so on.

EXIF metadata: Camera information that's stored as part of a digital photo file on some cameras; can be viewed in some image-organizer programs and other programs. See also *metadata.*

file format: A way of storing image data in a file. Popular image formats include TIFF, JPEG, and GIF.

flash EV compensation: A control that enables the user to adjust the intensity of light produced by the flash.

FlashPix: A file format developed to facilitate the editing and online viewing of digital images. Currently supported by only a handful of software programs.

f-number, f-stop: The aperture-size setting; a higher number translates to a *smaller* aperture, which allows less light into the camera.

gamut: Say "gamm-ut." The range of colors that a monitor, printer, or other device can produce. Colors that a device can't create are said to be *out of gamut.*

Gaussian blur: A type of blur filter available in many photo-editing programs; named after a famous mathematician.

GIF: Pronounced "gif," with a hard "g." GIF stands for *Graphics Interchange Format.* One of the two image file formats used for images on the World Wide Web. Supports 256-color images only.

gigabyte: Approximately 1,000 megabytes, or 1 billion bytes. In other words, a really big collection of bytes. Abbreviated as GB.

grayscale: An image consisting solely of shades of gray, from white to black.

histogram: A graph that maps out brightness values in a digital image; usually found inside exposure-correction filter dialog boxes.

HSB: A color model based on hue (color), saturation (purity or intensity of color), and brightness.

HSL: A variation of HSB, this color model is based on hue, saturation, and lightness.

interpolation: Changing the pixel count of an existing photo; also known as *resampling.*

ISO: Traditionally, a measure of film speed; the higher the number, the faster the film. On a digital camera, raising the ISO allows faster shutter speed, smaller aperture, or both, but also can result in a grainy image.

jaggies: Refers to the jagged, stair-stepped appearance of curved and diagonal lines in low-resolution photos that are printed at large sizes.

JPEG: Pronounced "jay-peg." One of two formats used for images on the World Wide Web and also used for storing images on many digital cameras. Uses *lossy compression,* which sometimes damages image quality.

JPEG 2000: An updated version of the JPEG format; not yet fully supported by most Web browsers or other computer programs.

Kelvin scale: A scale for measuring the color temperature of light. Named after Baron Kelvin of Largs, the scientist who developed the scale.

kilobyte: One thousand bytes. Abbreviated as *K,* as in 64K.

LCD: Stands for *liquid crystal display.* Often used to refer to the display screen included on some digital cameras.

lossless compression: A file-compression scheme that doesn't sacrifice any vital image data in the compression process. Lossless compression tosses only redundant data, so image quality is unaffected.

lossy compression: A compression scheme that eliminates important image data in the name of achieving smaller file sizes. High amounts of lossy compression reduce image quality.

megabyte: One million bytes. Abbreviated as MB. See *bit.*

megapixel: One million pixels. Used to describe digital cameras that can capture high-resolution images.

Memory Stick: A memory card used by several Sony digital cameras and peripheral devices. About the size of a stick of chewing gum.

metadata: Extra data that gets stored along with the primary image data in an image file. On a digital camera, metadata includes information such as the aperture, shutter speed, and EV setting used to capture the film, and can be viewed using special software.

metering mode: Refers to the way a camera's autoexposure mechanism reads the light in a scene. Common modes include spot metering, which bases exposure on light in the center of the frame only; center-weighted metering, which reads the entire scene but gives more emphasis to the subject in the center of the frame; and matrix or multizone metering, which calculates exposure based on the entire frame.

noise: Graininess in an image, caused by too little light, a too high ISO setting, or a defect in the electrical signal generated during the image-capture process.

NTSC: A video format used by televisions and VCRs in North America. Many digital cameras can send picture signals to a TV or VCR in this format.

optical zoom: A real zoom lens (as opposed to a digital zoom, which is just a software manipulation of an image).

output resolution: The number of pixels per linear inch in a printed photo; the user sets this value inside a photo-editing program.

PAL: The video format common in Europe and several other countries. Few digital cameras sold in North America can output pictures in this video format (see also *NTSC*).

panorama: A series of pictures that are joined together to make a single, larger image.

PCMCIA Card: A type of removable memory card used in some models of digital cameras. Now often referred to simply as PC Cards. (PCMCIA stands for *Personal Computer Memory Card International Association.*)

Photo CD: A special file format used by professional imaging labs for writing images to a CD. Don't confuse with Picture CD, a product offered by retail photo labs; when you order a Picture CD, the lab writes the images in the JPEG file format.

PICT: The standard format for Macintosh system images. The equivalent of BMP on the Windows platform, PICT is most widely used when creating images for use as system resources, such as startup screens.

pixel: Short for *picture element.* The basic building block of every image.

platform: A fancy way of saying "type of computer operating system." Most folks work either on the Windows platform or the Macintosh platform.

plug-in: A small program that works from inside another, larger program.

ppi: Stands for *pixels per inch.* Used to state image output (print) resolution. Measured in terms of the number of pixels per linear inch. A higher ppi usually translates to better-looking printed images.

RAW: A file format offered by some digital cameras; records the photo without applying any of the in-camera processing that is normally done when saving photos in other formats.

resampling: Adding or deleting image pixels. A large amount of resampling degrades images.

resolution: A term used to describe the capabilities of digital cameras, scanners, printers, and monitors; means different things depending on the device. (See Chapter 3 for details.)

RGB: The standard color model for digital images; all colors are created by mixing red, green, and blue light.

Secure Digital card: A type of removable camera memory.

sharpening: Applying an image-correction filter inside a photo editor to create the appearance of sharper focus.

shutter: A mechanism that opens and closes to allow light into the camera when the shutter button is pressed.

shutter-priority autoexposure: A semiautomatic exposure mode; the user sets the shutter speed, and the camera chooses the appropriate aperture.

shutter speed: The length of time that the shutter remains open.

slave flash: A type of auxiliary flash that works with cameras that don't have a hot shoe or cable connection for attaching a standard external flash. The slave flash fires when the camera's built-in flash goes off.

slow-sync flash: A special flash mode that forces a slower-than-normal shutter speed, resulting in brighter backgrounds in night-time photos.

SmartMedia: A thin, matchbook-sized, removable memory card used in some digital cameras.

TIFF: Pronounced "tiff," as in little quarrel. Stands for *Tagged Image File Format.* A popular image format supported by most Macintosh and Windows programs.

transparent GIF: A GIF image that contains transparent areas; when placed on a Web page, the page background shows through the transparent areas.

TWAIN: Say "twain," as in "never the twain shall meet." A special software interface that enables image-editing programs to access images captured by digital cameras and scanners.

unsharp masking: The process of using the unsharp mask filter, found in many image-editing programs, to create the appearance of a more focused image. The same thing as *sharpening* an image, only more impressive sounding.

uploading: The same as downloading; the process of transferring data between two computer devices.

USB: Stands for *Universal Serial Bus.* A type of new, high-speed port included on the latest computers. USB ports permit easier connection of USB-compatible peripheral devices such as digital cameras, printers, and memory card readers.

white balancing: Adjusting the camera to compensate for the type of light hitting the photographic subject. Eliminates unwanted colorcasts produced by some light sources, such as fluorescent office lighting.

xD-Picture Card: A type of removable camera memory used by some digital cameras.

Index